MASTERS OF THE CAMERA

MASTERS
OF THE
CAMERA
STIEGLITZ, STEICHEN
& THEIR SUCCESSORS

BY GENE THORNTON FOR THE AMERICAN FEDERATION OF ARTS

A RIDGE PRESS BOOK | HOLT, RINEHART AND WINSTON | NEW YORK

Editor-in-Chief: Jerry Mason
Editor: Adolph Suehsdorf
Art Director: Albert Squillace
Associate Editor: Ronne Peltzman
Associate Editor: Joan Fisher
Art Associate: David Namias
Art Production: Doris Mullane

Published in the United States of America in 1976 by Holt, Rinehart and
Winston, Publishers, 383 Madison Avenue, New York, New York 10017, U.S.A.
Published simultaneously in Canada by Holt, Rinehart and Winston of Canada, Limited.
Library of Congress Catalog Card Number: 76-6750
ISBN Hardbound: 0-03-018336-7
ISBN Paperback: 0-03-018331-6
Printed and bound in Italy by Mondadori Editore, Verona

CONTENTS

This book is based on an exhibition of twentieth-century American photography, "Masters of the Camera; Stieglitz, Steichen and their Successors," organized by The American Federation of Arts and partially supported by a grant from the National Endowment for the Arts. The exhibition began a two-year tour of American museums in the fall of 1976 at the International Center of Photography in New York City.

The aim of both book and exhibition is to focus attention on one of the most fundamental and controversial questions in modern photography. Must the maker of an artistic masterpiece have worked primarily to gratify his own creative urge? Or can a masterpiece result when a photographer is meeting the requirements of a client: a magazine or newspaper editor, an advertiser, a government or social agency, or a private portrait client?

Today our art museums have answered the question for us by showing both kinds of photography side by side. In effect, they say that the motive by which a photograph is prompted is not the key to its artistic merit. But this enlightened view has not always been held. The photographs in this book and exhibition were chosen and grouped to demonstrate the existence of two different and opposing traditions in twentieth-century American photography. Both traditions have produced masterpieces, as well as a lot of junk, but only one tradition has always and consistently been identified as art.

In selecting the pictures the author, who was also guest director of the exhibition, has had to make some hard choices. The photographers and pictures chosen do, he believes, give a true picture of major developments in the period covered. However, in the interests of clarity and concision, many photographers and pictures that would be essential to a comprehensive survey have been omitted. No reflection on their merit is intended.

Many people have helped make this undertaking possible. In addition to the photographers, collectors, dealers, and institutions without whose loans and permissions there would be neither exhibition nor book, four people deserve special thanks. John Szarkowski, Director of the Department of Photography of The Museum of Modern Art, helped clarify a basic concept of the exhibition at an early stage of the planning. At a later stage, after the main lines of the exhibition and book were set, three scholars read and commented on the manuscript of the book. They are Peter Bunnell, McAlpin Professor of the History of Photography at Princeton University; Eugenia P. Janis, Associate Professor of Art History at Wellesley College; and Eugene Ostroff, Curator of Photography at the Smithsonian Institution. Needless to say, none of them are responsible for the author's use of their comments and advice.

G. T.

MASTERS OF THE CAMERA

". . . if commercial art be defined as all art not primarily
produced in order to gratify the creative urge of its maker, but
primarily intended to meet the requirements of a patron
or a buying public, it must be said that non-commercial art is
the exception rather than the rule, and a fairly recent
and not always felicitous exception at that."

<div align="right">—Erwin Panofsky</div>

Famous photographers come in two kinds. On the one hand there are those whose best-known work is done for themselves. They are usually known as art photographers. On the other hand there are those whose best-known work is done for others: for newspaper and magazine editors, for advertisers, for government, social, and charitable agencies, for corporations and private portrait clients.

The works of both kinds of photographers are often shown side by side in museum and gallery exhibitions: art photographs by Alfred Stieglitz, Edward Weston, Harry Callahan, and Jerry N. Uelsmann alongside of newspaper, magazine, and documentary photographs by Dorothea Lange, Margaret Bourke-White, Weegee, and Irving Penn. In the end the merit of both kinds of picture must be judged by looking at the pictures themselves. When this is done it is sometimes hard to see any significant differences between them. Yet the differences between them are real and great, if not always in the pictures themselves, at least in the circumstances that give rise to them and the route that they take on the way to the exhibition.

The pictures of photographers who work for themselves characteristically go directly from the studio to the gallery or museum. In a sense they are made specifically for exhibition in museums and galleries—they have nowhere else to go—and when they arrive there they are greeted with the special reverence reserved for works of art. By contrast, the pictures of the other kind of photographer go to the museum or gallery, if at all, only after a detour through the pages of the mass media. Most of them never achieve the immortality of the museum, though they do lead a short, happy life in the media.

There is also a difference in the way the makers of the two different types of photograph are rewarded. Photographers who work for clients make a living from their work, sometimes quite a handsome living. However, photographers who work for themselves generally do not make a living from photography, at least not from the photography they are best known for. (One exception to this would seem to be Ansel Adams.) They teach or have private incomes or do commercial work which is never shown in museums or galleries. In short, they must be satis-fied with spiritual rewards such as fame or their own private satisfaction. The world is seldom prepared to reward them with cash.

The biggest and most important difference between the two kinds of photographer is, however, not in the way they reach people with their pictures or how they are rewarded for their efforts. It is in the way they go about their work. Photographers who work for themselves are free to express themselves to the very limit of their artistic and technical skills. They can choose their own subject and approach as well as their time and place of working. They do not have to consider anyone else's requirements. The same is not true of photographers who work for others. They must work when and where the work exists and according to the requirements of the job. They must consider the needs and wishes of editors, art directors, publicists, and sitters, not to mention the newspaper or magazine reader who is the ultimate client. They may want to express themselves and they may succeed. But in an age when art and self-expression are considered to be virtually identical, they think of themselves, and are thought of by others, as fighting an uphill battle.

This division between photographers who work for themselves and photographers who work for others has existed since the birth of photography in 1839. But it has never been wider, deeper, and more passionately felt than in America today. In American photography the division is often felt to be a moral one: Photographers who work for themselves are morally superior to photographers who work for others.

No doubt this feeling springs from the bedrock puritanism of the American people, who still expect of their preachers, presidents, and artists the sort of virginal purity once also expected of young, unmarried women. But it also springs from the precept and example of Alfred Stieglitz, the distinguished photographer and publicist whose passionate dedication to the art of photography led him to quarrel with his favorite disciple, Edward Steichen, when the latter went to work as a portrait and fashion photographer for *Vogue* and *Vanity Fair*.

The quarrel between Alfred Stieglitz and Edward Steichen has been hushed up and papered over

by partisans on both sides, and many younger photographers have never heard of it directly. It occurred, after all, nearly sixty years ago, and there is, or no doubt should be, a statute of limitations on quarrels that old. Yet it still echoes down the decades, mobilizing feelings of guilt and pride, abject unworthiness and self-righteous superiority in photographers and photography lovers on both sides of the gulf. It is time that this quarrel was brought out into the open once again to see what it really was all about and what relevance, if any, it has to photography today.

In the 1880's, when Alfred Stieglitz, then a young man in his twenties, first became seriously interested in photography, the institutions of the modern art world were already well established. They were the museum, the art school, the annual or biennial exhibition, the newspaper or magazine critic, and the collector.

Each of these institutions played an important part in the art life of the time. Together, they constituted a closed world beyond which few art lovers ever willingly ventured. The museum was the repository of the great art of the past and it was the aim of every serious artist to see his work join the works of the Old Masters there. The art school was the seedbed or seminary in which the artists of the future were inculcated with the skills and ideals of the past. The annual or biennial exhibition was the means by which living artists showed their new work to the public. The newspaper or magazine critic was a publicist who brought new work to the attention of the public and made the first tentative essays toward relating it to the accepted art of the past. The collector was the person who bought new work and eventually passed it on to the museums. Anything that did not fit into this system was not really worth thinking about.

The only real difference between the art world of Stieglitz's youth and the art world today was the nature of the annual or biennial exhibition. In the nineteenth century, living artists exhibited their new work in large group shows held in vast exhibition halls under the sponsorship of large semipublic organizations like the Royal Academy in London, the Académie des Beaux-Arts in Paris, and the National Academy of Design in New York. These organizations were run by artists, not by dealers or museum curators, and so it was the artists themselves, with some interference in France from government officials, who determined what the public would see. Today, however, new work is usually presented to the public in commercial galleries. Today it is the dealers, not the artists, who decide what the public will see. The large nineteenth-century group exhibition still survives in such roundups of contemporary art as the Whitney Biennial, but even here the show is usually selected by curators, not by a jury of artists, and in any case the commercial galleries have replaced it as the most important showcase of new art.

When Stieglitz was a young man these large group shows were usually called "salons" after the Grand Salon of the Louvre, where some of the first such exhibitions were held. For beginning artists the various annual or biennial salons were almost the only way to become known to the public. The public, in turn, looked to them as comprehensive and authoritative expositions of all that was new and good in the arts.

We tend to think of the nineteenth-century salons as being dictatorial and conservative, and up to a point they were. Their hanging committees were naturally dominated by older and better established artists who encouraged the young but tended to favor their own pupils over dissident outsiders. Thus the Barbizon painters and the Impressionists were at first excluded from the Paris Salon and the Pre-Raphaelite painters of England were put on probation (not a very long one, however) by the Royal Academy.

On the whole, however, the salon exhibitions gave the nineteenth-century public a very fair cross section of the good and new in nineteenth-century art. The academies that sponsored them were themselves so riven with dissension and contrary opinions that no one faction could permanently bar the works of another, and as the older generation flagged and grew faint it was inevitably replaced by the younger. Thus, in France in 1863 the classicism of Ingres and other successors of David was replaced by the academic realism of Gérôme, and this in turn was succeeded toward the end of the nineteenth century by the academic impressionism of Bastien-Lepage. Few nineteenth-century artists had an easy time at the start of their careers, but few who persisted failed

to win recognition in time. During the first three quarters of the century most of the great artists were frequent exhibitors in the salons, along with a host of lesser and now forgotten ones.

By the end of the century, however, many artists had begun to feel that the salon system no longer served their needs. One of the difficulties of the modern or free-enterprise system of supporting the arts is that there is no way of controlling the numbers and qualifications of artists. Under the guild and apprentice system that prevailed in the Middle Ages and Renaissance, only as many apprentices would be admitted to an artist's workshop as could actually be employed in the work on hand, and the master had every incentive to pick the most promising candidates. The same was true under the system of royal academies that, on the continent, partially replaced the guilds in the seventeenth century. In their origin the royal academies of continental Europe were essentially workshops organized to produce the furniture and decoration needed in royal palaces. Only the most able aspirants would be admitted, and only in such numbers as could actually be employed.

In our society, however, in the middle-class democracies of nineteenth- and twentieth-century Europe and America, anyone can set himself up as an artist without anybody's permission, whether or not there is any work to be done. The vast increase in the numbers of artists that has resulted from this approach has not been matched by a comparable growth in the public's desire for art. As early as the seventeenth century in Holland, where the free-enterprise system was first adopted in the arts, poverty and mass unemployment of artists became a serious problem. By the nineteenth century it was epidemic all over Europe and America, as it still is today. Today artists tend to blame their sufferings on an indifferent public. But then they tended to blame those fellow artists who controlled admission to the annual exhibitions, and they began to seek alternative ways of putting their work before the public.

In Paris in the last half of the century new and rival salons proliferated, some organized by struggling newcomers like the Impressionists, others by such well-known and well-established painters as Meissonier and Puvis de Chavannes. Another challenge to the old salon's monopoly came when a dealer in artist's supplies named Durand-Ruel began to sell Barbizon paintings to American millionaires. Bypassing the Paris Salon altogether (which had, in any case, slighted the Barbizon painters), Durand-Ruel took his paintings directly to New York where he presented them as the latest and best in French art. Durand-Ruel made a fortune in Barbizon paintings and another fortune in the Impressionists. He showed the way to other enterprising dealers, whose privately owned galleries eventually replaced the artist-run salons as the principal showcases of contemporary art.

There was, however, a form of contemporary art that was always excluded, not just from the salons and museums but also from the consideration of critics and collectors. This was the kind of art that was made for reproduction in the mass media. The complex technology of reproduction that made possible modern newspapers and such magazines as *Life* did not exist when Stieglitz first seriously interested himself in photography. However, the art of reproduction by lithography and wood engraving was highly developed. There were, in the 1880's, periodicals such as *Harper's Weekly,* the *Illustrated London News,* and *L'Illustration* that were extensively illustrated with wood engravings, and modern halftone engraving was soon to be perfected. Like movies and television today, these publications were the principal source of pictures in their time.

Sometimes the illustrations were based on the kind of paintings that were shown in salons and museums. But generally they were based on sketches specially made for the paper by artist-reporters who were the forerunners of modern press and magazine photographers. The best of the nineteenth-century illustrators were better than many of the artists who showed in the salons, and one of them, Daumier, was as great as any painter of the age. However, unless they also made pictures in oil on canvas and exhibited them in gold frames like the Old Masters in the museums, collectors did not buy their work, salons did not exhibit it, museums did not add it to their collections, and only eccentric critics like Baudelaire so much as noticed it. To most people the artists who worked for the mass media

were not really artists at all, but only what today we call commercial artists.

Art then, when Stieglitz was starting out, was very much what it is today. It was what critics wrote about and collectors collected, what first reached the public through exhibitions and ended up in museums. The other kind of picture was not art. It was not made to gratify the artist's creative urge but to interest the public. No critic noticed it, no museum or collector wanted it, it appeared in vast quantities in ephemeral publications, and usually it ended up in the trash.

This concept of art and this set of art institutions are, one must remember, scarcely two hundred years old even today. Salon exhibitions first began to be held regularly in France in the eighteenth century. The first art criticism was written by Diderot between 1759 and 1779. The first public art museum opened in the Belvedere Palace in Vienna in 1781. The first illustrated newspapers were published in the 1830's.

Before that time most art was done on commission for monarchs and noblemen, for churches, for municipalities and other corporate bodies, for very rich merchants and bankers. Giotto, Michelangelo, and El Greco, like modern commercial artists, worked to order for clients, not for themselves. It was not till the old forms of patronage collapsed that artists became free to work for themselves: till the Protestant Reformation put an end to ecclesiastical patronage in Northern Europe, till the triumph of the middle classes after the French Revolution put an end to royal and aristocratic patronage all over Europe.

It was, to be sure, a cold and lonely freedom. With no clients and no commissions, the artists of the nineteenth century were on their own. They transformed the old royal academies into mutual self-help societies devoted to exhibitions and teaching, and founded new academies where old ones did not exist. Then, making a virtue of necessity, they vaunted their new-found freedom as a form of moral glory that lifted them far above 1) the king-serving, priest-ridden artist of the past, and 2) contemporary "commercial" artists who served a new ruling class of editors, businessmen, and middle-class portrait clients.

Freedom was highly thought of in the nineteenth century, as highly as equality is today. Nobody could get too much of it. The people in congress or parliament assembled rejoiced in their freedom from the dictates of kings and courts. Scientists and historians in their laboratories and libraries rejoiced in their freedom from the dead hand of ecclesiastical authority. Businessmen in their factories and offices rejoiced in their freedom from state supervision and direction. Everyone felt that if each pursued his own ends the common good would be served.

Artists inevitably felt the same. Once they had been the servants of emperors and popes. Now they began to conceive of themselves as trailblazers and revolutionaries who would show mankind its way to the highest good. The public was expected to support them in their endeavors, as kings and popes had in the past. However, in order to achieve the public good, artists had to be free to function without regard to what the public might want.

How did photography fit into this picture? It fitted very nicely. When it was introduced in 1839 many painters feared it would put an end to painting, but of course it did not. It did not even put an end to newspaper and magazine illustration, which continued to flourish throughout the nineteenth century and into the twentieth. What it did do was help free painters to concentrate on the highest goals of their art.

It did this by taking over two branches of picture-making where accuracy of representation was the most essential element and where the camera's inability to transform or invent in the interests of better design or more forceful expression was least harmful: portraiture and topographical view painting. These two minor but popular branches of picture-making had provided work for innumerable painters and draftsmen in the late eighteenth and early nineteenth centuries, most of whom were ruined by the competition of photography. However, some of the survivors came to feel that this was a small price to pay for the freedom from representation that photography brought them. Long before the invention of photography "mere representation" was regarded as the lowest and most mechanical element of painting.

Now painters no longer had to be concerned with it. Photography would do it for them, or at least, would do the kind of picture where it was most important.

Since most nineteenth century photography was done in the very areas of portraiture and topographical landscape where accurate representation was most important, photography shared in their low esteem. Everyone conceded that the camera was superior to the pencil and the brush as an instrument for making accurate representations of nature. But this was like saying that donkeys were better than men at carrying heavy burdens. Influential critics from Baudelaire to Clement Greenberg argued that the camera's very skill in representation barred it from the higher reaches of art, whether these be defined as romantic fantasy, the classical Ideal, self-expression, or the preservation of the flatness of the picture plane. At the same time, the average man, whose idea of art did not go beyond accurate representation, knew from experience that it was easier to make an accurate representation of nature with a camera than with a pencil and brush. Either way, photography stood condemned to the lowest levels of picture-making.

There was, however, by the middle of the nineteenth century, a group of photographers who claimed for their art the same exalted status that painters claimed for theirs. They pointed out that it was not the camera but the man behind the camera that made the picture. If he was an artist, his picture was a work of art, whether he made it by machine or by hand. More to the point, perhaps, professional photographers such as Henry Peach Robinson and O. G. Rejlander demonstrated that photographs could be made that strongly resembled the paintings exhibited in the salons. In the third quarter of the century, photographs began to be exhibited in special sections of the great salon exhibitions, where they were written up by critics and bought by collectors as eminent as Queen Victoria.

From the very beginning amateurs played an important part in securing the recognition of photography as art. They organized camera clubs and they stormed the doors of the salons and of such professional organizations as the Royal Photographic Society of England. However, in the days of wet plates and bulky cameras, when photographs were relatively hard to make, their numbers were small. It was not till the 1880's and 1890's, when a series of new developments occurred including the gelatin dry plate, the hand-held camera, roll film and processing laboratories, that the amateurs really took over art photography.

These new developments made picture-taking so easy that anyone could do it, and the number of amateur photographers greatly increased. Most of the new amateurs had no pretensions to being artists. They were the forerunners of the modern snapshooter, who floods the world with pictures of his family and friends and scenes of his vacation fun, but does not expect the world to take note of him. However, a number of the new amateurs joined the ranks of the serious workers who wished their pictures to be seen in salon exhibitions.

These serious amateurs wished to distinguish themselves, on the one hand from snapshooters and on the other hand from commercial photographers. They reorganized the camera clubs and founded new organizations to place the emphasis on the art rather than the craft of photography. They were excluded from the regular painters' salons and they grew dissatisfied with photography exhibitions like those of the Royal Photographic Society that mixed artistic work in with the work of scientists and mere technicians. So they began to arrange their own exhibitions, drawing on the work of like-minded photographers from all over Europe and America. The first of these international photographic salons was organized in 1891 by the Vienna Camera Club. By the end of the decade they were also being held in London, Paris, Hamburg, Florence, Berlin, Washington, Munich, Turin, Philadelphia, Toronto, New York, Chicago, and Calcutta.

The photographic salons were modeled on the salons of the painters. So far as possible they were held in art museums, where the photographs were matted, framed, and hung as if they were drawings and etchings. They had juries and prizes, just as the salons of the painters did, and often painters were included among the judges.

Last but most important, the photographs shown in the salons were based on the works of

well-known painters. At the turn of the century there were four main styles of art photography. The type of sentimental, anecdotal genre that H. P. Robinson had popularized in England in the 1850's continued to be made by serious amateurs on both sides of the Atlantic through the nineteenth and into the twentieth century. In the 1880's, the Anglo-American photographer P. H. Emerson introduced a new style of photography based, he believed, on nature, though nature as interpreted in the paintings of Jean-François Millet and the Barbizon School landscape painters. Emerson's naturalistic photography was followed by a soft-focus painterly style based on the works of the Anglo-American painter and etcher James A. McNeill Whistler. This so-called "Impressionistic" photography, with its broad, painterly effects, its suppression of details and its asymmetrical Japanese compositions, was avant-garde up to the First World War, and it continued to be done well into the 1930's. A fourth type of art photography came into being at the turn of the century when photographers turned to the painters of the sixteenth seventeenth centuries for subject matter and style.

Together these various approaches to photography were known as pictorialism. Today the term "pictorial" is pejorative when applied to photography, but in the 1890's it was not. It merely distinguished photography used as means of personal artistic expression from artless snapshots and from the purely descriptive reportage of science and journalism. Thus all the photographs shown in the new salons were pictorial, not just the sentimental story-telling ones or the ones that were obviously based on famous paintings.

From the 1880's on, American photographers played a prominent part in the new photographic salons, and by 1900 four of them were internationally recognized as leaders of the new pictorialism. They were Alfred Stieglitz of New York City, F. Holland Day of Boston, Rudolf Eickemeyer, Jr. of Yonkers, and Edward Steichen of Wisconsin, Paris, and New York.

Rudolf Eickemeyer, Jr. (1862-1932), was the oldest of the four. The son of a well-to-do Yonkers manufacturer, he made his name as a photographer while working full time in the family business. He was already a well-known amateur in 1892, when he was invited to show in the Society for Advancement of Amateur Photography's first international exhibition at the Hamburg Kunsthalle, and he continued to exhibit and win medals for many years. In 1895, when his father died, he did what he had always wanted to do: He left the family business to become a professional photographer.

F. Holland Day (1864-1933) was perhaps more typical of the new breed of serious amateur. A brilliant, neurotic Boston millionaire, he never had to work a day in his life and he moved restlessly from one hobby to another. He sandwiched his five years as a salon photographer in between a flyer in fine book publishing and a long retirement into private life. He continued to photograph after his retirement, but he seldom exhibited after 1902, and then usually only work he had done before that date.

Alfred Stieglitz (1864-1946) was also free to do as he pleased. Though he was not a millionaire, his father was well-to-do, and he never had to earn a living himself. After several years of study, travel, and photography in Europe, he returned to New York where his father set him up as a partner in a photoengraving business, but after five or six years, during which he continued to photograph, he quit to devote himself full time to amateur photography. He exhibited at the first photographic salon organized by the Vienna Camera Club in 1891, as well as at most other major salon exhibitions. When he stopped exhibiting in salons he had won over one hundred and fifty medals and prizes.

Edward Steichen (1879-1973) was the only one of the four who had neither family money nor a family business to back him up. But he too began his photographic career as an amateur in the salons, and within two years he was internationally famous. Most of the well-known photographs of the years before the First World War were taken while he was actively pursuing a career as a professional painter. Like Eickemeyer, Holland Day, and Stieglitz, Steichen was an American member of the Linked Ring, a London-based organization of seceders from the Royal Photographic Society that was an international center of pictorial photography.

Though each of the four were pictorialists,

each approached pictorial photography in a different way. Eickemeyer, the oldest, stayed closest to the anecdotal approach of H. P. Robinson. In painting as well as photography, this was still the most popular approach well into the twentieth century, and Eickemeyer's "The Vesper Bell" was shown and applauded in salons from Hamburg to Calcutta (page 31). However, Eickemeyer also turned to Whistler's version of Japanese painting for models. A copy of his delicately impressionistic "A Summer Sea," a characteristic example of this mode, was owned by Stieglitz. In his popular picture "In My Studio" Eickemeyer posed the beautiful young actress Evelyn Nesbit in a typically Whistlerian Japanese kimono on a typically Whistlerian white bearskin rug in a typically Whistlerian off-center Japanese composition (page 30-31).

F. Holland Day had the highest artistic aspirations of the four. He dared to tackle one of the greatest subjects of Western painting, the passion of Christ, using himself and his friends as models. In "The Seven Last Words," a set of seven close-up heads of Christ on the Cross for which he himself posed, he very nearly succeeded (pages 34-35). The first of these heads was based on a celebrated painting of Guido Reni. Holland Day also worked in the semi-Japanese, semi-Whistlerian soft-focus impressionist mode (pages 36-39), but he never descended to anything so low as anecdotal genre. The closest he came to it was in the photographs he took during his retirement, which he did not exhibit, of young men dressed in exotic costumes or posing nude in the woods in classical attitudes (page 39).

Stieglitz, unlike Holland Day, did make genre scenes that were almost as sentimental as Eickemeyer's. One of them, "The Net Mender," was one of the most popular pictures of its time (page 40). He also made "picturesque bits" of landscape and cityscape in the Whistlerian mode (pages 47, 49, and 50). Technically Stieglitz was the best trained and most proficient of the four. He prided himself on doing what other photographers then believed was impossible: photographing in snow storms, or at night, or during the rain, or making artistic pictures with the despised instrument of the snapshooters, the hand-held camera (pages 44, 46, and 49). He was not above

recommending a little darkroom manipulation, and like other salon photographers he used the soft-focus lenses and platinum papers that contributed to a soft, atmospheric effect.

Steichen was half a generation younger than the others, and the fashion for genre had peaked before he began. He was a painter as well as a photographer, and in his early landscapes and nudes he fully realized the turn-of-the-century photographer's desire for painterly effects. In his earliest landscapes he kicked his tripod at the moment of exposure or splashed water on the lens to get misty, atmospheric effects (page 54). He once hand-colored a thousand photogravure copies of a print (page 110). Later he took advantage of the new papers and printing processes that enabled photographers to transform their photographs into passable imitations of drawings, etchings, and paintings (pages 56, 57). Perhaps because he was himself a painter, he came closest of all to realizing the painterly ideals of photography pictorial.

The rich and varied tradition of pictorial photography that these four Americans inherited was almost fifty years old at the turn of the century, and its changing and often contradictory ideas about what constituted the art of photography have deeply affected twentieth-century thought. The first pictorialists, H. P. Robinson and O. G. Rejlander, had pieced together their imitations of mid-Victorian painting out of parts of several different photographs. These composite photographs were greatly admired in their time and greatly influenced the course of art photography in England and America down to the twentieth century. Robinson believed in maintaining sharp focus throughout his pictures, and he wrote a book explaining how photographers could adapt to their work the principles of design and composition developed by painters.

Emerson disagreed with Robinson in almost everything. For one thing, he believed that photographs should be slightly out of focus because scientists had told him that the human eye sees nature slightly out of focus. He also believed that photographs should be made directly from nature, not from bits and pieces assembled in the studio. He thought painters should also work directly from nature avoid-

15

ing any subjects not right before their eye, and he preferred Millet to Giotto because the latter had painted angels and fables rather than scenes of everyday life.

Like many other self-taught amateurs, Emerson often had cranky and absurd ideas. His belief that photography could be art depended on the mistaken idea that photographers could change the relationship between tones at will during the process of development. When he discovered that this was not so, he denounced the whole idea of art photography. But the idea of art photography was too well established by now, and nobody listened.

The next generation of artistic amateurs worked from nature as Emerson recommended, but they carried soft focus to lengths that horrified him. They used it to imitate the paintings of Whistler, who suppressed details and emphasized atmosphere in order to transform the warehouses and chimneys of turn-of-the-century London into the palaces and campaniles of a legendary Venice. They also began to use new papers and processes that enabled them to transform photographs into fairly convincing simulacra of drawings, etchings, and paintings.

It was with this younger generation, to which Stieglitz, Eickemeyer, and Holland Day belonged, that some photographers began to adopt the contempt for subject matter that Whistler had made fashionable. To Whistler the most commonplace subject matter—a dish of fruit, a wave breaking on a shore, a bridge—was enough to make an artistic picture, provided it was artistically treated. The anecdotal, sentimental, or picturesque interest of the subject matter was less important than the relationships between tones. The kind of picture that grew out of this way of thinking was never as popular as anecdotal genre, but it came to be more highly thought of in artistic circles and by the turn of the century was often seen in photographic salons.

Despite these differing views as to what made it art, photography was widely accepted as art in America by 1900. All over the country serious amateurs vied with each other and their European counterparts in photographic salons which were judged and commented on by well-known painters and critics and frequently held in leading art museums and academies.

There was, however, one pictorialist who felt that the movement was being compromised by its very success. For eleven years, from 1891 to 1902, Alfred Stieglitz had worked with the Society of Amateur Photographers and its successor, the Camera Club of New York, as an editor of publications and organizer of exhibitions. During this period he had come to two conclusions. One was that few of the amateurs of the camera clubs were either serious enough or good enough to merit the kind of exposure they were getting in the salons. The other was that he and he alone, without help or hindrance from anyone, was qualified to judge who did and who did not deserve to be seen.

As vice-president of the Camera Club of New York and chairman of its publications committee, Stieglitz was in a position to enforce his own standards and he did not hesitate to do so. He was ruthless in his rejection of what he thought was inferior work, and he alienated many members by rejecting their work and publishing instead the work of nonmembers in the Club's own publication, *Camera Notes*.

The Camera Club also put Stieglitz in a position to assert his leadership of American amateur photography as a whole. His only possible rivals were Eickemeyer and Holland Day, and Eickemeyer had disqualified himself in 1895 by turning professional. By 1900 only Holland Day remained. In 1900 Stieglitz refused to cooperate when Holland Day asked his help in organizing a big exhibition of American photography at the Boston Museum of Fine Arts. Then, when Holland Day, without his help, organized a large exhibition of American photography in London, Stieglitz not only refused to participate but used his considerable influence in London to prevent its taking place at all, saying that the exhibition did not include some of the best American photographers and that the prints it did include were second- or third-rate.

In fact, it was the best exhibition of American photography ever seen in Europe up to that date, and when it opened in October at the Royal Photographic Society, it firmly established the American school as a major presence on the international scene. In 1901

it went on to Paris, where Holland Day was hailed as the leader of the new American school and Steichen as its *"enfant terrible."* However, this exhibition was Holland Day's last effort to promote American photography. After it closed in Paris, the Boston aesthete retired from the exhibition scene. Stieglitz was now alone in the field. He resigned as vice-president of the Camera Club of New York and in 1902 he founded a new organization, the Photo-Secession.

Stieglitz later maintained that he had never intended to found a new organization. The Photo-Secession, he said, was merely a name he thought up on the spur of the moment to publicize the New York showing of a traveling show he had already organized for the Camera Club. However, the president of the Camera Club thought otherwise. Before the exhibition even opened he voiced his fear that the Photo-Secession would become a new group organized around a new magazine which would take Stieglitz and his friends away from the Camera Club. And this is in fact what happened.

The exhibition, an expanded version of the original Camera Club show, opened on February 17, 1902, at the National Arts Club in New York. The managing director of the National Arts Club was also art editor of *The New York Times,* and as Stieglitz later observed, "It didn't take long before the *Photo-Secession* was known all over the world." A few months after the exhibition opened, Steiglitz resigned as editor of *Camera Notes,* and August that year he announced plans for the new publication, *Camera Work,* the first issue of which appeared in January, 1903.

There was still no formal membership organization, but in July, 1903, a list of members and officers was announced that included most of the photographers Stieglitz had published in *Camera Notes* and all of his closest associates at the Camera Club of New York. Holland Day was asked to join but refused. Eickemeyer either was not asked or refused. Two years later, in 1905, the Photo-Secession opened a gallery at 291 Fifth Avenue, where for several years the works of members and foreign photographers were regularly shown.

Despite its carefully drawn up lists of officers, the Photo-Secession was not a democratically run organization. Stieglitz did not like to work with committees. He had to be free to do things his own way. The Photo-Secession soon became in effect a private gallery and a quarterly magazine run in tandem by the same man. It was part of the world-wide trend toward showing new art not in artist-run salons but in private galleries.

As long as the Photo-Secession continued to serve its members, they put up with Stieglitz's high-handed behavior. And for several years it did, publishing their pictures in a quarterly magazine that excited the admiration of serious amateurs and art lovers all over the world, and showing them in a series of well-publicized exhibitions both at home and abroad that would be the envy of the modern museum director. However, the last major undertaking of the Photo-Secession was the International Exhibition of Pictorial Photography held at the Albright Art Gallery in Buffalo in 1910. After this exhibition, the Photo-Secession Gallery at 291 Fifth Avenue (or "291," as it came to be called) showed photographs only three times in seven years. The rest of the shows were of paintings, drawings, and sculptures. During the same period *Camera Work* increased its coverage of the nonphotographic arts. Because of this, most of the photographer members of the Photo-Secession dropped away to form new organizations of their own several years before 291 and *Camera Work* came to an end.

It is often suggested that the photographers of the Photo-Secession spearheaded a revolt against the soft-focus pictorialism of the salon photographers in favor of sharp-focus modern photography. This was not so. They were soft-focus pictorialists, too, better than some, but not essentially different. It was not the Photo-Secession but (as usual) a new style of painting and sculpture first seen in America at 291 that killed pictorialism and led to the birth of modern photography.

In Paris in the first decade of this century a group of young artists were setting the art world on its ear. When seen in America at 291 from 1908 on, and then in 1913 at the Armory Show, the raw colors and distorted or fractured figures of Matisse, Picasso, and Brancusi outraged and disgusted most of the art public, as well as the photographers of the Photo-

Secession. Even those few photographers who did not reject this new art were unable to make use of it in their own work. It was true that Whistler had led them a long way toward abstract art by encouraging them to place their emphasis on form and color, rather than subject matter. But in Whistler's paintings the subject matter had remained sufficiently close to what the average eye sees for the camera to imitate it. Now, however, painters and sculptors were producing works in which the subject matter was too violently distorted or abstract to be imitated by the camera.

This did not, of course, prevent certain young photographers from trying, in Europe as well as America. Some tried to make abstract photographs by using prisms or fun-house mirrors to distort their subjects, by coming in close to fragments of still life or nature, or by shooting their subjects from such an unexpected angle that the subject could scarcely be recognized for what it was. Others went modern by pointing their cameras at subject matter as shockingly far from accepted standards of beauty and decorum as the grotesquely distorted figures of the painters and sculptors. A few played with solarization or with "photograms" made without cameras by placing objects directly on sensitized paper.

In the end, however, their efforts to create a photographic equivalent of modern painting and sculpture were defeated by the nature of the photographic medium. A painter or sculptor working from nature could distort or abstract at will. A photographer could not. He could move his camera in relation to the subject or change and rearrange the subject. He could solarize or work without a camera. However, the inherent realism of the photographic medium would not let him go as far in expressive distortion or in abstraction as modern painters and sculptors did. So the creators of modern photography made a virtue of necessity. Without abandoning any of their new devices, their plunging perspectives, their semiabstract close-ups, their shocking or revolting subject matter, they began to praise the objective realism of the camera.

They suddenly discovered that the essence of photography consisted in the very things their elders had tried to get away from: the preciseness with which the camera could capture fine detail and the subtlety with which it could set down an unbroken sequence of tones from black to white. They persuaded themselves that by preserving these characteristics in their purity they would distinguish photography once and for all from painting, drawing, etching, and any other process of making pictures by hand. And so they rejected the soft focus, matte papers, and manipulated prints of their elders in favor of sharp focus and straight printing on glossy papers.

Thus by a long and complicated route the artist-photographers of the salons returned to the kind of straight photography from which photographer-reporters like Lewis Hine had never departed. Lewis W. Hine (1874-1940) was a trained sociologist who used his camera to record the lives and circumstances of the working people of his time and place. He was aware of the pictorial movement in photography, and he was not above enlarging, cropping, and matting a favorite photograph to improve its pictorial effect (page 96). However, he was far more interested in factual accuracy. He did not use soft-focus lenses or special papers or engage in darkroom manipulation to produce the handmade look of pictorial photography. Nothing could have been less Whistlerian than his photographs. He focused his principal subjects clearly and sharply and he printed his negatives straight.

By the standards of the salon pictorialists, including the Photo-Secessionists, Hine's pictures were nothing more than record shots. They were newspaper and magazine illustrations taken for reproduction to publicize the work of organizations such as the National Child Labor Committee. Not even the flaming radicals of modern photography thought of them as art.

They were, therefore, no help whatsoever in answering what once again became, with the advent of modern photography, a burning question. If art was not a mere representation of nature, how could a photograph be a work of art? Having forbidden soft-focus retouching and darkroom manipulation, the modernists had reduced the art of photography to two things only: selection of subject and selection of point of view. But these two things were only the beginning of the painter's involvement with his painting. The

painter's touch and temperament were seen and felt in every stage and part of his picture, not just in the initial stages of selection. So it came to seem to some simple-minded people that photography, if an art, was not as much of an art as painting.

Defenders of modern photography never entirely overcame this skepticism. When faced with it they retreated into an angry refusal to discuss what art is. Or they launched an attack on their elders for imitating painting. Or they talked about the importance of previsualization. Or they embarked upon rhapsodic praise of the truly creative personality of the artist-photographer. Or they scornfully reminded their questioners that pencils and brushes were tools, just the same as cameras, forgetful of the fact that pencils and brushes cannot make pictures without the guidance of man, while cameras can.

They never ceased to praise the photographers who made their own prints, though their own doctrine suggested that the real work is done once the exposure is made. Indeed, they themselves regularly engaged in such handwork as burning, dodging, and spotting, in defense of which their arguments got as abstruse and unconvincing as those of a medieval theologian debating how many angels can dance on the head of a pin.

In America the pioneer of modern photography was Paul Strand (1890-1976). As a schoolboy in New York City, Strand had studied with Lewis Hine, then only just beginning his own photographic career. However, it was not the influence of Hine but an exhibition of pictorial photography at 291 that decided Strand to become a photographer. Strand was amazed and delighted by this revelation of photography as a fine art, and began to visit 291 regularly, showing Stieglitz his work and imbibing the lessons of the artists exhibited there.

Strand was a little too late to receive the full impact of pictorialism. However, the works of such modern painters and sculptors as Matisse, Picasso, and Brancusi impressed him greatly. At first he was as puzzled and astonished by them as anyone else. Even Stieglitz sometimes forebore to defend them on their merits and fell back on defending their right to exist and be seen, however perverse and bizarre. Strand, however, in his effort to understand, made

the first modern art photographs in America: the first abstract still lifes, the first brutally realistic candid shots intended as an art rather than reportage, the first photographs to be taken from such unexpected angles that the subject paled into insignificance (pages 60-65). Stieglitz was so impressed by these pictures that in 1916 he gave a Strand a show—the last photography show at 291—and in 1917 published his photographs in the last two issues of *Camera Work*. And thus was modern photography launched in America.

It was not in fact a widely noted event. Most of the charter members of the Photo-Secession remained unreconstructed pictorialists to the end of their days. So did Eickemeyer, Holland Day, and most of the other salon photographers.

Steichen and Stieglitz, however, went over to modernism. Even during his pictorialist phase, which lasted roughly down to 1917, Stieglitz had usually avoided retouching and darkroom manipulation in his own work. He now began to talk this up and to emphasize the fact that he (unlike the other photographers) had never wanted to be a painter. He stopped enlarging and cropping his pictures, both of which he had frequently done before, and began printing on glossier paper. He never went so far in pursuit of ugly or distressing subject matter as young Strand had done in his candid close-ups of New York's poor, but his later pictures of clouds and buildings were quite sufficiently far from the picturesque beauty of his early cityscapes to be called modernist (pages 66-69).

Steichen's conversion to modernism was not so extreme. He never abandoned picturesque subject matter or a fondness for a really striking effect. He did, however, sharpen his focus and abandon his practice of working over his prints (pages 70-73). He attributed his conversion to modernism not to the influence of modern painting or Strand, but to his experiences as an aerial reconnaissance photographer during the First World War, where sharp focus and straight printing were essential to doing the job (page 70).

In the 1920's modern photography began to challenge pictorialism in the salons of Europe and America. In California the most notable modernists

were Imogen Cunningham (1883-1976) and Edward Weston (1886-1958), who with young Ansel Adams (born 1902) and others exhibited in the 1930's as Group f.64. Cunningham and Weston were both professional portrait photographers whose early salon work, done in the intervals of their portrait business, had consisted of soft-focus landscapes and nudes in the pictorial style. In the 1920's, however, they sharpened their focus and turned to the characteristic subjects and approaches of modern photography: flowers, roots, rocks, and vegetables photographed in extreme close-up, and nude figures folded together and framed so that they looked like eggs or plants. No more cute kids or picturesque bits such as the young Alfred Stieglitz had been proud to do. Nothing with even the least hint of storytelling about it.

The California modernists were not so prone as the Easterners to dwell upon the ugly and the grotesque. Aside from an occasional dead tree or toilet bowl, they kept to subjects that would not upset the squeamish. However, their emphasis on abstract design and on such characteristics of the photographic medium as sharp focus and subtle contrasts of tone, tended to diminish or distort the emotional significance of their pictures. Weston photographed rocks and vegetables as well as human faces all in the same cool, impersonal way (pages 74-81). Even the landscapes of Ansel Adams, the most popular works the modernists produced, have the smooth perfection of a bleached bone in the desert (pages 86-91).

We must now approach the central theme of this work: the quarrel between Stieglitz and Steichen over which direction photography should take. It was not a quarrel between modernism and pictorialism because both photographers had rejected pictorialism and embraced modernism. It was a quarrel between commercial art and art for art's sake, and the fact that it could take place at all was due to the growing use of good photographs in quality magazines.

At the turn of the century photographs were well on the way to replacing drawings and paintings as illustrations in newspapers and magazines. The Spanish-American War was the last American war to be covered primarily by artist-reporters. The First World War was covered predominantly by photog-raphers. However, unless magazine and newspaper photographers also exhibited pictorial work in the salons, they were no more taken seriously as artists than the illustrators who preceded them had been in Daumier's day. Lewis Hine is the classic instance of this.

This continued to be the situation until the 1930's. However, even before the First World War, publishers of quality magazines such as *Vogue, Harper's,* and *Everyman's* began calling on leading salon photographers to work for them. Steichen was by no means the first of these, but he was the most famous. In 1923 he went to work for *Vogue* and *Vanity Fair* as a portrait and fashion photographer and for the J. Walter Thompson agency as an advertising photographer. Two years later Stieglitz resumed his activities as a gallery director, opening the first of two galleries in which he carried on the work of 291. He continued his own photography in intervals of work and on summer vacations at his family's house at Lake George in upstate New York.

Since Steichen's main occupation since 1907 had been painting, his commercial work in magazines and advertising was in a sense the fulfillment of an early promise to Stieglitz never to abandon photography. However, the kind of work he was doing was very different from anything Stieglitz was interested in. Steichen proposed to use photography in order to communicate to large numbers of people ideas that were not necessarily his own. Stieglitz, on the other hand, was transforming his photography into a means of self-expression so personal and private that only a few could hope to understand.

A comparison between the works they produced in the twenties and thirties will make it clear how widely they had diverged from one another. Steichen's photographs were clear and expressive of his intentions, whether he was doing celebrity portraits, advertisements, or fashion photographs. In his portraits the beauty and glamour of Marlene Dietrich and the fearful courage of Paul Robeson as the Emperor Jones come through clearly and forcefully (pages 104, 105). So do the strength of "The Matriarch," from an advertising photograph for the Federation of the Jewish Philanthropies, the pleasure of owning an elegant new automobile in an advertising

photograph for Packard, and, in a *Vogue* fashion photograph, the radiant delight a beautiful woman feels when she knows she is looking her best in a brand-new dress (pages 107, 112, and 102).

In Stieglitz's "Equivalents," on the other hand, it is by no means clear what is meant. Stieglitz once said that he started doing these little photographs of clouds to find out what he had learned in forty years of photography and to show that he could make any commonplace subject expressive of his philosophy of life. Certainly they show Stieglitz's technical mastery, but it is hard to tell what philosophy of life, if any, they express. One may feel that heavy black clouds are expressive of a heavy black mood, while light, bright clouds are expressive of a light, bright mood. Beyond that, however, it is difficult to tell what they mean (pages 68, 69). It is also hard to tell whether Stieglitz's late pictures of New York, taken from high above its streets, are intended to express the photographer's feelings about the city's growing impersonality or merely to create a handsome abstract design. Something similar can be said about the famous portraits of his second wife, Georgia O'Keeffe (pages 66, 67).

Steichen's later pictures, then, are more communicative than Stieglitz's. In part this is no doubt due to the fact that they were commercial art, not art for art's sake, and they had to communicate. But it was also due to the fact that Steichen was a more communicative person than Stieglitz. Steichen was a large, ambitious, outgoing, expansive man who felt at home in the world and knew how to get along. Stieglitz was a small, reclusive, contentious, hermetic man who hated to have to ask for anything and always felt himself to be misunderstood. It was as natural for a man of Steichen's disposition to be drawn to the world of publishing and advertising as it was for a man of Stieglitz's disposition to gravitate toward the more private world of noncommercial galleries and art for art's sake. It is indeed impossible to imagine Steichen willingly spending eight hours a day in a gallery just as it is impossible to imagine Stieglitz working effectively on a large-circulation magazine or in an advertising agency.

However, the differences in character and temperament that led them to choose such different careers also led them to work in different ways. Even when they were both working side by side in the world of salon pictorialism, Steichen's pictures were bold and showy and perhaps just a little bit shallow, while Stieglitz's were deeper, subtler, and more refined. Later, when their paths diverged, these differences became more pronounced. Steichen's commercial work grew bolder and showier, while Stieglitz's late private work grew deep and subtle to the point of incomprehensibility. These differences in their pictures existed before their paths diverged and reflected their divergent characters and temperaments quite as much as they reflected the imperatives of their subsequent careers.

It is therefore wrong to suggest that Steichen was going against his nature when he went to work for magazines and that he did it only for money. On the contrary, he was fulfilling, not denying, his nature when he went commercial, and he understood this very well. He had always done celebrity portraits, and the still lifes he had made during his transition to modernism were easily adapted to commercial purposes. Steichen put the matter clearly to his brother-in-law Carl Sandburg: "If my technic, imagination and vision is any good I ought to be able to put the best values of my noncommercial and experimental photography into a pair of shoes, a tube of tooth paste, a jar of face cream, a mattress, or any object that I want to light up and make humanly interesting in an advertising photograph. If I can't express the best that's in me through such an advertising photograph as 'Hands Kneading Dough,' then I'm no good."

Steichen also understood that Stieglitz's way of working primarily for himself was not the only possible way for a serious artist, or indeed the usual one. He understood that much of the great art of the past had been produced, as the art historian Erwin Panofsky has put it, not primarily "to gratify the creative urge of its makers" but "to meet the requirements of patrons or buying public." He understood that in this respect the advertising photography he was doing was not essentially different from the painting of Michelangelo, Titian, and Rubens. "There has never been a period when the best thing we had was not commercial art," he said. Whether the artist

21

worked for Renaissance princes and popes, for kings and rich merchants in seventeenth-century Europe or for the big industrial organizations of twentieth-century America, "the artist is usually what we might call a glorified press agent."

Stieglitz, however, did not understand this. He thought (as many others did and still do) that the Renaissance princes and popes had provided their artists with money and studios and then left them free to do whatever they wished, and he thought somebody ought to do this for him. He himself could not work with others, and he did not understand that a man like Steichen not only could work for others, but might work best that way.

Consequently, Stieglitz came to think that when Steichen went to work as a commercial photographer, he did so merely for money. Steichen was stung by this unjust suspicion and the two masters who had worked so closely with one another for so many years ceased to communicate.

Stieglitz probably suffered most from this. Steichen had been to him like the son he had never had. He had also provided much of the initiative of the 291 days. It was Steichen who persuaded Stieglitz to open the gallery and Steichen who introduced Stieglitz to the works of most of the painters and sculptors who showed there. Without Steichen, thought one old friend, Stieglitz's later galleries lacked the zest and originality of 291.

Stieglitz also had more time and inclination to brood over the injustices of life. During the winter he spent every day in his gallery seeing no one but admirers and whoever the chances of the day brought to his door, and in summer he isolated himself and his friends at the family vacation house in upstate New York. He brooded over the fate of the artist in America. If there was nobody in America to provide the kind of support that (he imagined) princes and popes had furnished artists in the past, what hope was there for him? In fact, his family, admirers and followers supported him all his life and never asked him to do what he did not like. But Stieglitz never seemed to understand this. He began to see himself as betrayed by America as well as by Steichen, a martyred saint, an unheeded seer, a prophet without honor in his own country.

Steichen also suffered from the separation. For more than a decade he had been Stieglitz's favorite and he never ceased to feel the older man's rejection of him. He was, however, far too busy to brood. Winter and summer he was out and about in the worlds of publishing, fashion, and advertising, constantly meeting new people and doing new things. If he still felt the sting of rejection, he had the satisfaction, perhaps the greatest satisfaction an active man can have, of seeing his judgment proved right by events. During the three or four decades after he went to work for *Vogue* and *Vanity Fair,* most of the best American photography was done by working professionals like himself whose pictures first appeared in newspapers and magazines. In their efforts to interest and move a large audience they created a new kind of photography that crystalized public hopes, dreams, and fears in clear and striking images.

The Hungarian-born Nickolas Muray (1892-1956) was one of these. For his own amusement he made salon nudes during the 1920's, but the work for which he was known was published in *Harper's Bazaar* and *McCall's.* Muray was the quintessential commercial photographer. "You dream it, we'll photograph it—all in the day's work!" he exclaimed at the height of his success. What Muray's clients required was glorification of the products and pleasures that American industry was making available to a larger part of one nation's people than had ever happened before in human history, and Muray provided it. By the standards of the time his women were more beautiful than real women, his table settings more glittery, his food more detectable, his all American athletes more foresquare and rugged than any human being could hope to be (pages 114-121).

Another successor to Steichen was the *Vogue* photographer Irving Penn (born 1917), who brought to pictures of workmen, artists, and African tribesmen the formal elegance of a high-fashion photograph. More than Steichen or Muray, Penn proved that a photographer could achieve an individual style while working for the media (pages 122-129).

In addition to fashion and advertising photography, the years of the picture magazines also saw a great efflorescence of photojournalism and what is now called documentary photography. Between

1935 to 1943 the Federal government hired a remarkable group of photographers to record the activities of a government bureau, the Farm Security Administration. Much of their work consisted of routine record shots. However, some of the photographs of life in rural and small town America that were made under the direction of Roy Emerson Stryker were so moving that they soon began to be used in the complicated maneuvers of democratic government. They were distributed free to newspapers and magazines all over the country to win public support in the cities for the government's efforts to help the rural poor.

The F.S.A. photographers came from a wide variety of backgrounds. Dorothea Lange (1895-1965) was a member of the f.64 group in California. Ben Shahn (1898-1969) was a New York painter. Walker Evans (1903-1975) was an aspiring writer who had absorbed the lessons of modernism direct from the source in Paris. Arthur Rothstein (born 1915), the youngest of the group, was hired to run the F.S.A.'s photography laboratory and later was sent out to photograph. Russell Lee (born 1903), John Vachon (1914-1975), and Jack Delano (born 1914) were budding photojournalists.

The F.S.A. photographers were the true successors of Lewis Hine and they freely acknowledged their debt to him. However, they were also the heirs of the pictorialists and their modernist successors in the salons. They lacked the simple, naïve vision of Hine. Artistically, they were more sophisticated, more closely related to magazine photographers like Steichen and Muray. Where Steichen and Muray glorified the success of American industry in making a better life available to a growing number of citizens, the F.S.A. photographers were glorifying the courage and patience of some of the American people who were still suffering from poverty (pages 130-155).

The Federal Arts Project was another government agency of the 1930's that used the work of photographers. Berenice Abbott (born 1898) began her photographic survey of changing New York City on her own, but she finished it with Federal Arts Project support. Her photograph of the Flatiron Building brutally outlined against a noonday sky (page 158) was a modernist treatment of a theme that Alfred Stieglitz had treated with typical pictorialist delicacy and atmosphere (page 49).

The third important development in photography in the 1930's was the advent of *Life* (November, 1936) and other magazines in which photographers joined with writers to produce a new kind of journalism. Several of the F.S.A. photographers went on to careers in photojournalism. However, the prototypical *Life* photographer was Margaret Bourke-White (1904-1971), a young woman from the Midwest who began her career by making glamour pictures of industry in Cleveland. Stylistically, Margaret Bourke-White moved from the soft-focus pictorialism of "Terminal Tower" (page 160) through the hard-edged semiabstraction of "Cables" (page 161) to the kind of journalistic realism that has no name because it pretends it is not a style at all but simply a transparent window on the world (pages 162-169). Personally she was the classic instance of the happy professional who derives intense personal satisfaction from doing just the kind of picture her editors want.

Most photojournalism loses its power when the events that gave rise to it cease to be news. However, Bourke-White succeeded in taking pictures that continue to have a life of their own. Her classic picture "At the Time of the Louisville Flood" (page 162) shows what is in fact a line of bedraggled refugees from flooded-out homes and farms. But because they are standing before a billboard extolling the happy prosperity of American life, this picture from the Depression era is usually read as a bitter commentary on America's inability of live up to its own ideals.

W. Eugene Smith (born 1918) was another *Life* photographer whose best pictures transcend the occasion that gave rise to them. The dark, brooding tones and classical composition of a picture like "The Spanish Funeral" are reminiscent of Old Master painting (pages 170-175).

Unlike his friend Bourke-White, Smith was unhappy at *Life*. He fought with his editors over the way his pictures were used and helped perpetuate the legend of the serious artist destroyed by the media—a very popular legend at Time, Inc. However, even after he resigned from the staff of *Life*, he continued to take the kind of pictures that the editors of *Life* could use,

23

and they continued to use them.

Ernst Haas (born 1921) was never on the staff of *Life*, but he frequently worked on assignment for *Life*. A specialist in color photography, he has the distinction of being the only photographer whose pictures were both the basis of a *Life* photo-essay and the subject of a one-man show at The Museum of Modern Art (pages 238-242).

While these new forms of professional photography were coming into being, the neighborhood portrait photographer continued to flourish in quiet obscurity, while the now common use of photographs to illustrate newspapers produced a school of press photography that was widely known but not very well respected.

James Van Der Zee (born 1886) was a portrait photographer in Harlem whose fame did not spread beyond his own neighborhood till after he had retired. He did the usual work of a neighborhood photographer: weddings, funerals, portraits, and record shots for local business, social, and religious groups. It was not until the Metropolitan Museum of New York included his pictures in a historical and documentary re-creation of bygone days in Harlem that the larger world learned that a neighborhood portrait photographer could be touched with greatness (pages 176-181).

Weegee (1900-1968), or Arthur Fellig, to give his proper name, worked for the New York Press as a photographer of crimes, accidents, fads, and society high-jinks. He had a better eye than other big-city press photographers for the bizarre and comic aspects of city life, and his pictures reached a new audience in the 1940s when several books of his photographs were published. In recent years his photographs have been included in several major museum exhibitions (pages 182-187).

Despite their diversity of styles and approaches, these working professionals have one thing in common: Most of their pictures are built around the hopes, fears, and activities of people. People as subject matter for pictures have always appealed to the public more than anything else, including laughing cats, and this was no doubt why professional photographers concentrated on people. However, while pleasing the public, the professional photographers of mid-twentieth century America also did for their time and place what Balzac and Dickens did for theirs: They created a rich and varied picture of human life the likes of which had never been done before in photography and is not likely ever to be done again. This tremendous undertaking depended on the financial and logistical support provided by the organizations for which the photographers worked. None of them could have done it on their own, and to the degree that this sort of support has ceased to exist, this kind of photography is ceasing to be done.

Meanwhile, Stieglitz and his successors, working in comparative isolation and solitude, were pushing a radically different approach to photography to its logical conclusions. Stieglitz's last photographs were made during the first years of the Farm Security Administration and *Life*. His emphasis on formal and personal values, not on meeting the requirements of any public, was followed by three younger photographers who brought photography as close as it could come to pure abstraction: Aaron Siskind (born 1903), Minor White (1908-1976), and Harry Callahan (born 1912). All three were (and are) teachers and all three helped keep the Stieglitz tradition alive through the heyday of the picture magazines.

Aaron Siskind's early close-ups of scarred walls and blistered paint have been compared to the works of abstract-expressionist painters. In these, as in later photographs of rock walls, human feet, and eroded bits of antique sculpture, the subject matter is almost entirely subordinated to the effects of abstract design (pages 190-197).

Minor White also photographed fragments of nature in such a way that their actual identity was often lost. A conscious and articulate follower of Stieglitz, he elaborated a theory of equivalents that attempted to put Stieglitz's cryptically phrased intuitions on a more rational basis (pages 198-203).

The subject matter of Harry Callahan's photographs was more recognizable, but his emphasis on abstract design was nevertheless the most striking thing in them. This is as true of his silhouette of a woman entitled "Eleanor, 1948" (page 207) as of his studies of tangled grass (pages 204, 210) and urban landscape (pages 208, 209).

Before Stieglitz died in 1946, Steichen visited him and the two old friends who had been so long estranged were reconciled. However, the quarrel between them transcended their individual lives and survived both their deaths. Is it better for a photographer to work for himself, or is it better for him to work for others? Which way led to art? As long as clients paid good money for pictures, many great photographers accepted Steichen's answer, or simply forgot about art and got on with the job. However, the Second World War put an end to the F.S.A., and thereafter the advent of television put an end to Life and most of the other mass-circulation picture magazines. At the same time the failure of modern painting to live up to expectations spurred a renewed interest in photography as art. In these circumstances a new generation of photographers emerged that sought recognition not in the pages of magazines and newspapers, but in museums and galleries.

In one respect this new generation is composed of children of Stieglitz. None of them earns a living from the photography they exhibit. They live instead on teaching jobs, foundation grants, or the proceeds of commercial work they do not exhibit. However, most of them have abandoned the narrow purism of Stieglitz's later years for a wide variety of different approaches.

Paul Caponigro (born 1932) is one of the few younger photographers who continues the purist tradition of modern photography into the present day. However, his dark, brooding prints of ancient stones, cliff faces, and sunflowers have a romantic feeling of their own (pages 214-217).

Jerry N. Uelsmann (born 1934) revived the composite photography of Robinson and Rejlander in the aftermath of Surrealism. His mysterious pictures of floating rocks and cloud-filled doorways evoke a subconscious world of dreams and agitations (pages 218-221).

Lee Friedlander (born 1934) bases his pictures not on painting but on the kind of accidents and mistakes a novice snapshooter might make. In his "Self Portrait" the photographer's shadow or reflection falls on seemingly random bits of cityscape to create a wry and lonely urban poetry (pages 222-227).

William Eggleston (born 1939) adopts a snapshot approach to color photography. Color itself is the principal subject of his seemingly random shots of everyday things (pages 229-233).

Benno Friedmann (born 1945) revived the handwork and darkroom manipulations of the turn-of-the-century pictorialists in the age of color-field painting and hard-core pornography. In his unique prints veils and clots of color reveal or destroy the image on the negative (pages 234-237).

Geoff Winningham (born 1943) undertakes to do Life-style photo-essays on his own. In his "Friday Night at the Coliseum," an essay on professional wrestlers and their audience in Houston, he combines pictures and text to create a penetrating report on popular life in America (pages 244-249).

Many of the photographers of this younger generation have a serious, not to say solemn, attitude toward their art. In this they resemble the serious amateurs of the turn-of-the-century salons. But they differ from the salon photographers in one important respect. Instead of running their own exhibitions and magazines, they are now dependent for public recognition on two or three critics, a handful of dealers, and (for the highest accolade of all) the director of the photography department of one major art museum. This is one consequence of the recognition of photography as art that Stieglitz and the salon pictorialists undoubtedly did not foresee. Whether it will turn out to be a good thing for twentieth-century American photography remains to be seen.

1. THE AMATEUR AND THE SALON:

PICTORIALISM

At the beginning of the twentieth century, American art photography was dominated by serious amateurs who exhibited in great international photography salons that flourished throughout North America and Europe. These artist-photographers referred to themselves as pictorialists, which in 1900 was not the term of abuse it later became, but simply meant that the photographer sought to use his medium as a means of personal artistic expression. In their efforts to make art with the camera, American pictorialists modeled their productions on the works of Old Master painters, popular nineteenth and early twentieth century genre and landscape painters, Japanese printmakers, and contemporary "impressionists," especially Whistler.

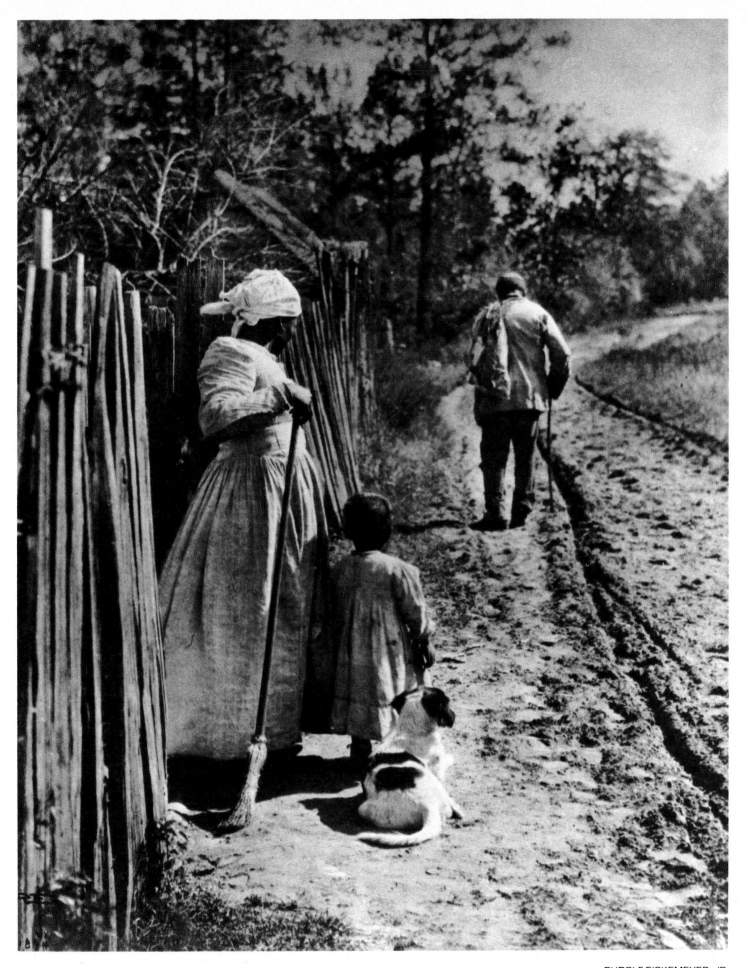

RUDOLF EICKEMEYER, JR.
Who's Dat?, 1894
Division of Photographic History, Smithsonian Institution, Washington, D.C.

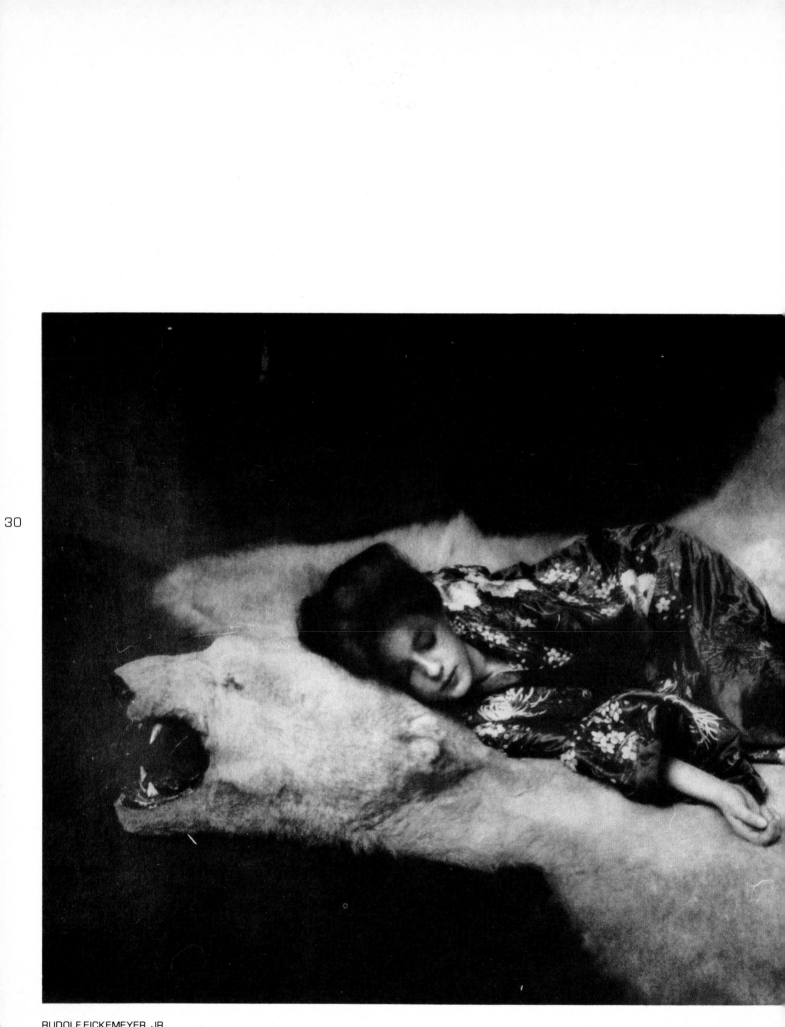

RUDOLF EICKEMEYER, JR.
In My Studio (Evelyn Nesbit), 1901
Hudson River Museum, Yonkers, N.Y.

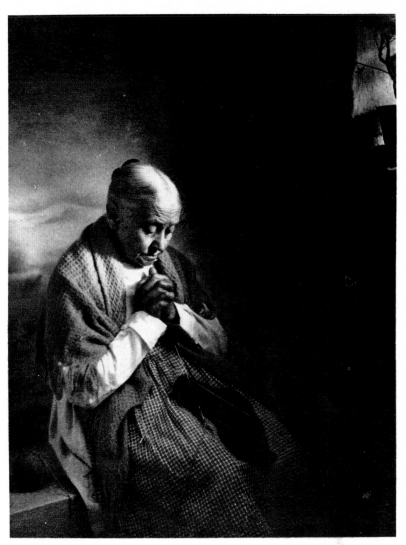

RUDOLF EICKEMEYER, JR.
The Vesper Bell, 1894
Hudson River Museum, Yonkers, N.Y.

RUDOLF EICKEMEYER, JR.
A Summer Sea, 1902
The Metropolitan Museum of Art, New York
The Elisha Whittelsey Fund, 1973

33

RUDOLF EICKEMEYER, JR.
Birches from Camp Cascadnac, Vermont, 1920's
Hudson River Museum, Yonkers, N.Y.

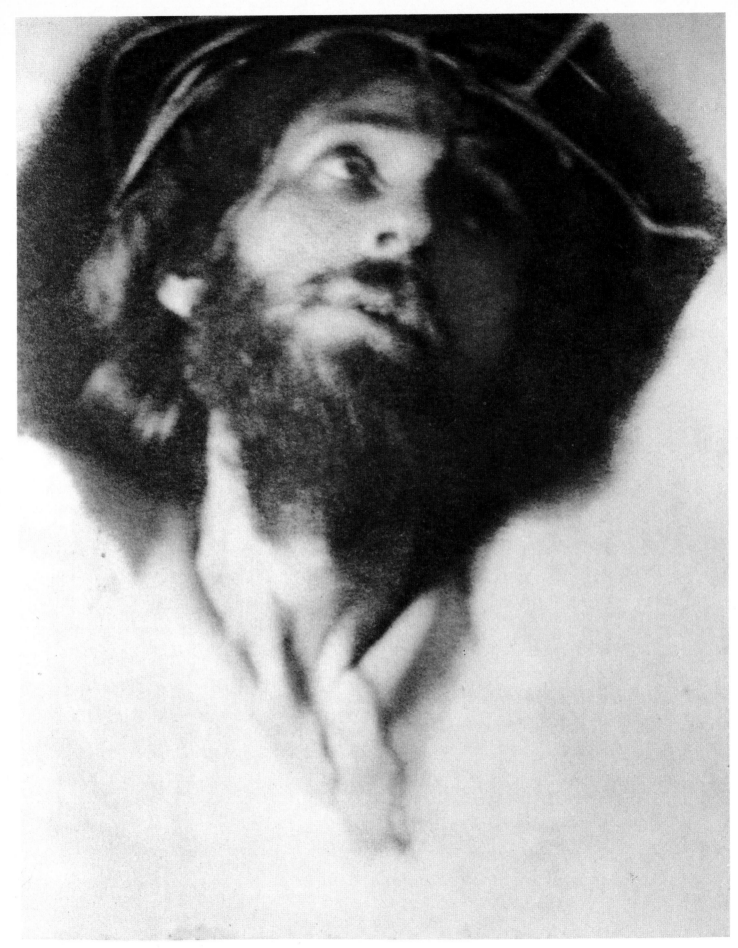

F. HOLLAND DAY
The Seven Last Words, I:
"Father, Forgive Them: They Know Not What They Do," 1898
The Library of Congress, Washington, D.C.

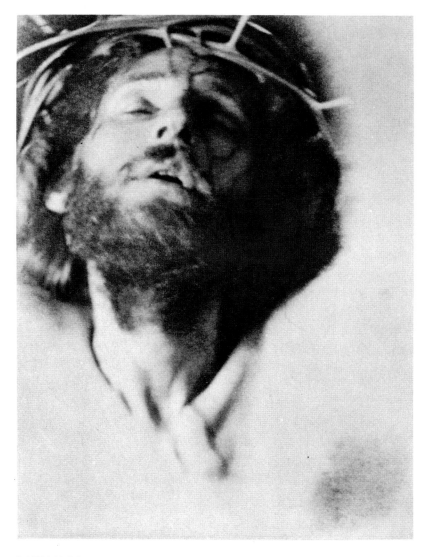

F. HOLLAND DAY
The Seven Last Words, VI:
"Into Thy Hands I Commend My Spirit," 1898
The Library of Congress, Washington, D.C.

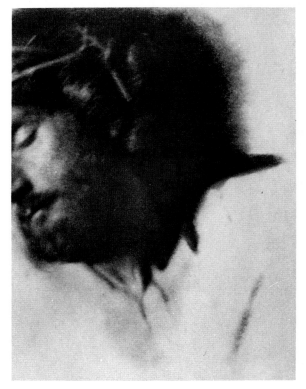

F. HOLLAND DAY
The Seven Last Words, VII: "It is Finished," 1898
The Library of Congress, Washington, D.C.

36

F. HOLLAND DAY
Landscape, ca. 1905
The Library of Congress, Washington, D.C.

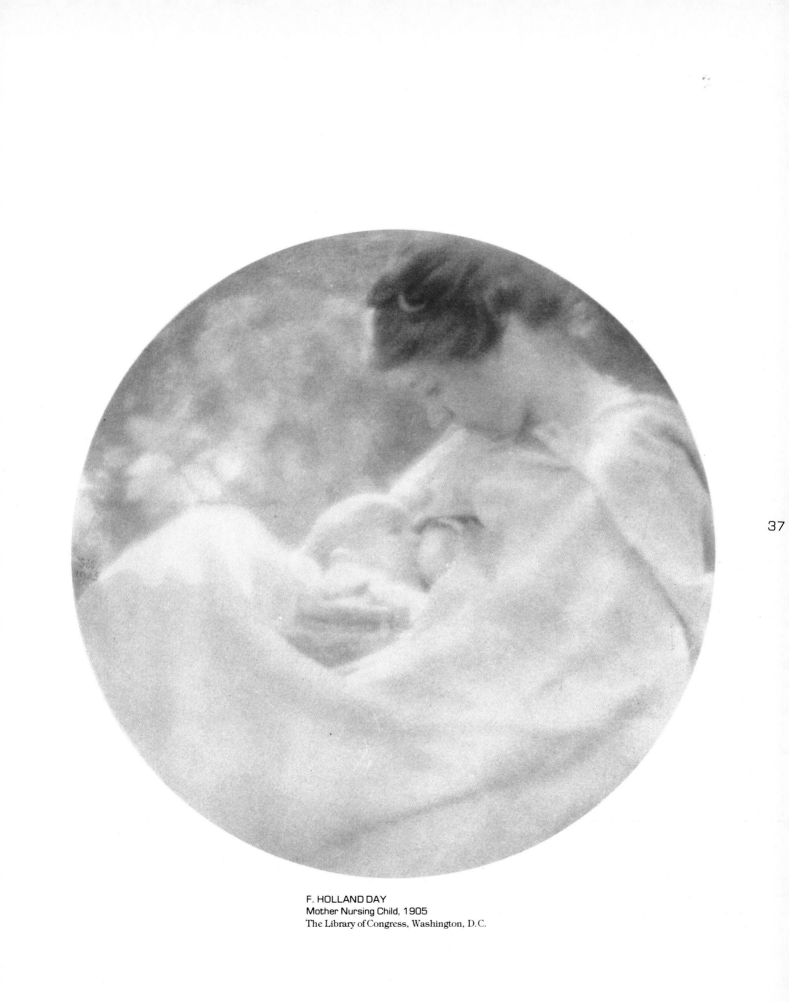

F. HOLLAND DAY
Mother Nursing Child, 1905
The Library of Congress, Washington, D.C.

F. HOLLAND DAY
Triptych, Boy with Rabbit, ca. 1905
The Library of Congress, Washington, D.C.

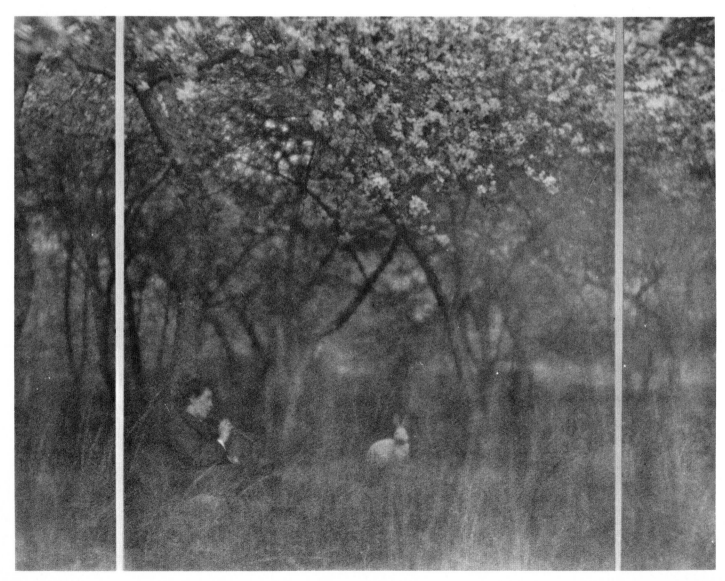

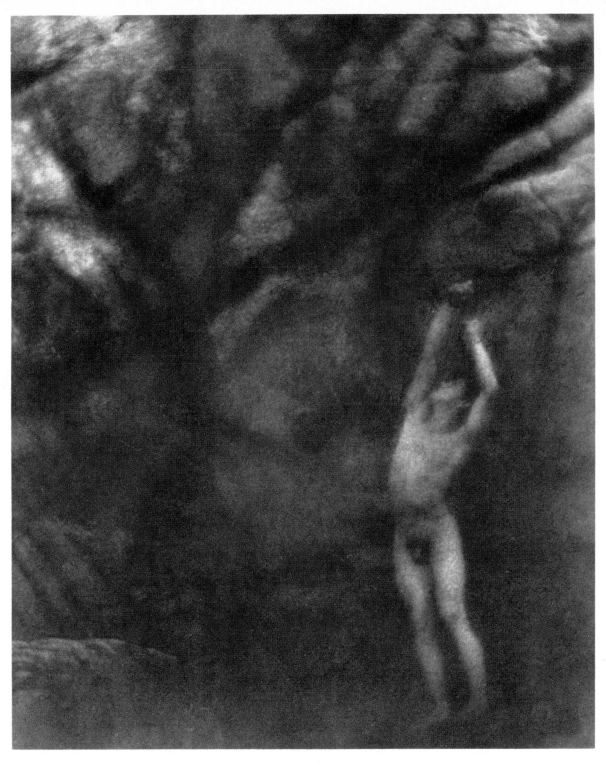

F. HOLLAND DAY
Nude Youth in the Forest, ca. 1905
The Library of Congress, Washington, D.C.

ALFRED STIEGLITZ
The Net Mender, 1894
Courtesy Robert P. Mann

40

42

ALFRED STIEGLITZ
Goats Outside of Paris (A Decorative Panel), 1894
Courtesy Robert Schoelkopf Gallery, New York

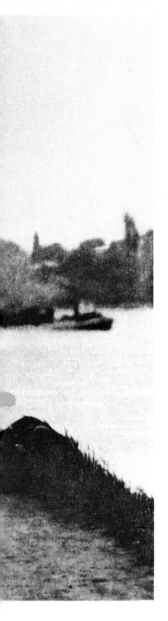

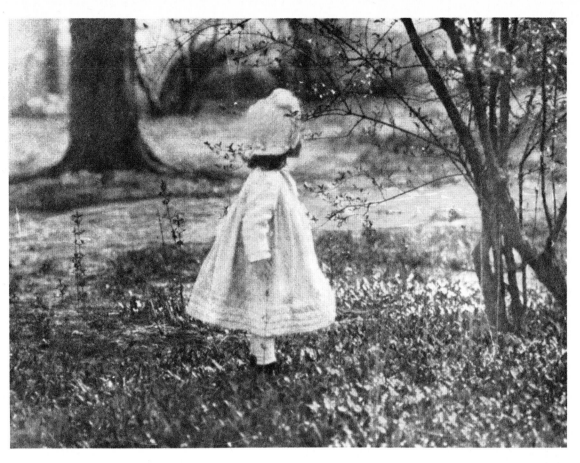

ALFRED STIEGLITZ
Spring, 1901
Courtesy Robert P. Mann 43

44

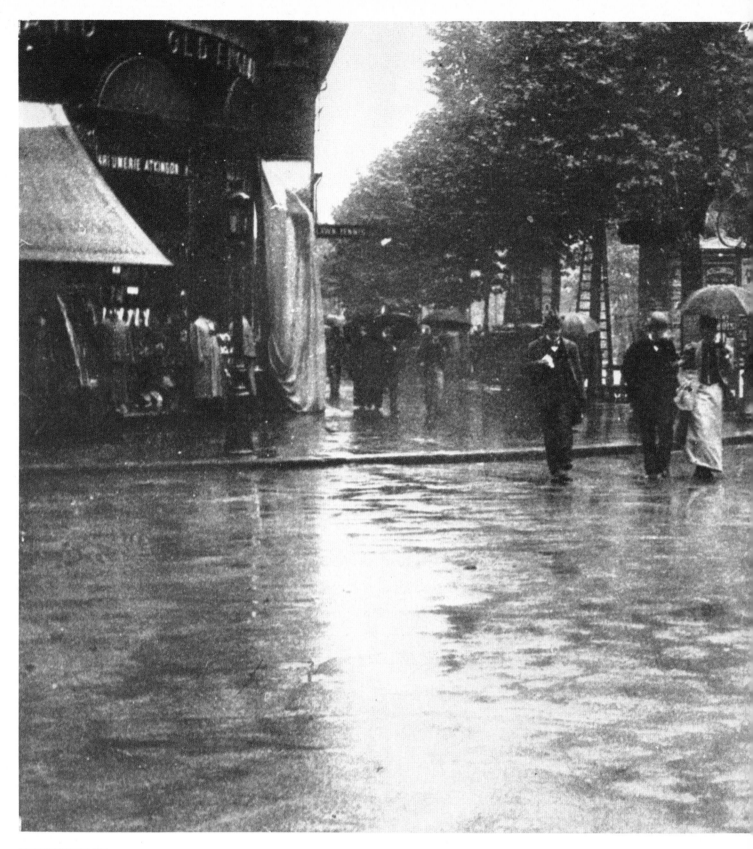

ALFRED STIEGLITZ
A Wet Day on the Boulevard, Paris, 1894
Courtesy Robert P. Mann

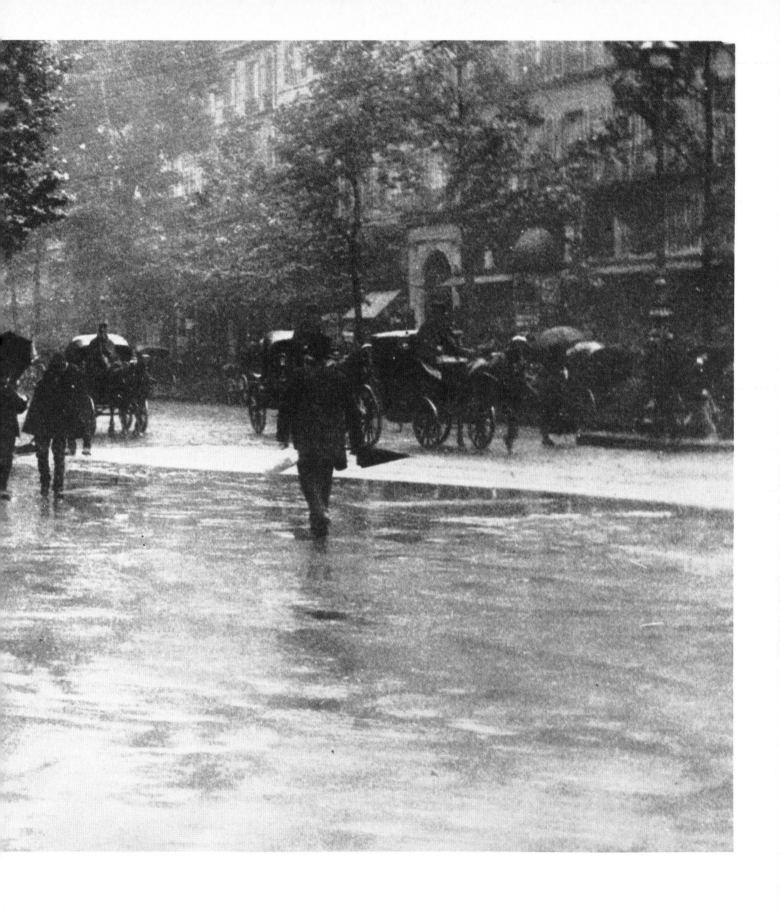

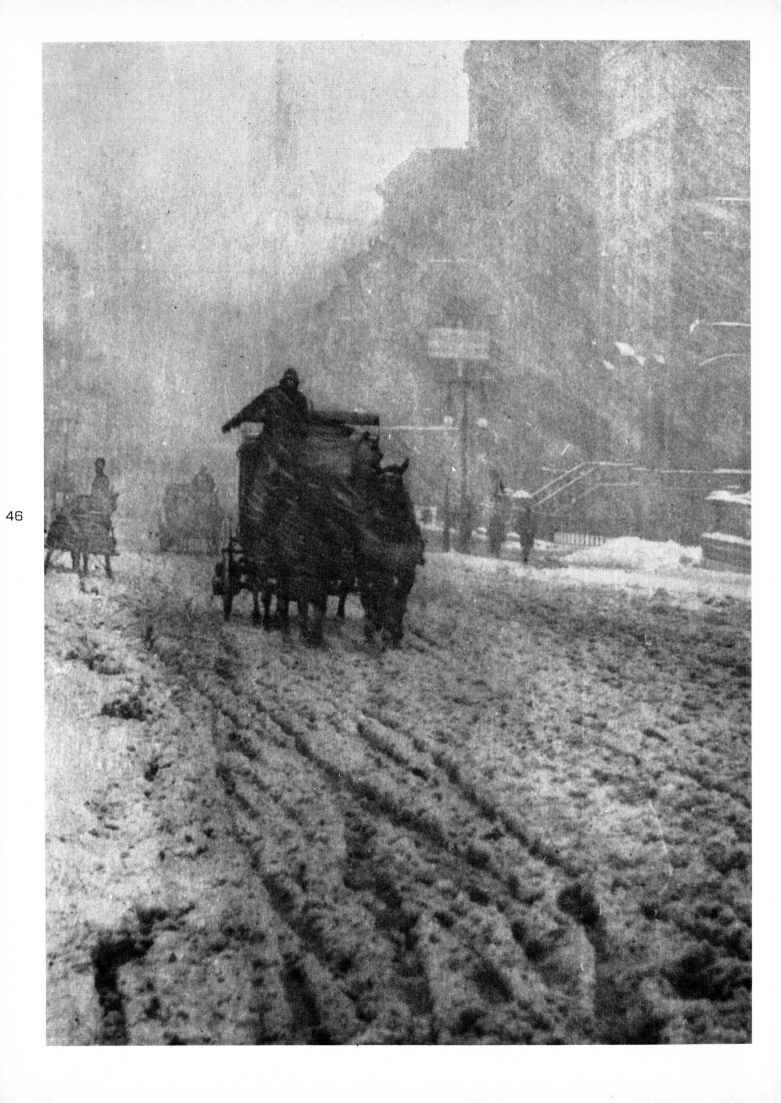

46

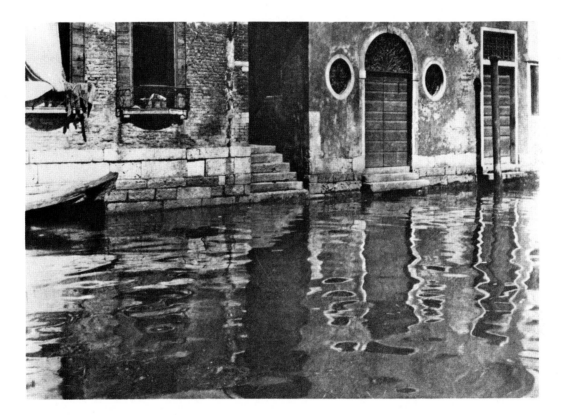

ALFRED STIEGLITZ
Venice, Canal, 1894
Courtesy Robert P. Mann

ALFRED STIEGLITZ
Winter, Fifth Avenue, New York, 1893
Private Collection, New York

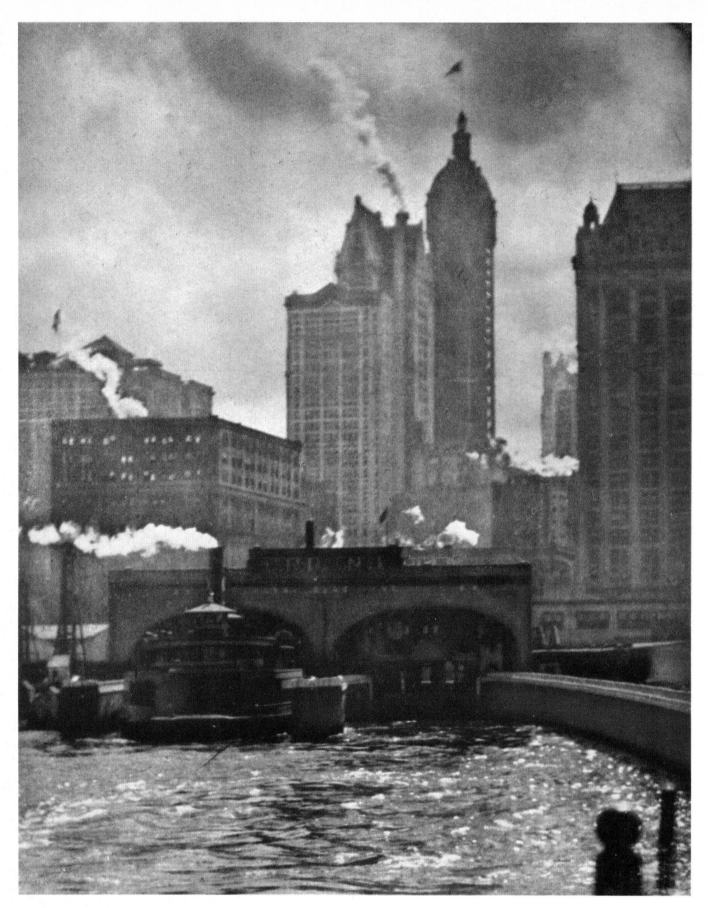

48

ALFRED STIEGLITZ
The City of Ambition, New York, 1910
Courtesy Robert P. Mann

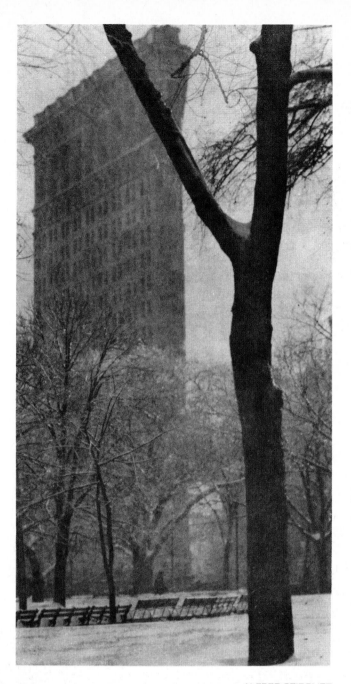

ALFRED STIEGLITZ
The Flatiron Building, New York, 1903
Courtesy Robert P. Mann

ALFRED STIEGLITZ
An Icy Night, New York, 1898
Private Collection, New York

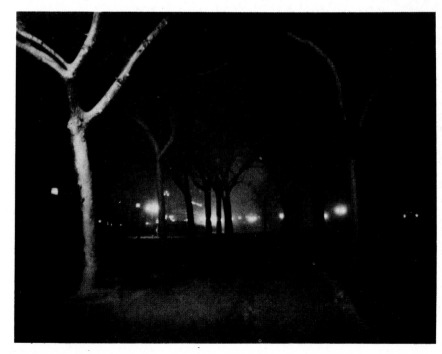

ALFRED STIEGLITZ
The Street—Design for a Poster, 1903
Courtesy Robert P. Mann

50

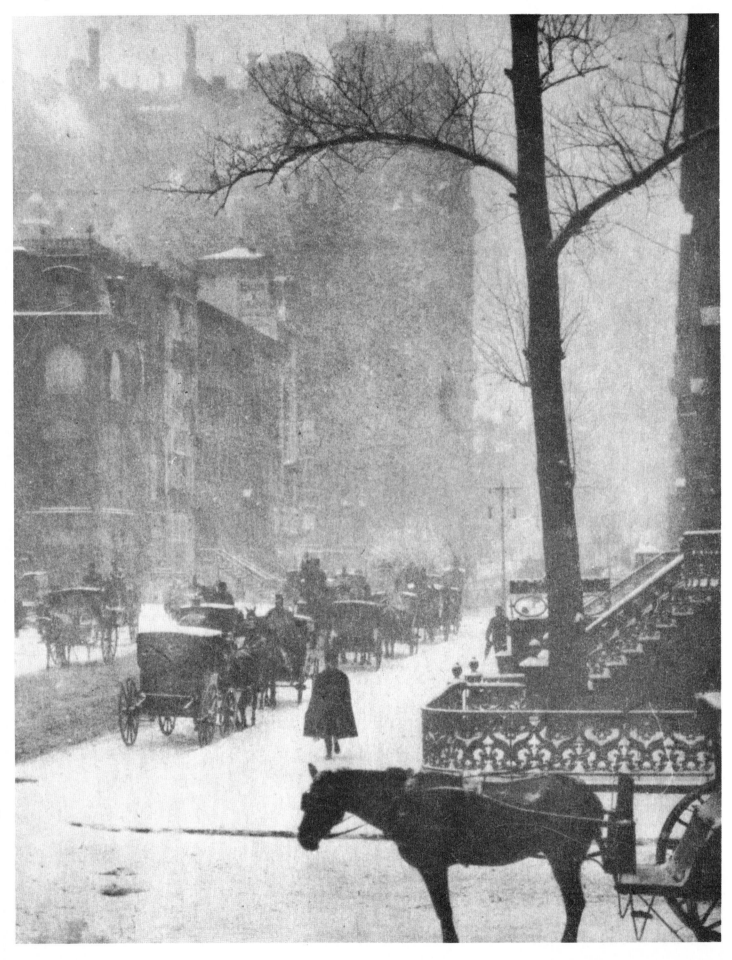

ALFRED STIEGLITZ
The Hand of Man, Long Island City, New York, 1902
Courtesy Robert P. Mann

52

ALFRED STIEGLITZ
A Dirigible, 1910
Courtesy Robert P. Mann

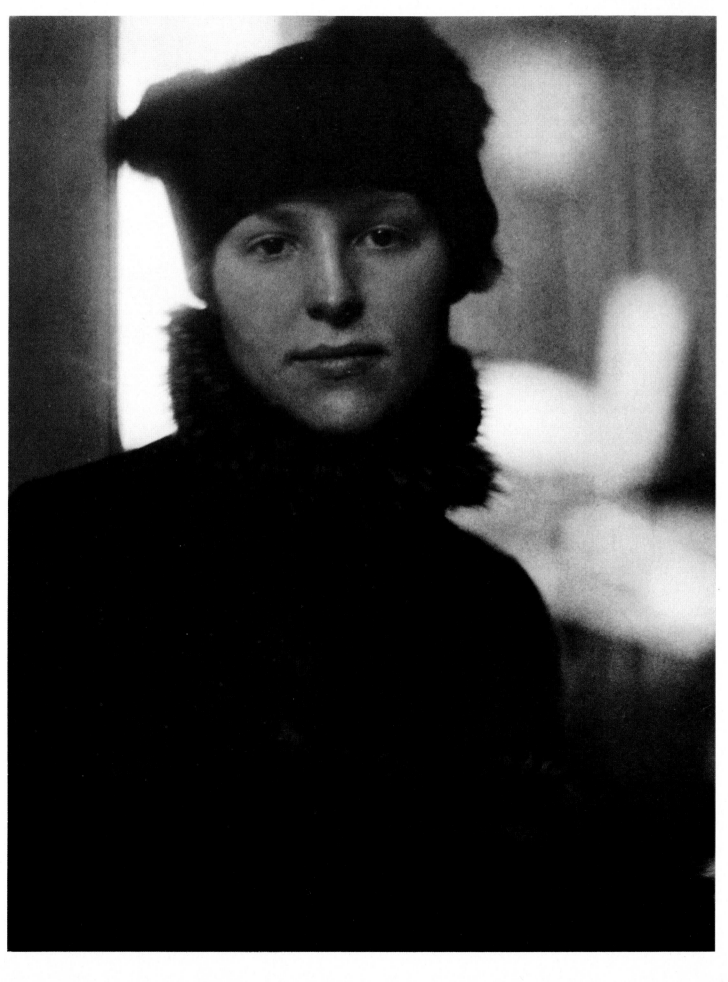

53

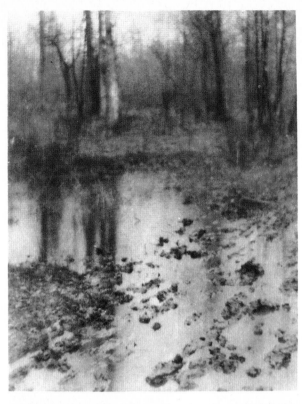

EDWARD STEICHEN
The Pool—Evening, Milwaukee, 1899
Courtesy The Witkin Gallery, Inc., New York

EDWARD STEICHEN
Rodin—Le Penseur, Paris, 1902
Courtesy Lunn Gallery/Graphics International Ltd., Washington, D.C.

54

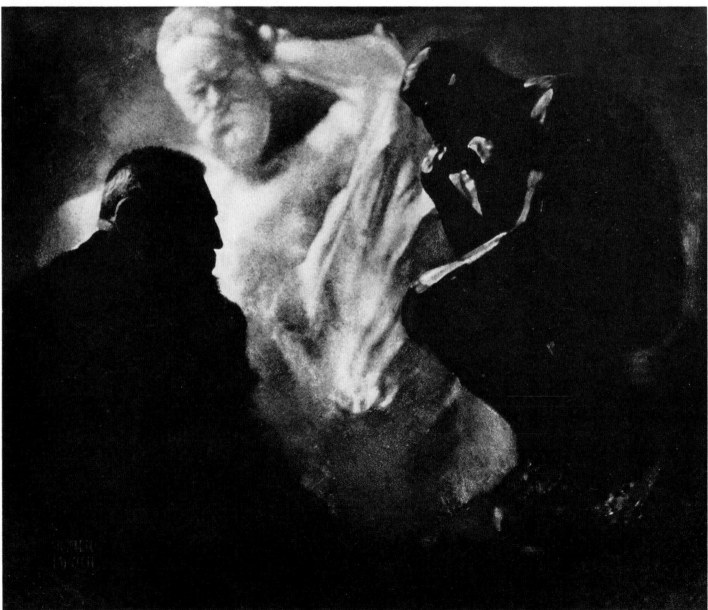

EDWARD STEICHEN
Frederick Evans, ca. 1900
Collection of Lee D. Witkin

EDWARD STEICHEN
Edward Stieglitz, ca. 1902-1906
Private Collection, New York

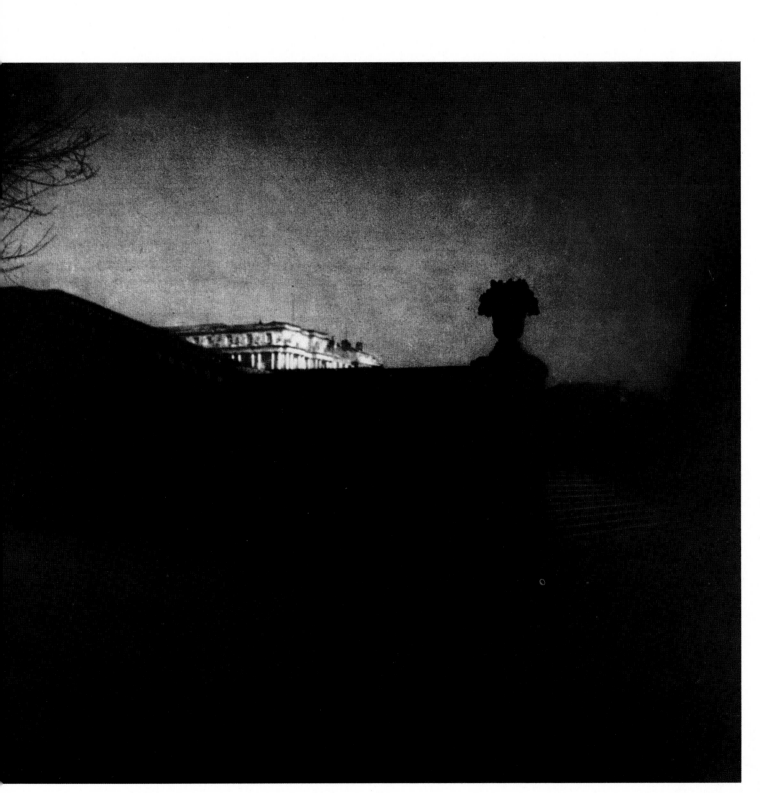

EDWARD STEICHEN
Nocturne—Orangerie Staircase, Versailles, 1907
Albright-Knox Art Gallery, Buffalo, N.Y.

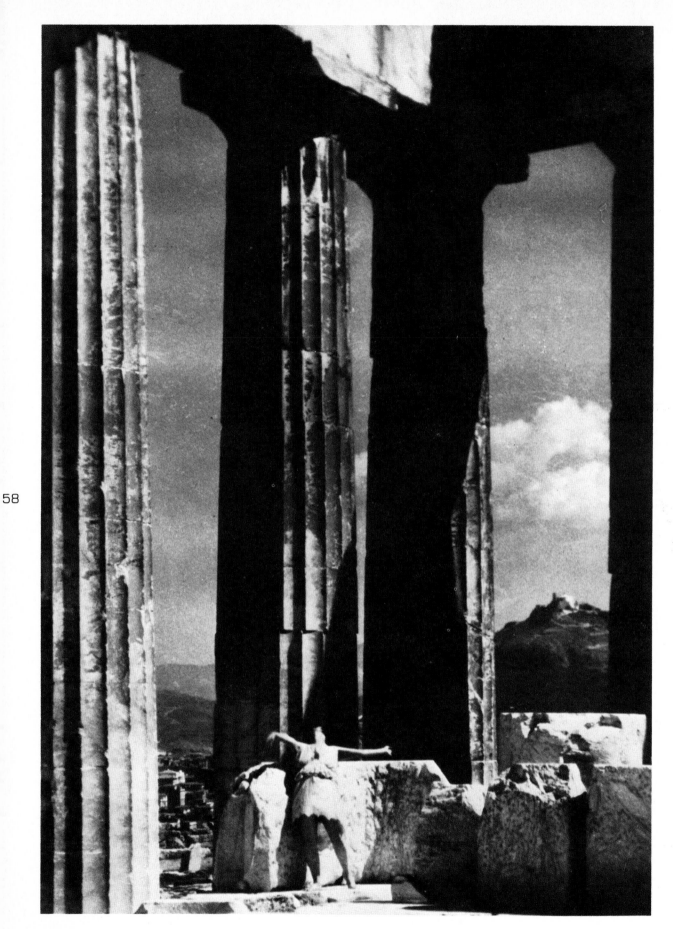

EDWARD STEICHEN
Isadora Duncan at the Parthenon, 1921
Lunn Gallery/Graphics International Ltd., Washington, D.C.

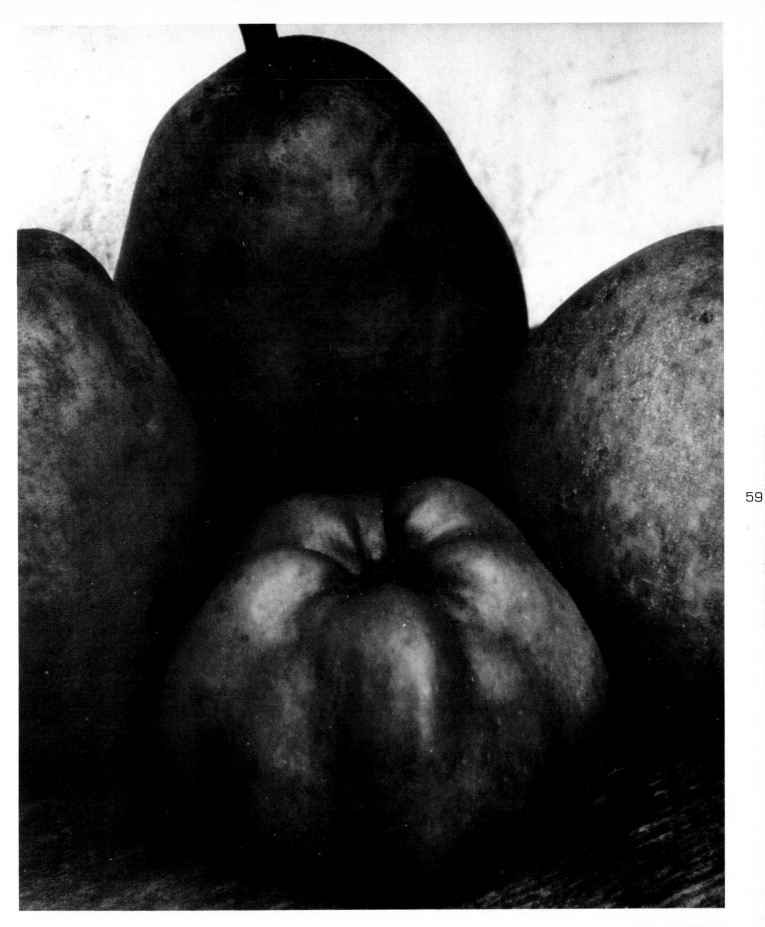

EDWARD STEICHEN
Three Pears and an Apple, France, ca. 1921
Private Collection, New York

60

MODERNISM

Around the time of the First World War the artistic
assumptions of salon photography were shattered by the
drastic innovations of such modern painters as Picasso and
Matisse. The inherently realistic medium of photography
did not allow photographers to abstract or distort to
the extent that these painters did. However, a growing number
of artist-photographers, including Alfred Stieglitz
and Edward Steichen, tried to bring photography in line with
modern painting by emphasizing the abstract or formal
elements of picture-making or by choosing "ugly" subject
matter. In the process they rediscovered the sharp-focus
realism previously thought unartistic and turned
"pictorialism" into a dirty word. In America Paul Strand
was the pioneer of this movement.

PAUL STRAND
Abstraction, Porch Shadows, Connecticut, 1915
The Dan Berley Collection

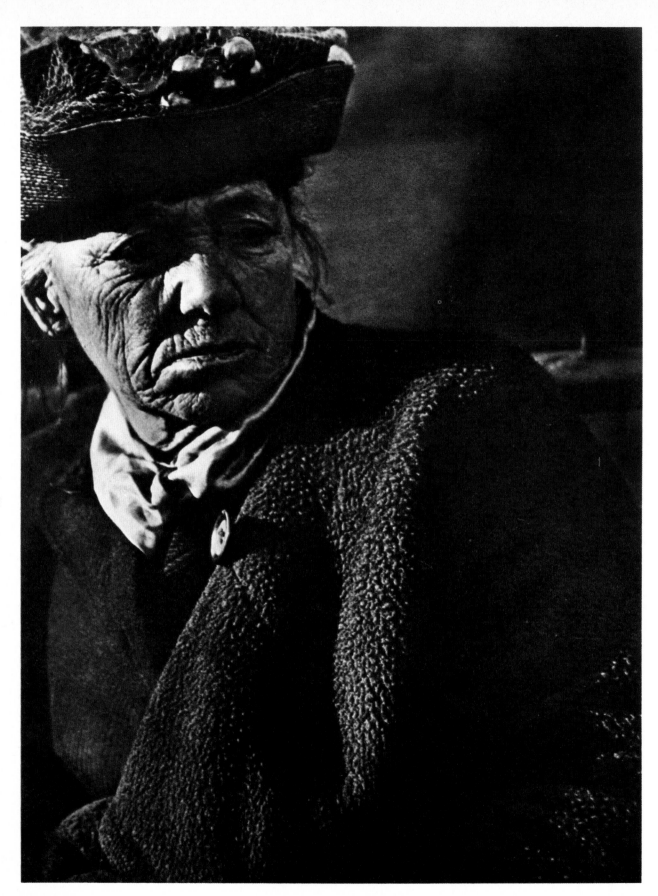

PAUL STRAND
Portrait, Washington Square, New York, 1916
Private Collection, New York

PAUL STRAND
Man, Five Points Square, New York, 1916
Courtesy Robert P. Mann

PAUL STRAND
Abstraction, Bowls, Connecticut, 1915
Private Collection, New York

64

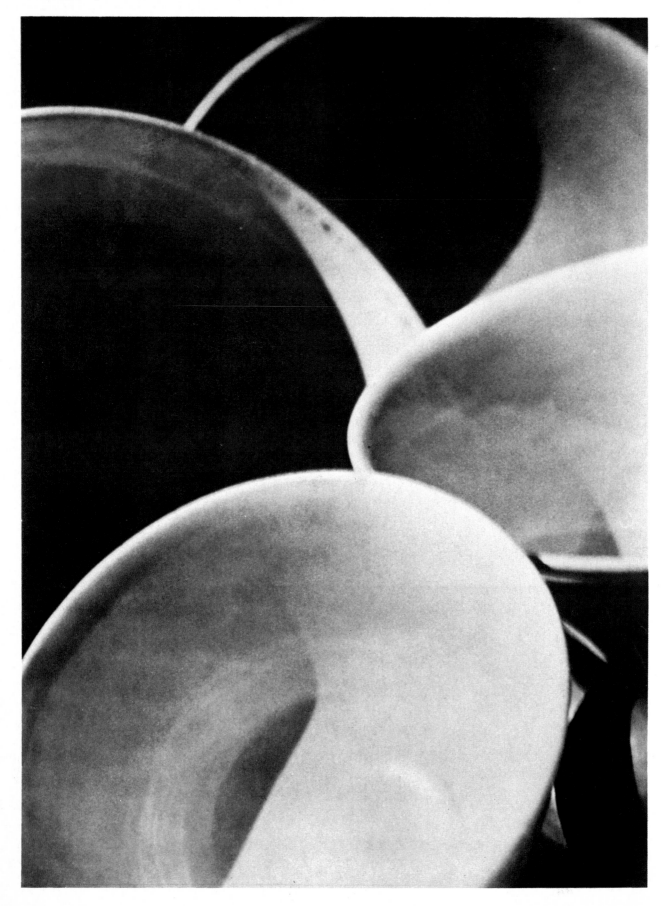

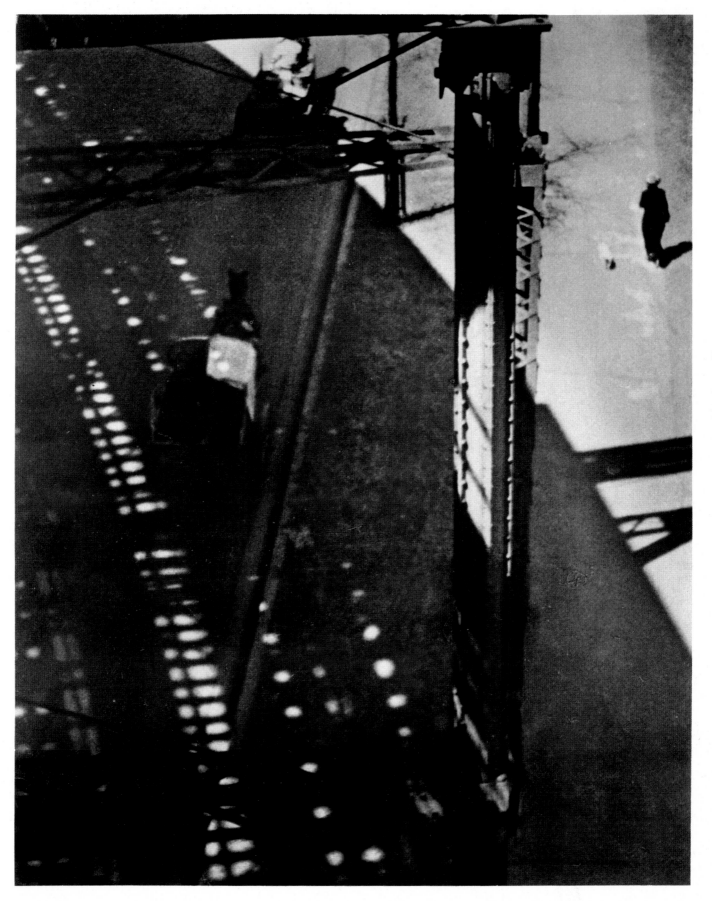

65

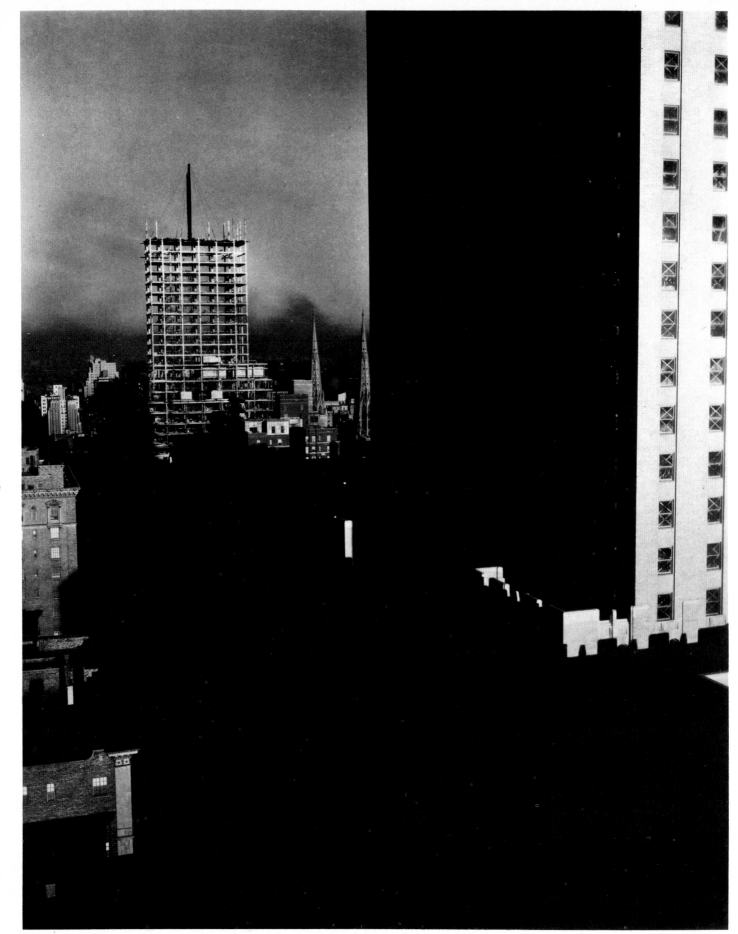

66

ALFRED STIEGLITZ
New York in 1932 (Looking Northwest from the Shelton), 1932
The Cleveland Museum of Art, Gift of Cary Ross, Knoxville, Tennessee

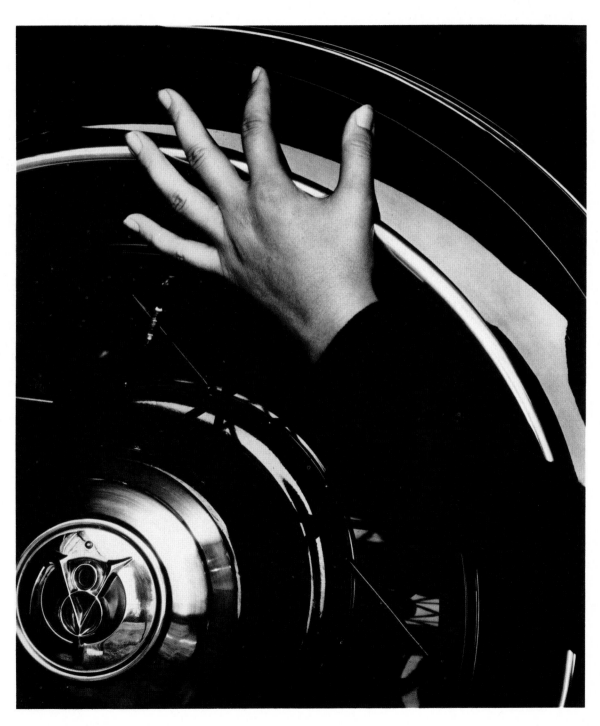

ALFRED STIEGLITZ
Hand and Wheel (O'Keeffe Hand and Ford Wheel), 1933
The Cleveland Museum of Art, Gift of Cary Ross, Knoxville, Tennessee

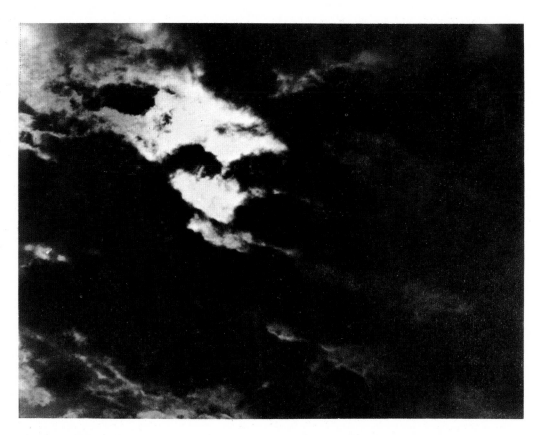

ALFRED STIEGLITZ
Equivalent, ca. 1929
Private Collection, New York

ALFRED STIEGLITZ
Equivalent, 1929
Courtesy The Witkin Gallery, Inc., New York

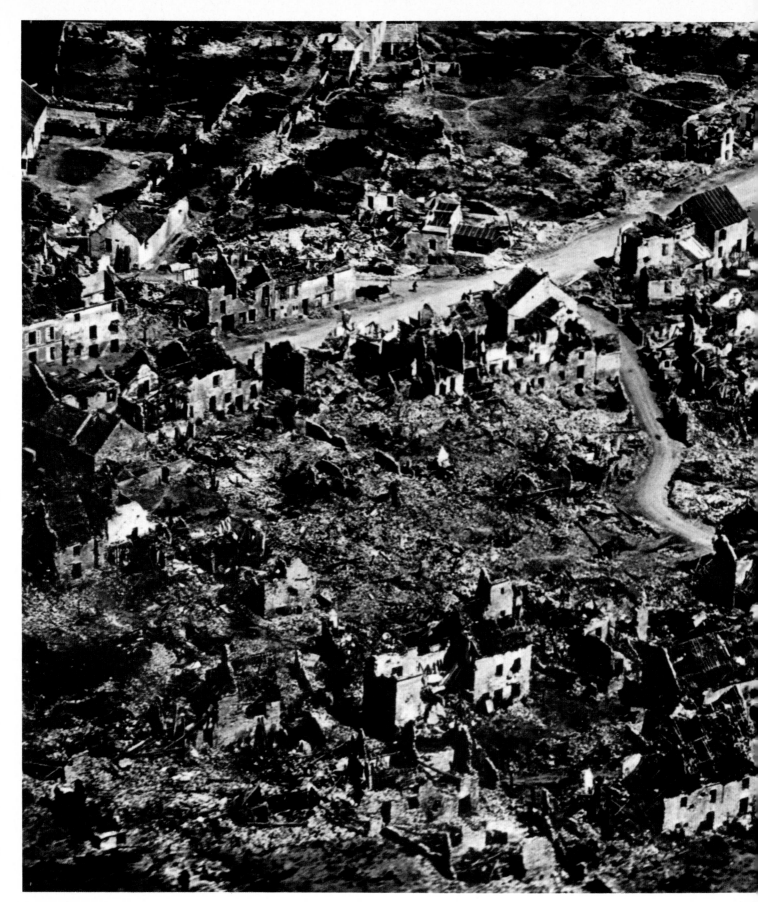

U.S. AIR SERVICE, OFFICE OF EDWARD STEICHEN:
World War I Aerial View of Vaux, France, After Bombing Attack, 1917
Private Collection, New York

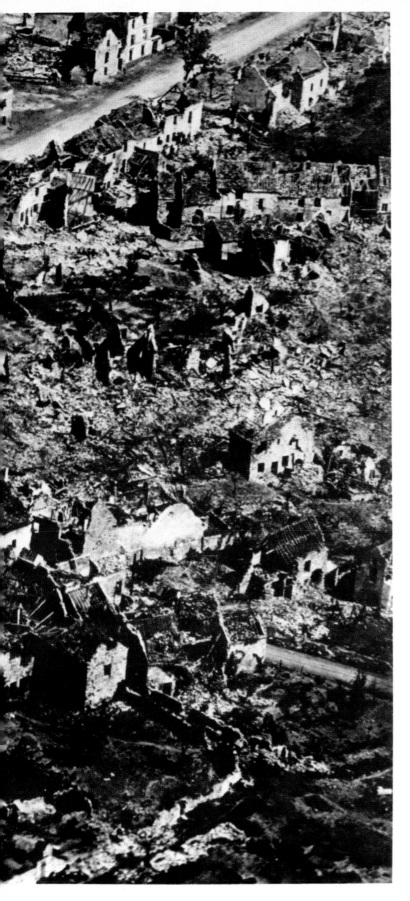

EDWARD STEICHEN
Wheelbarrow with Flower Pots, France, 1920
Private Collection, New York

EDWARD STEICHEN
Sunflower in Seed, France, ca. 1920
The Museum of Modern Art, New York

EDWARD STEICHEN
Laughing Boxes: West 86th Street, New York, ca. 1922
The Museum of Modern Art, New York

EDWARD WESTON
Cypress Root, 1929
Courtesy of Witkin-Berley Ltd.

EDWARD WESTON
Manuel Hernández Galván, Shooting, 1924
Courtesy Cole Weston

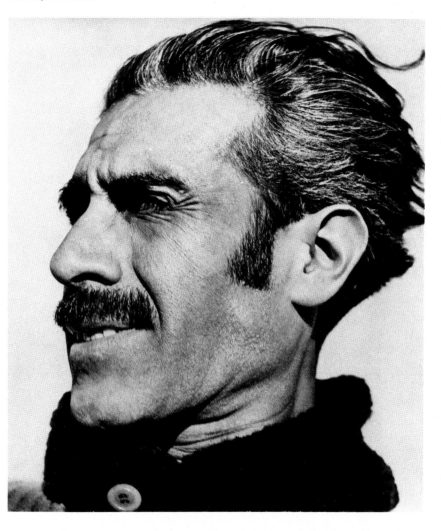

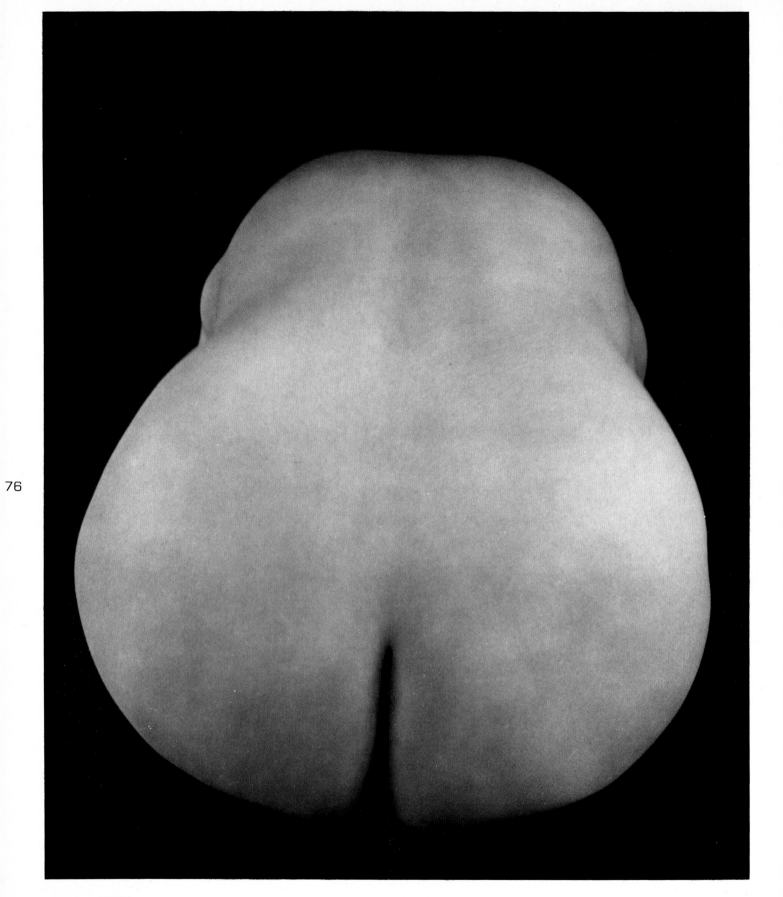

EDWARD WESTON
Nude, 1925
Courtesy Cole Weston

EDWARD WESTON
Rose Covarrubias, 1926
The Dan Berley Collection

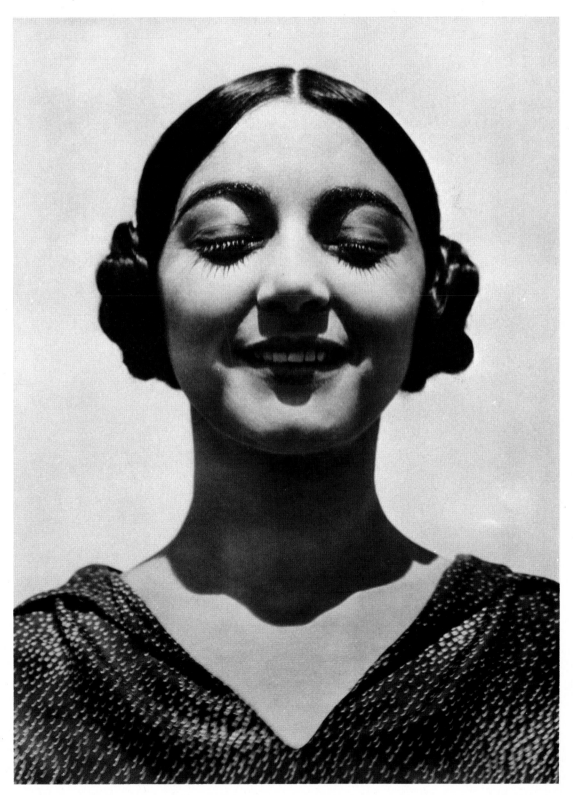

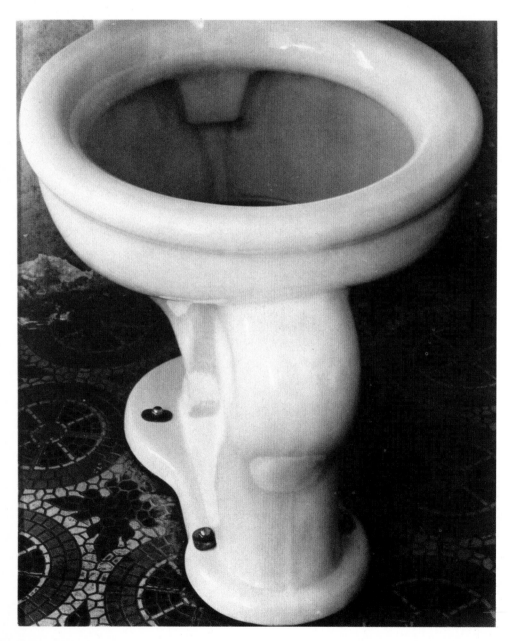

EDWARD WESTON
Excusado, 1925
Collection of Lee D. Witkin

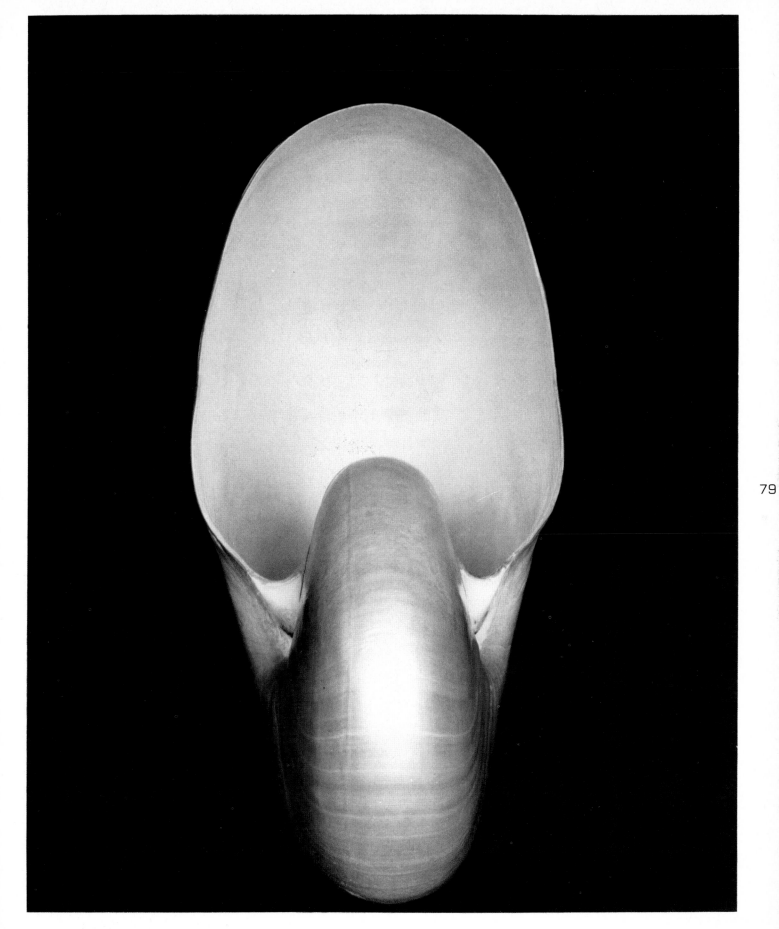

EDWARD WESTON
Shell, 1927
Courtesy Cole Weston

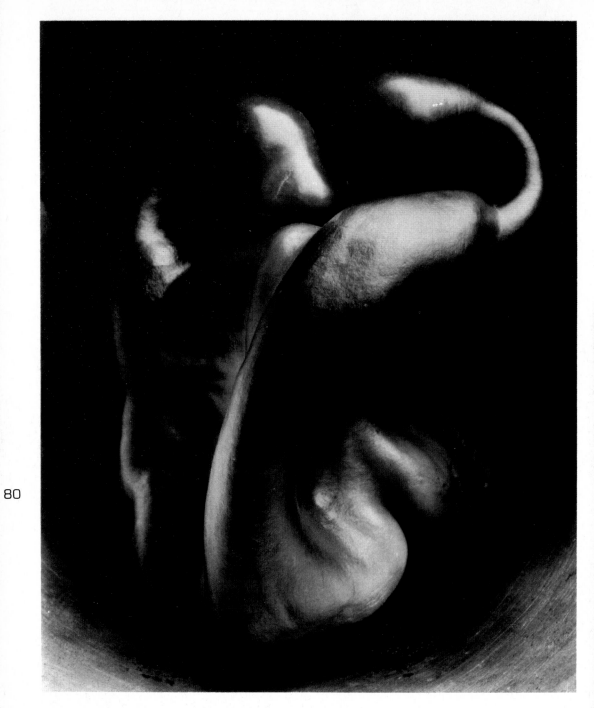

EDWARD WESTON
Pepper No. 30, 1930
Mary and Weston Naef Collection

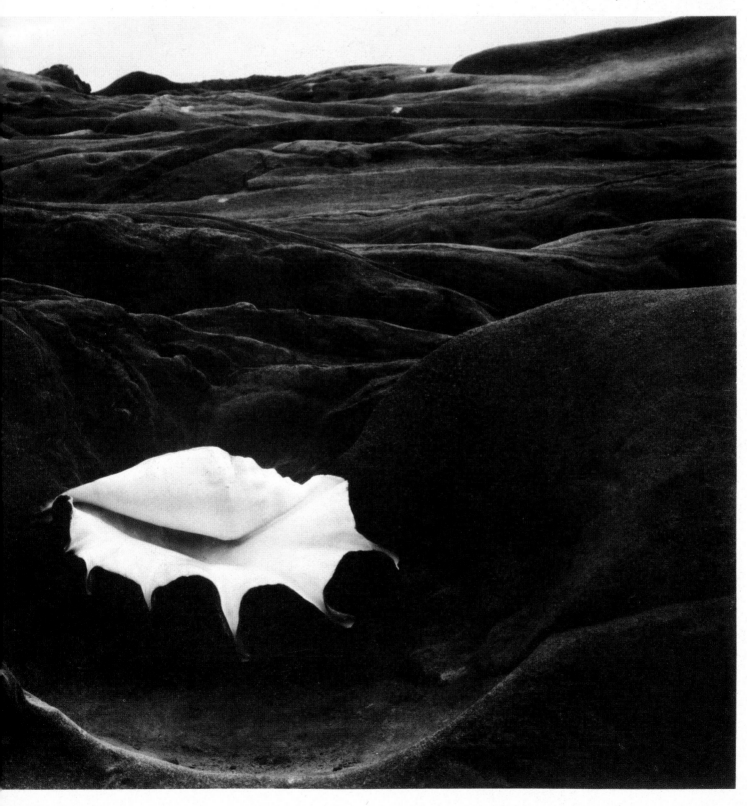

81

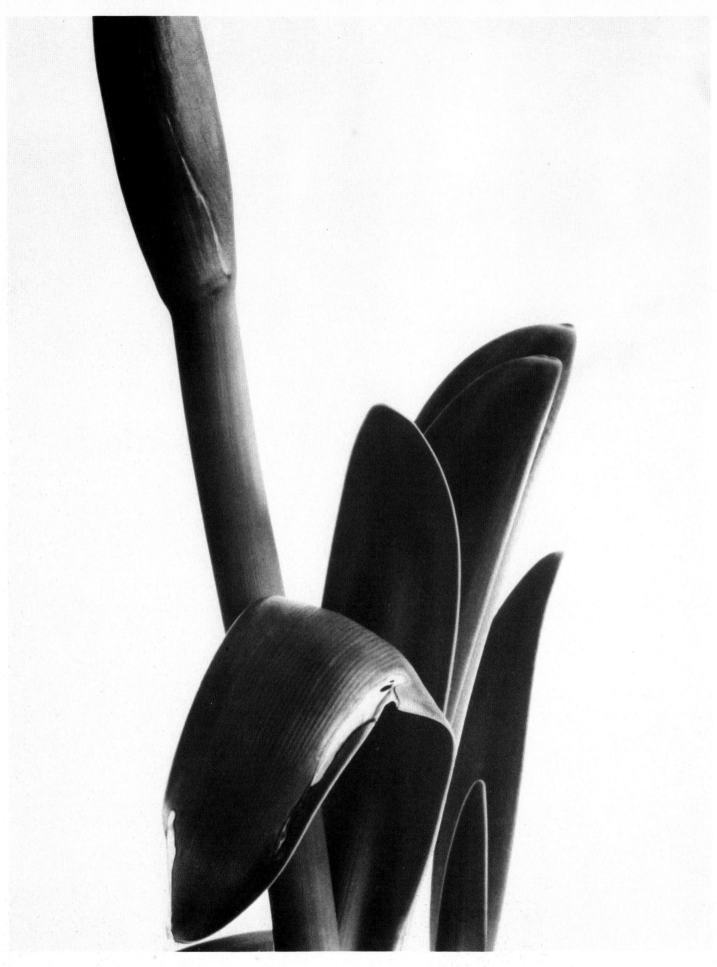

82

IMOGEN CUNNINGHAM
Amaryllis, 1933
Courtesy The Imogen Cunningham Trust

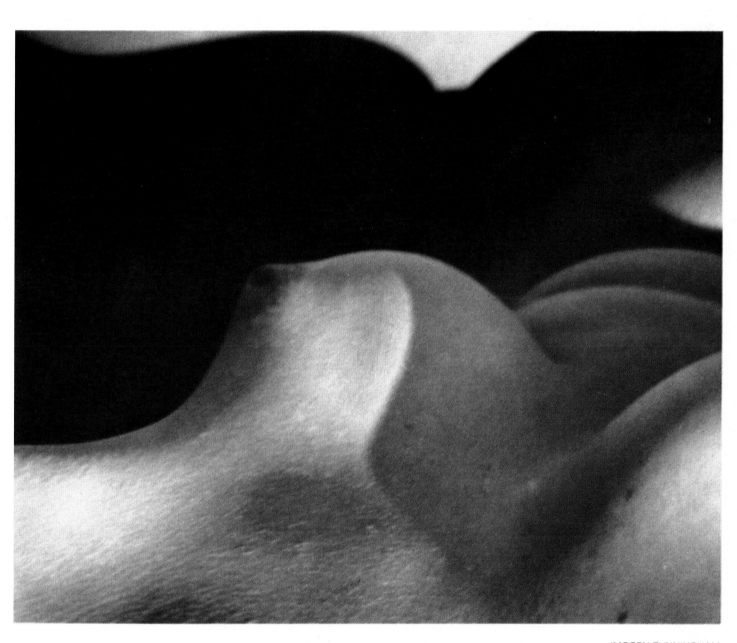

IMOGEN CUNNINGHAM
Her and Her Shadow, 1936
Courtesy the Imogen Cunningham Trust

84

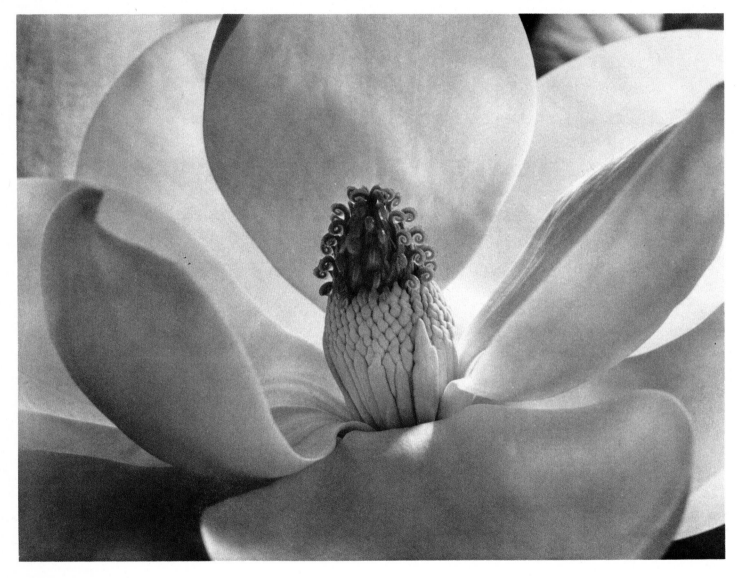

IMOGEN CUNNINGHAM
Magnolia Blossom, 1925
Courtesy The Imogen Cunningham Trust

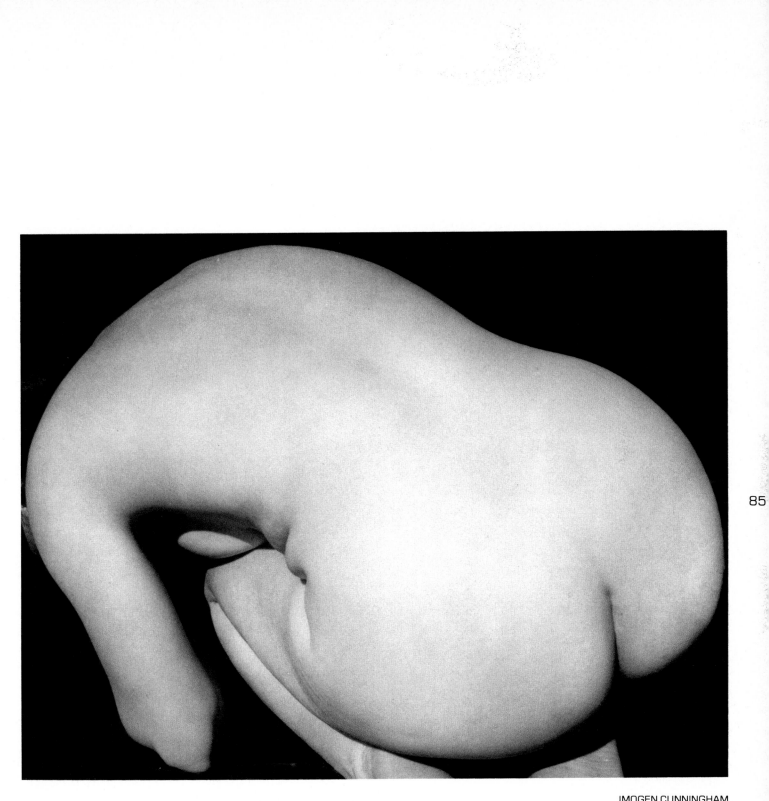

IMOGEN CUNNINGHAM
Nude, 1932
Courtesy The Imogen Cunningham Trust

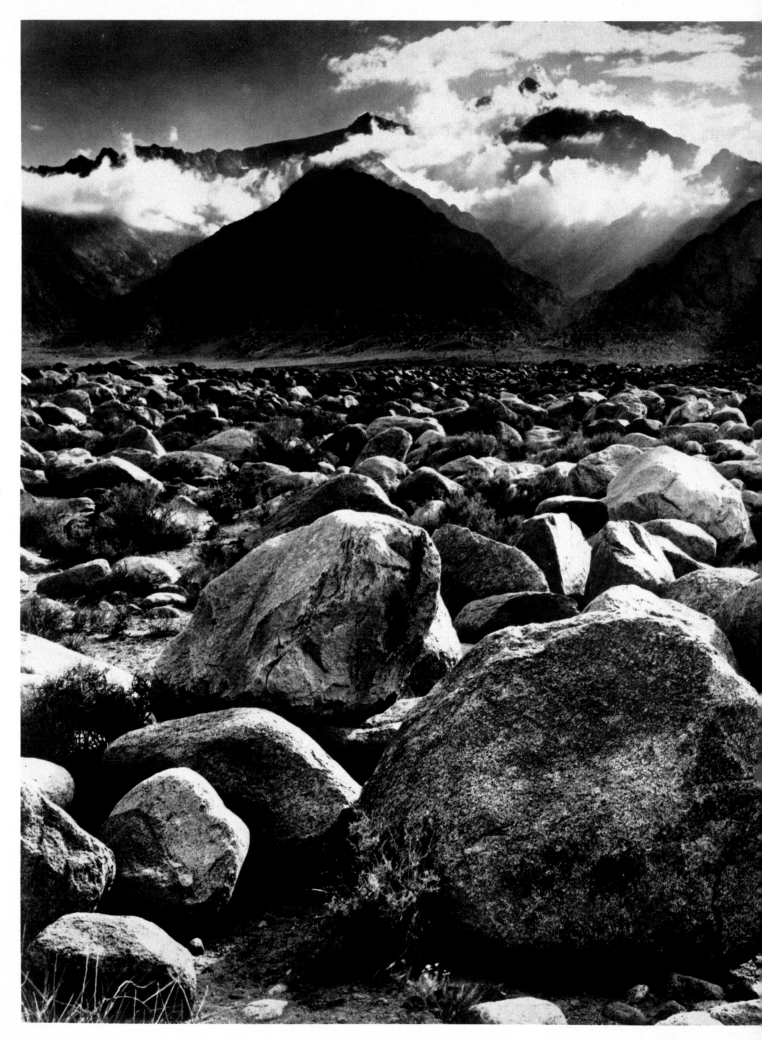

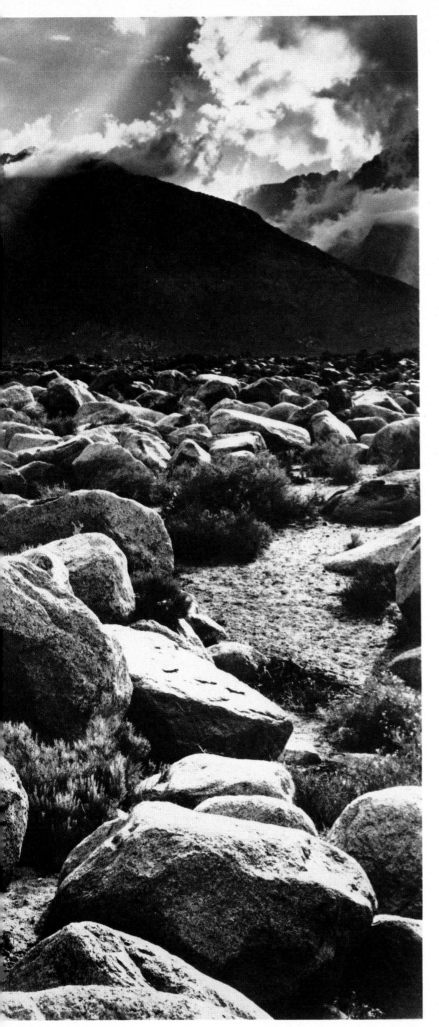

87

ANSEL ADAMS
Mount Williamson, Sierra Nevada, from Manzanar,
California, 1944
Courtesy Light Gallery, New York

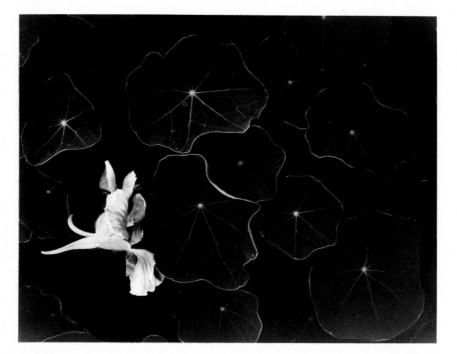

ANSEL ADAMS
Nasturtiums, Halcyon, California
Collection of Lee D. Witkin

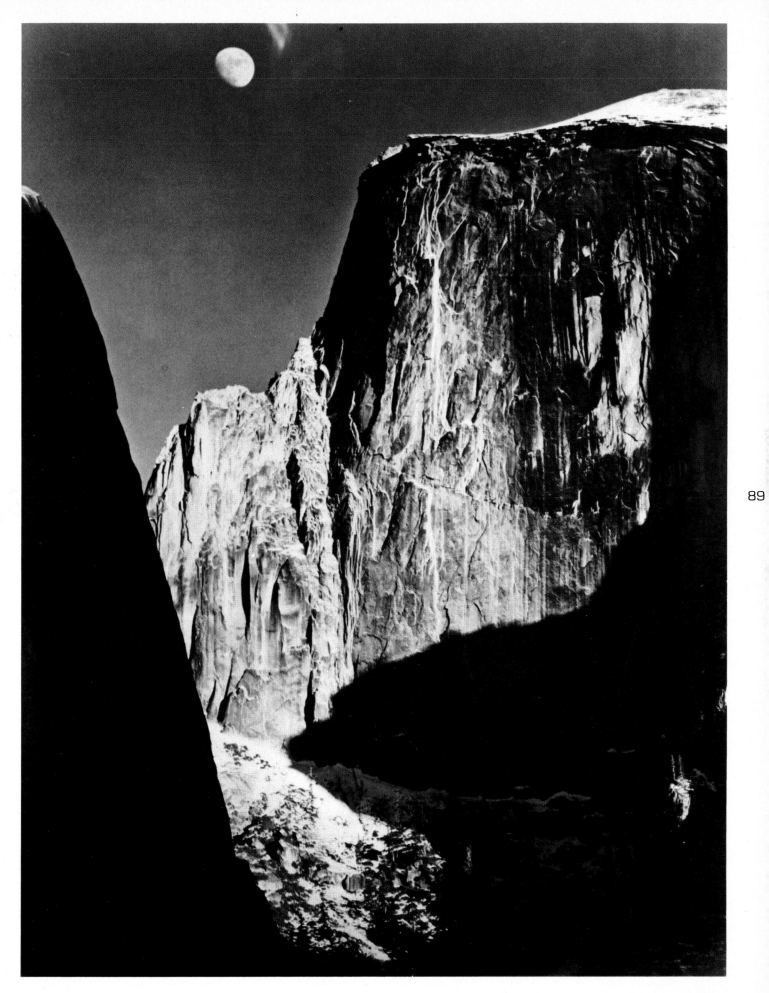

ANSEL ADAMS
Moon and Half Dome, Yosemite National Park, California, 1960
Collection of Lee D. Witkin

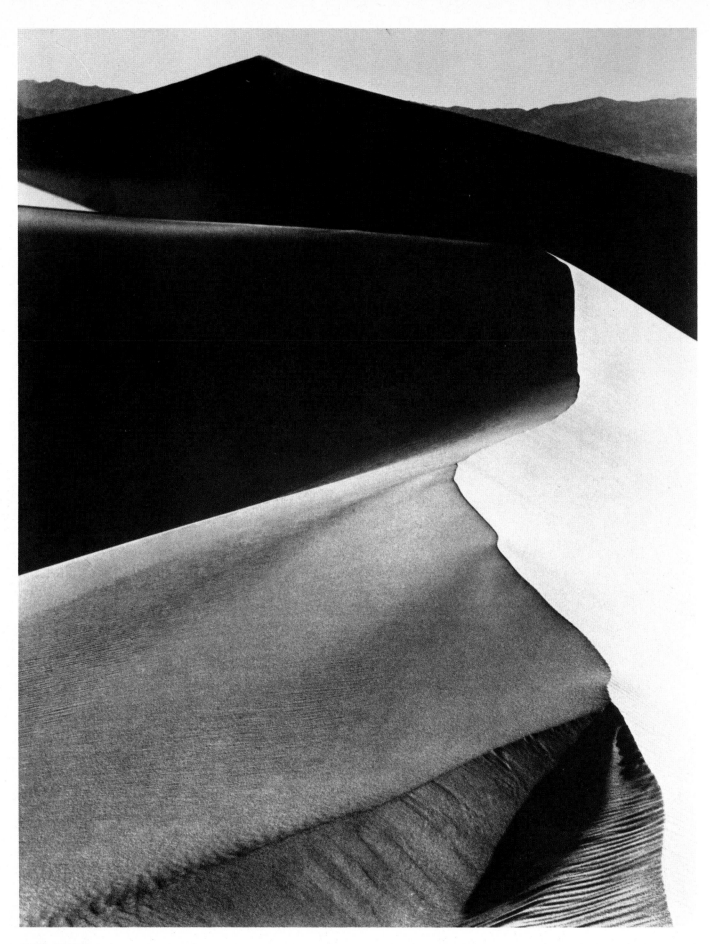

ANSEL ADAMS
Sand Dunes, Sunrise, Death Valley National Monument, California, ca. 1948
Courtesy Light Gallery, New York

ANSEL ADAMS
White Branches, Mono Lake, California, 1950
Courtesy Light Gallery, New York

2. PHOTOGRAPHY FOR CLIENTS:

A PUBLIC ART

Throughout the heyday of salon photography most photographers
ignored the salons and worked for clients as reporters,
portraitists, or propagandists. Like Lewis Hine, they were not
taken seriously as artists unless they also showed
"personal" work in the salons. Around 1920, however, Edward Steichen
and other salon photographers began to make portrait,
fashion, and advertising photographs for quality magazines like
Vogue and Harper's. Steichen's old friend and mentor
Alfred Stieglitz bitterly opposed this development, for he did not
believe good work could be done commercially. However, the
efforts of magazine photographers to interest and move their large
new audience resulted in a new kind of photography that crystalized
the hopes, dreams, and fears of a large public
in clear and striking images.

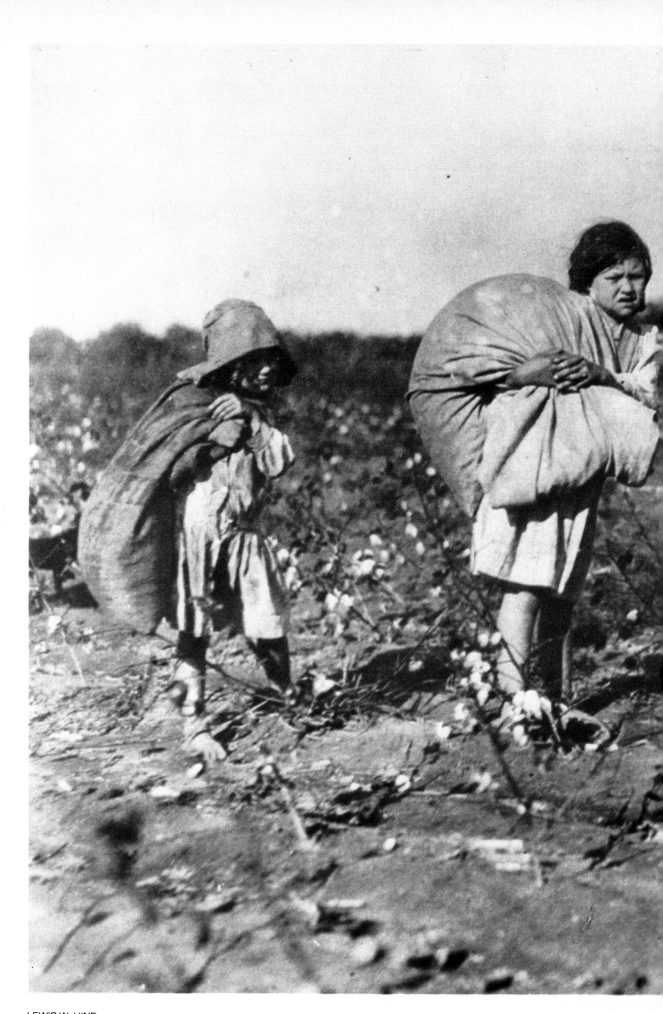

LEWIS W. HINE
Four Children in Cotton Field, Bells, Texas, 1913
Courtesy Robert P. Mann

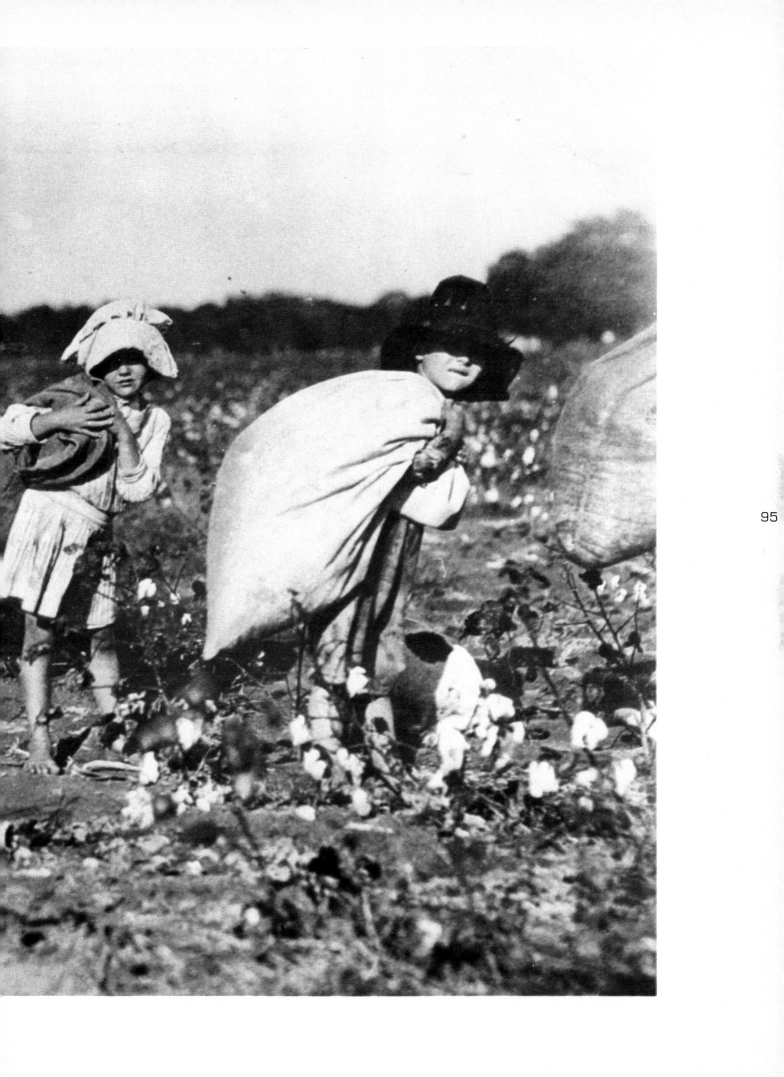

96

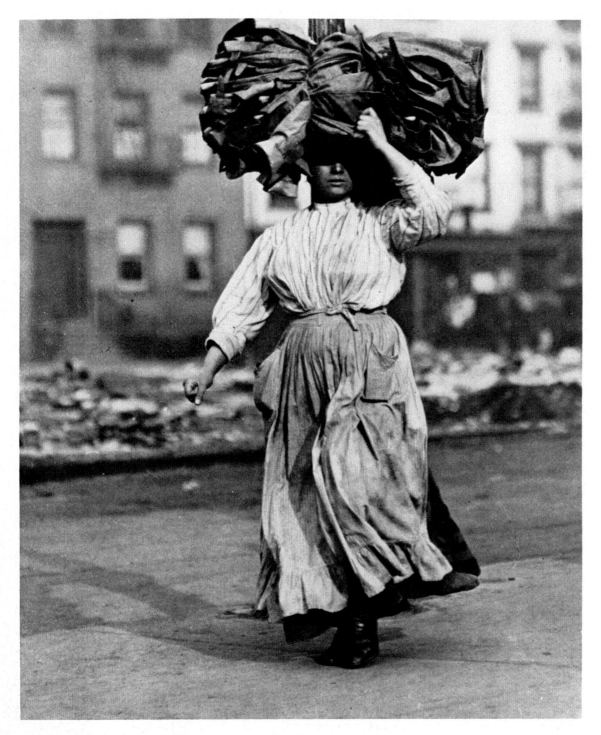

LEWIS W. HINE
Woman Delivering Clothes, New York City, 1910
Courtesy Robert P. Mann

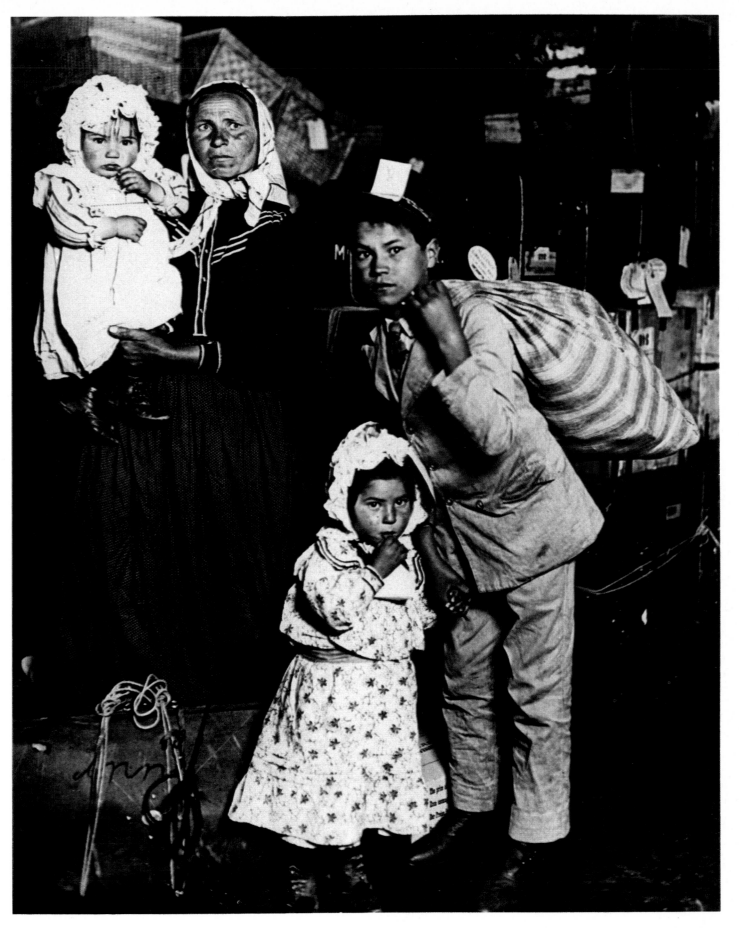

LEWIS W. HINE
Italian Family Seeking Lost Luggage, Ellis Island, 1905
Private Collection, New York

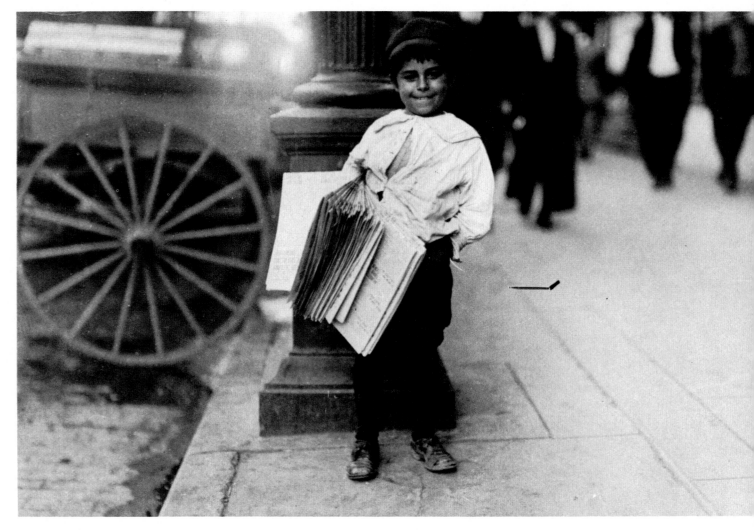

LEWIS W. HINE
Newsboy, Dallas, 1913
Courtesy Robert P. Mann

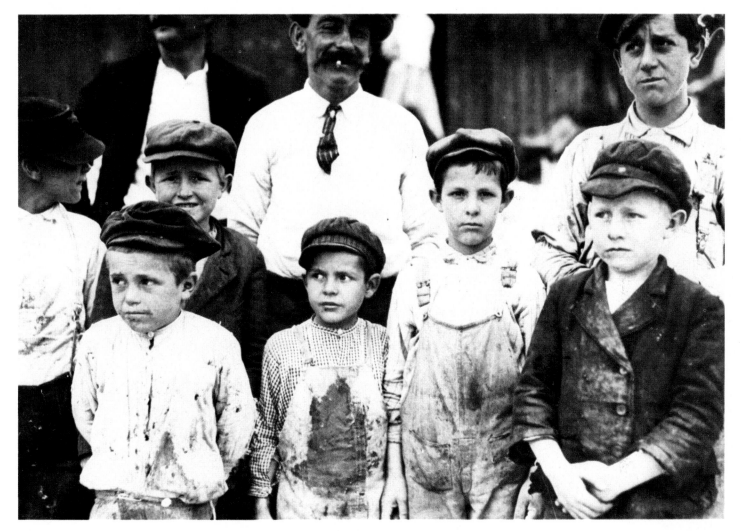

LEWIS W. HINE
Young Shrimp Pickers, Biloxi, 1911
Courtesy Robert P. Mann

RUDOLF EICKEMEYER, JR.
Among the Sand Dunes at Barnegat
(Advertisement for Eastman Kodak Company), 1921
Hudson River Museum, Yonkers, N.Y.

EDWARD STEICHEN
Advertisement for Eastman Kodak Company "Snapshots," 1933
The Museum of Modern Art, New York

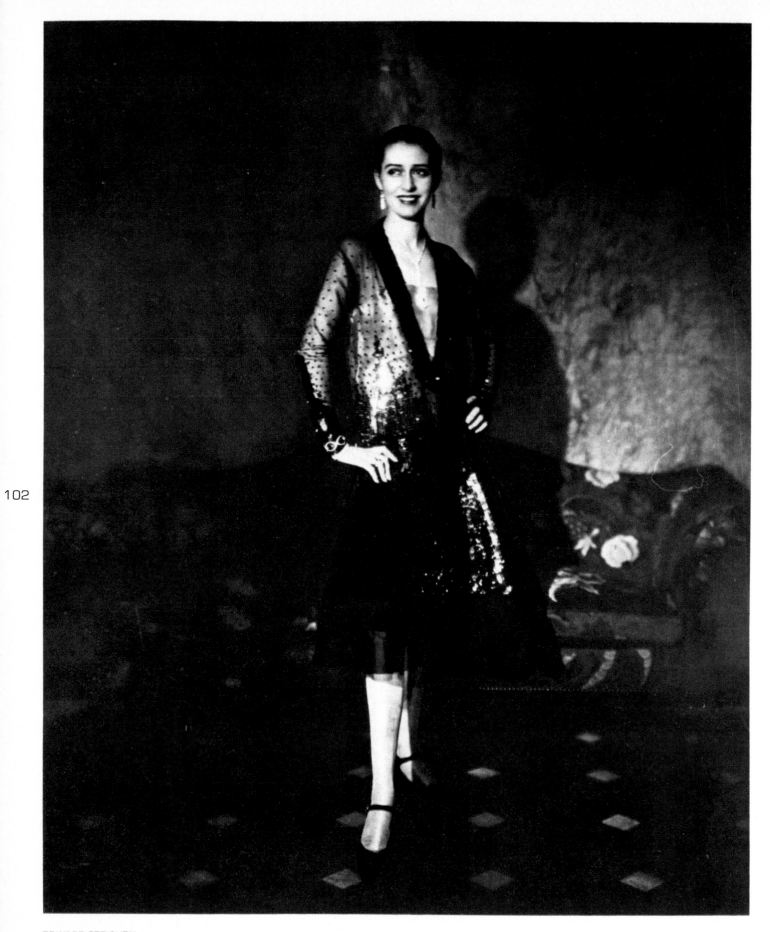

EDWARD STEICHEN
Cheruit Gown (Marion Moorehouse—Mrs. E. E. Cummings), New York, 1927
Private Collection, New York

EDWARD STEICHEN
Spectacles (Fabric Design for Stehli Silks), 1927
The Museum of Modern Art, New York

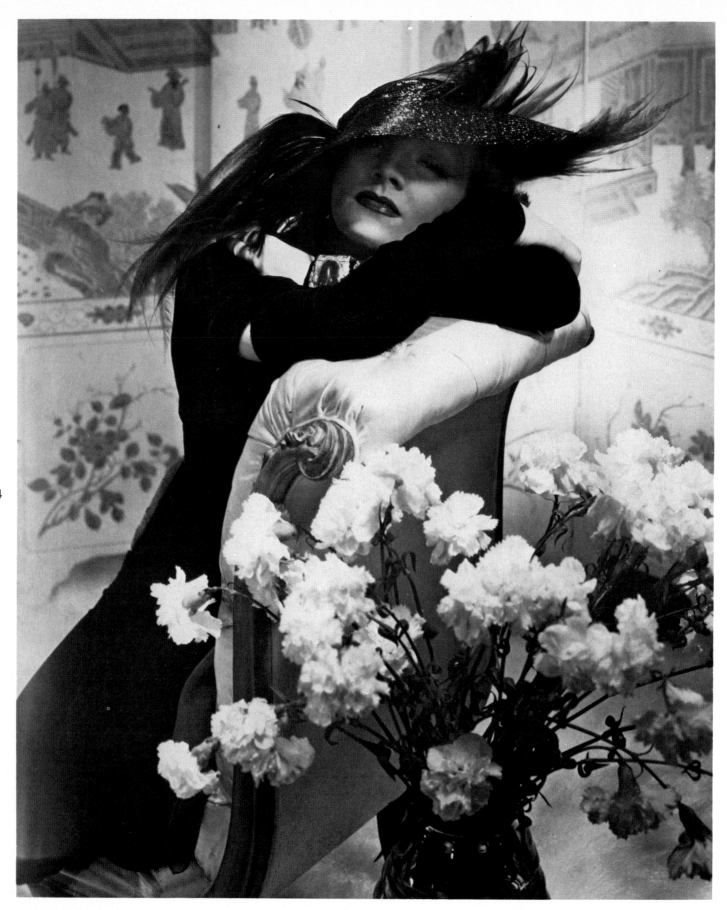

EDWARD STEICHEN
Marlene Dietrich, New York, 1932
The Museum of Modern Art, New York

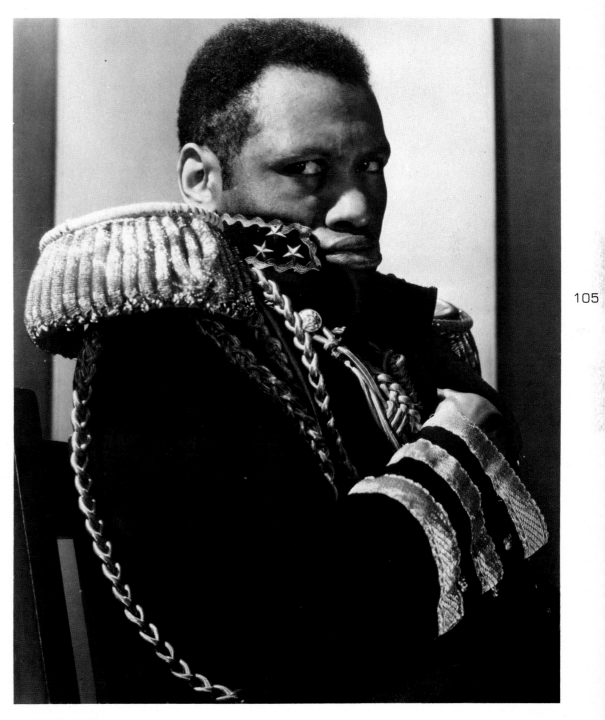

EDWARD STEICHEN
Paul Robeson as "The Emperor Jones," New York, 1933
The Museum of Modern Art, New York

EDWARD STEICHEN
Peeling Potatoes (Advertisement for Jergens Lotion), 1923
The Museum of Modern Art, New York

EDWARD STEICHEN
The Matriarch, for Federation of Jewish Philanthropies of New York, 1935
Courtesy Lunn Gallery/Graphics International, Ltd., Washington, D.C.

EDWARD STEICHEN
After the Taking of Iwo Jima Island, 1943
The Museum of Modern Art, New York

110

EDWARD STEICHEN
Pastoral—Moonlight, ca. 1907
Courtesy The Witkin Gallery, Inc., New York

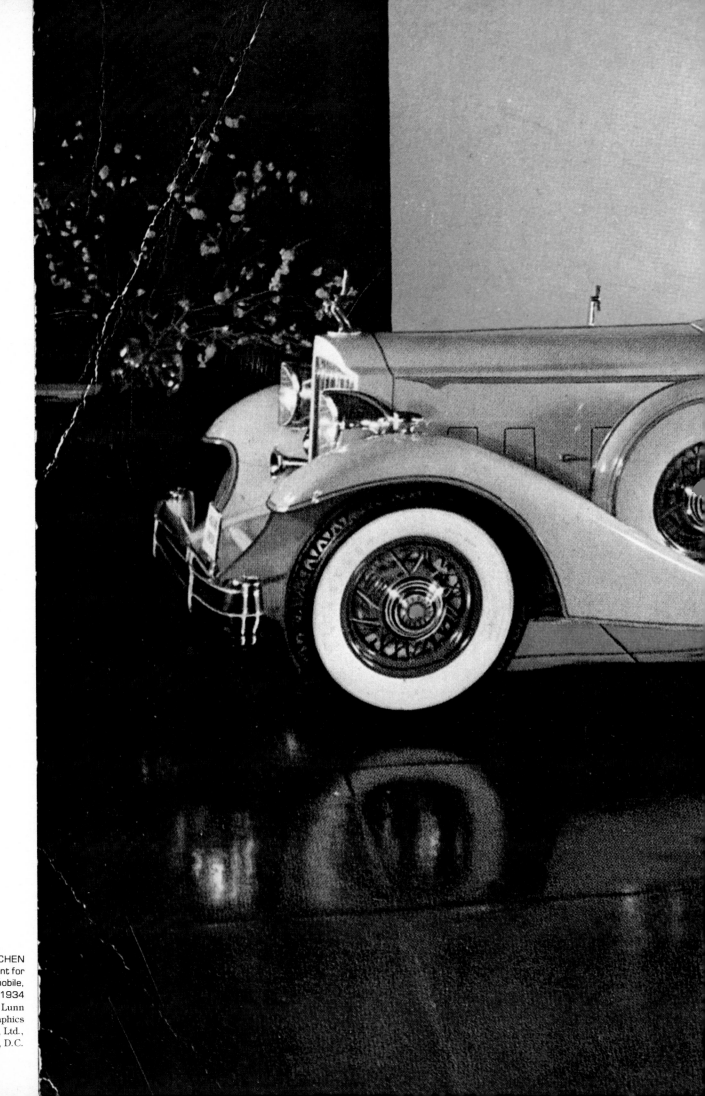

112

EDWARD STEICHEN
Advertisement for
Packard Automobile,
ca. 1934
Courtesy Lunn
Gallery/Graphics
International, Ltd.,
Washington, D.C.

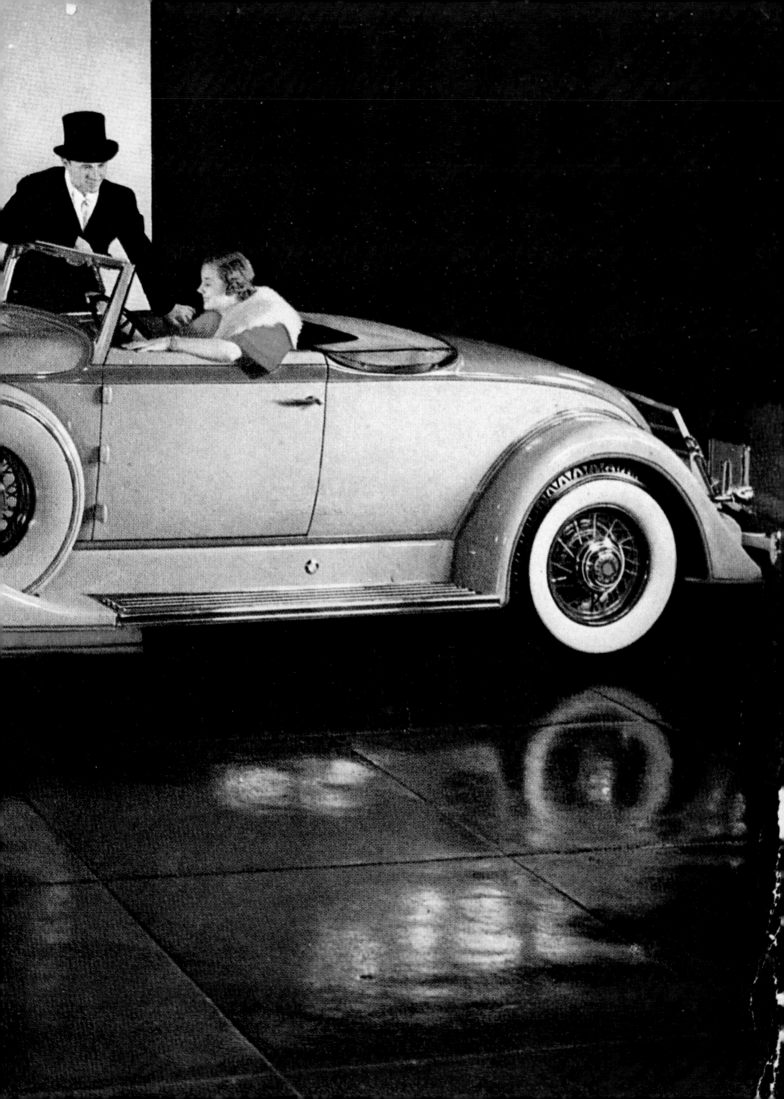

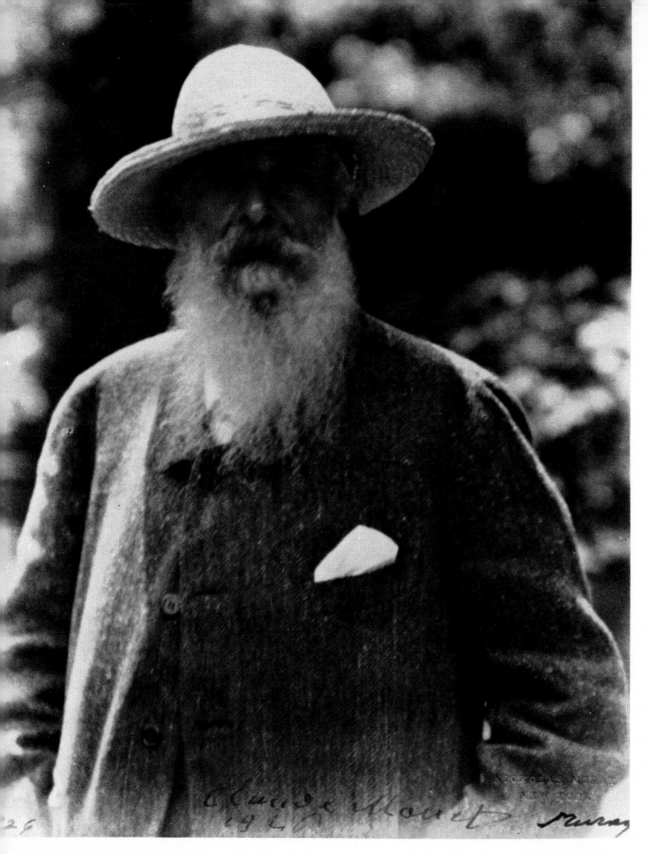

NICKOLAS MURAY
Claude Monet, 1926
International Museum of Photography at
George Eastman House, Rochester, N.Y.

NICKOLAS MURAY
Gloria De Haven, 1947
International Museum of Photography at
George Eastman House, Rochester, N.Y.

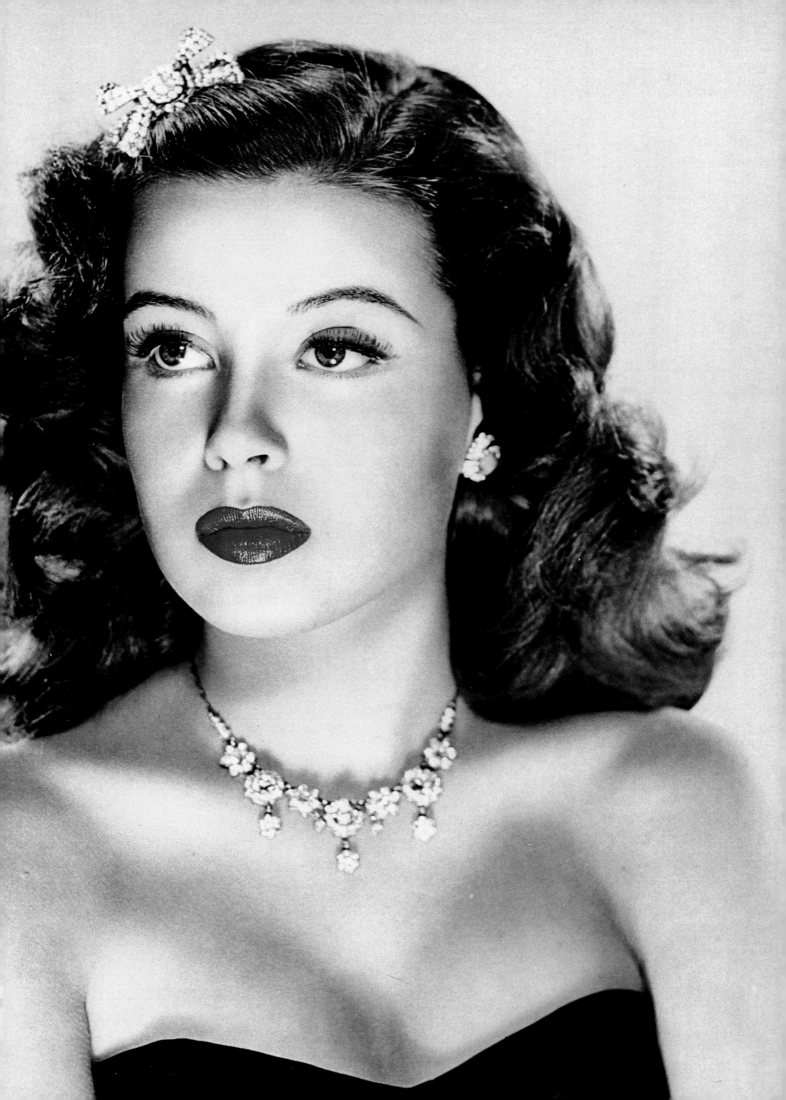

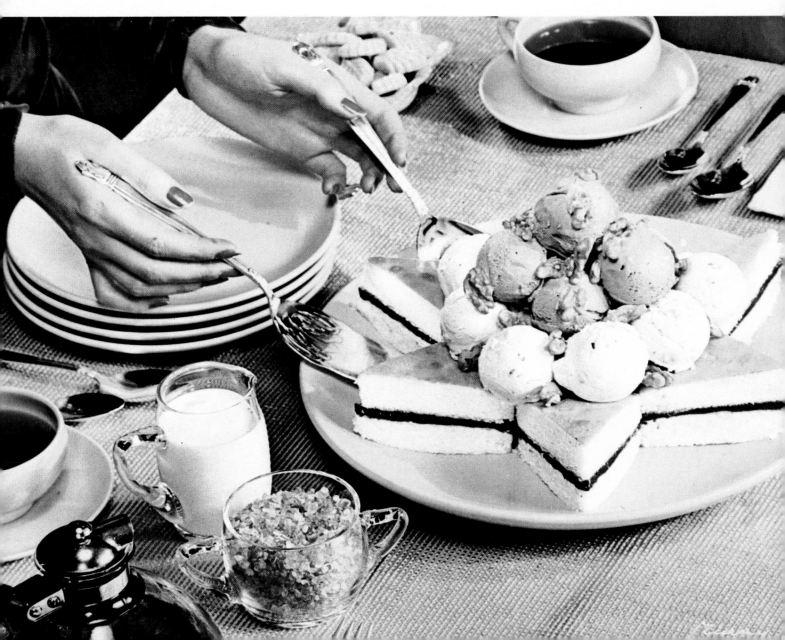

NICKOLAS MURAY
Still Life for Seabrook Farms
Small Creamed Onions Package, 1960's
International Museum of Photography at
George Eastman House, Rochester, N.Y.

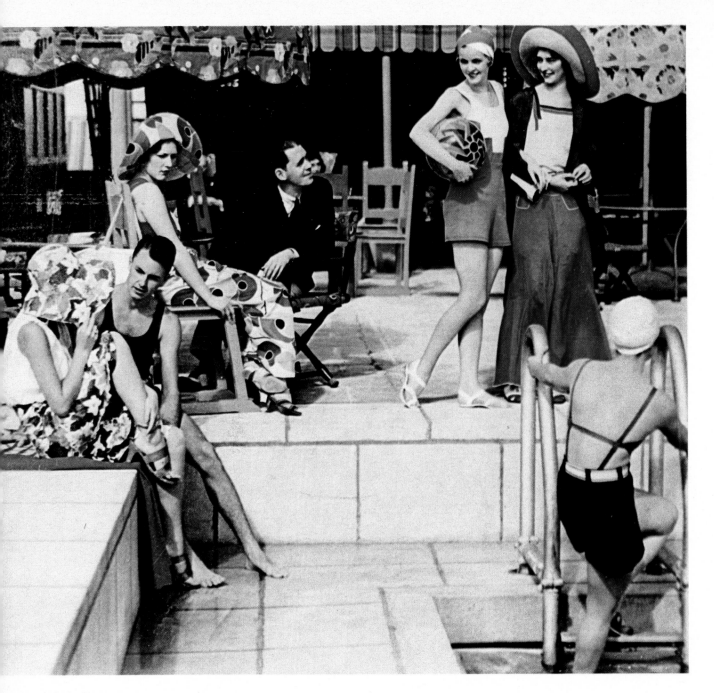

NICKOLAS MURAY
Bathing Pool Scene for *Ladies Home Journal,* 1931
International Museum of Photography at
George Eastman House, Rochester, N.Y.

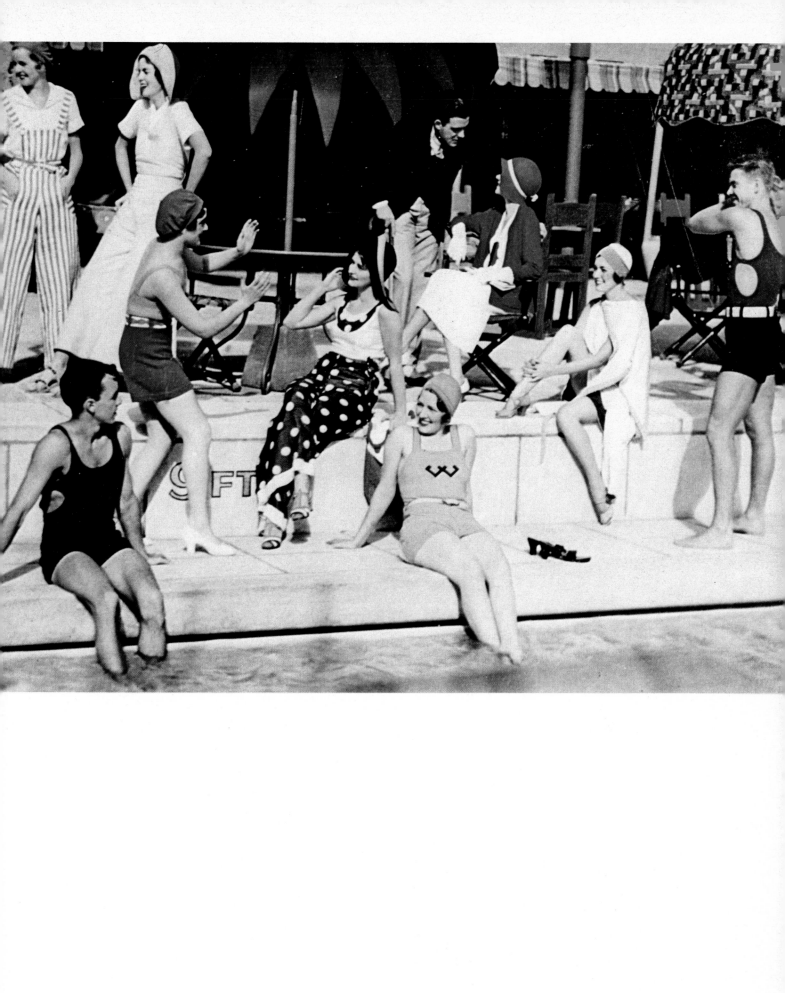

NICKOLAS MURAY
Loretta Young and Sisters, 1920's
International Museum of Photography at
George Eastman House, Rochester, N.Y.

NICKOLAS MURAY
Babe Ruth, ca. 1927
International Museum of Photography at
George Eastman House, Rochester, N.Y.

122

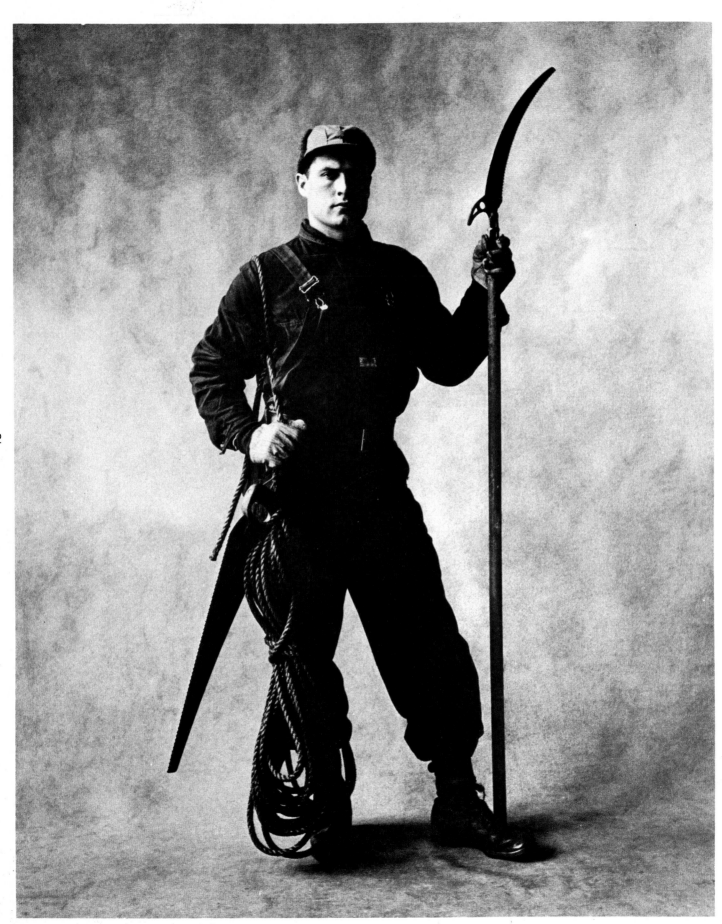

IRVING PENN
Tree Pruner, New York, 1951
Courtesy the Photographer, © 1951 by The Condé Nast Publications, Inc.

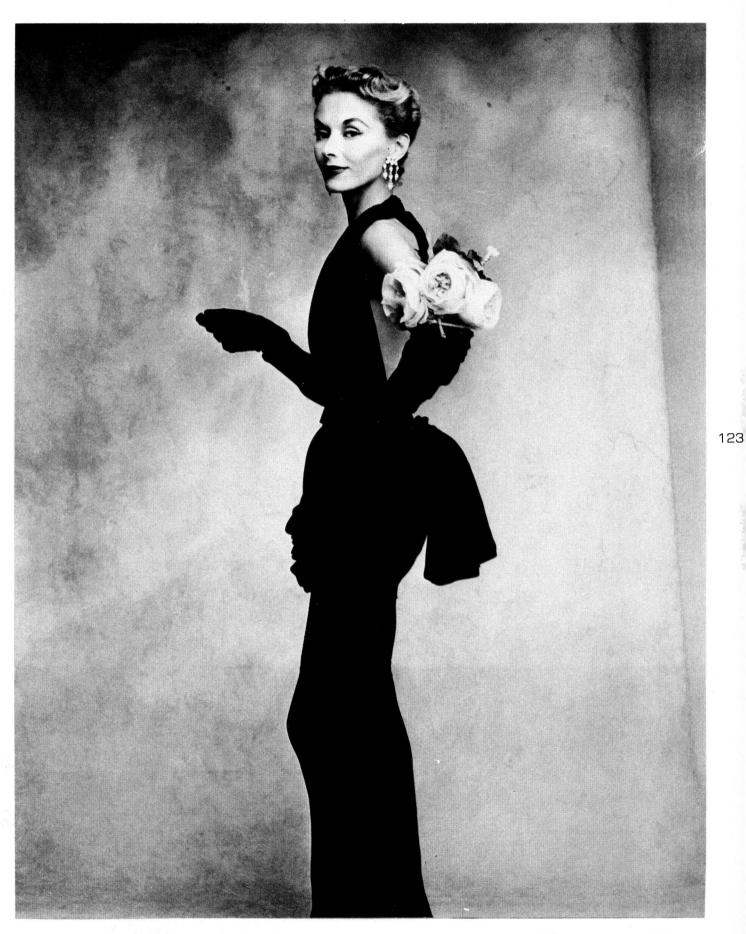

IRVING PENN
Lisa Fonssagrieves-Penn (Woman in Black Dress), 1947
Courtesy the Photographer, © 1947 by Les Editions Condé Nast S.A.

124

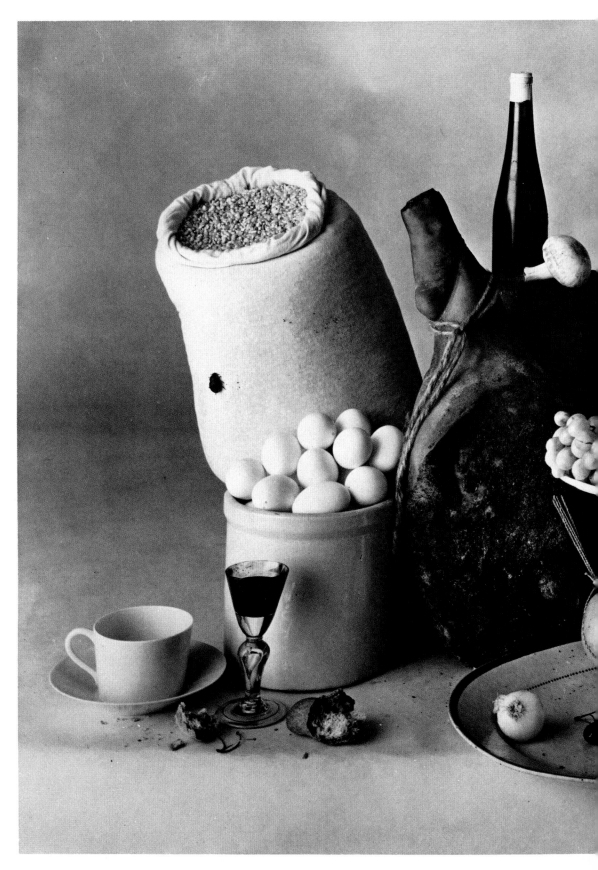

IRVING PENN
New York Still Life with Food, 1947
Courtesy, the Photographer, © 1947 by The Condé Nast Publications, Inc.

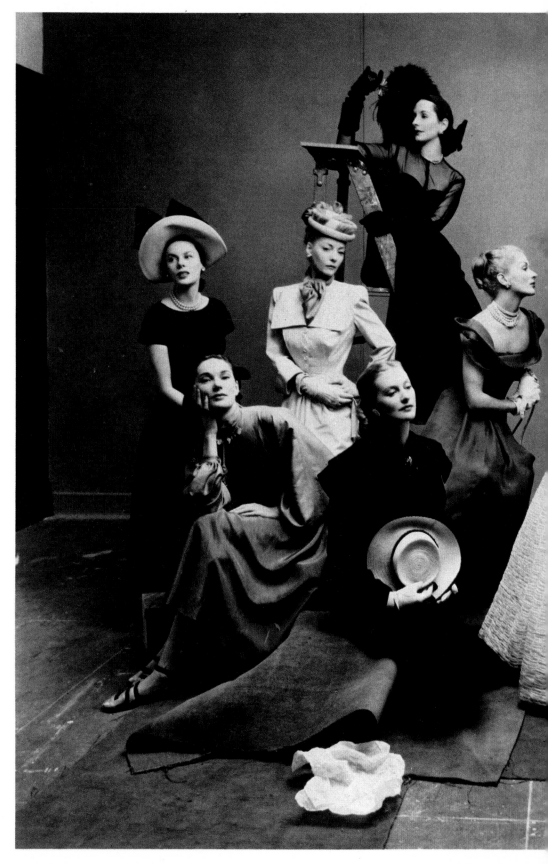

IRVING PENN
Twelve Most Photographed Models, 1947
Courtesy, the Photographer, © 1947 by The Condé Nast Publications Inc.

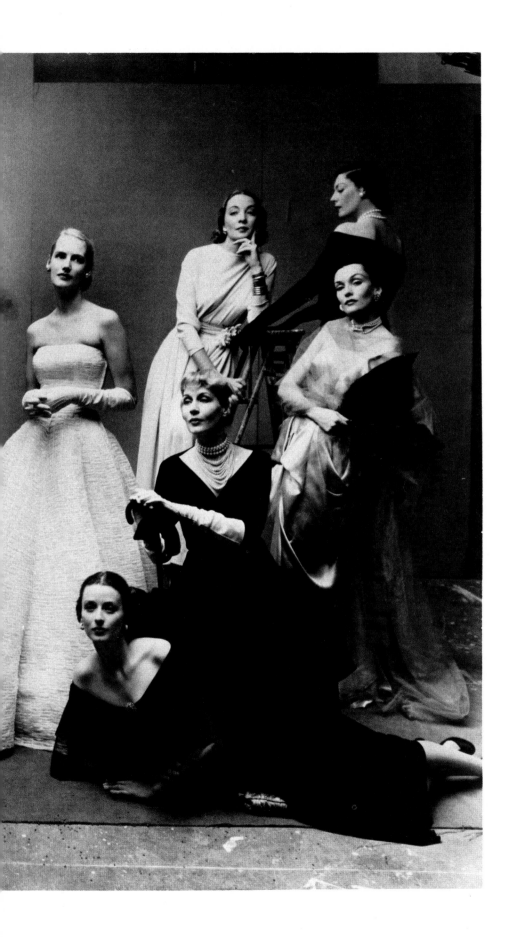

IRVING PENN
David Smith, 1964
Courtesy the Photographer, © 1965 by The Condé Nast Publications, Inc.

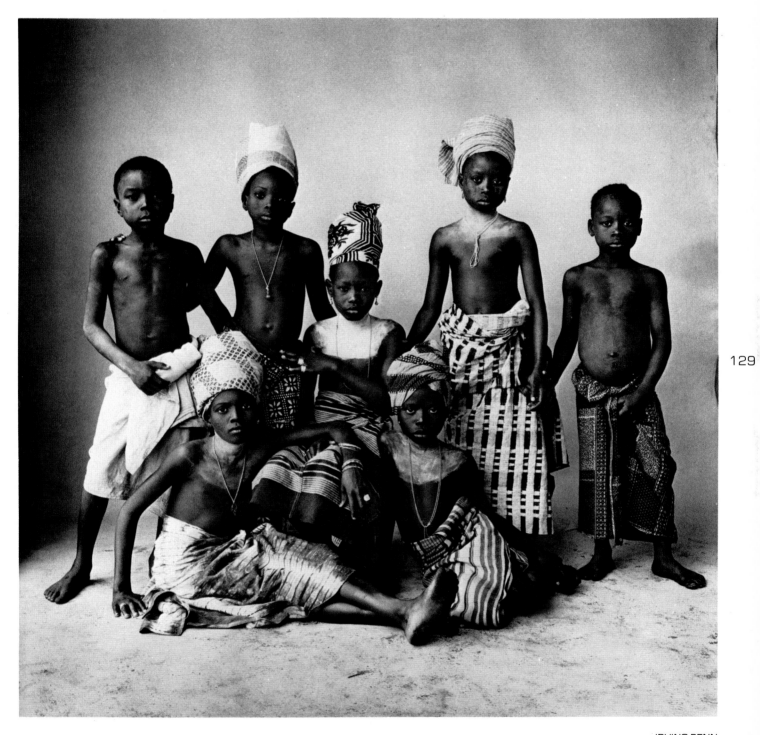

IRVING PENN
Dahomey Children, 1967
Courtesy the Photographer, © 1974 by Irving Penn

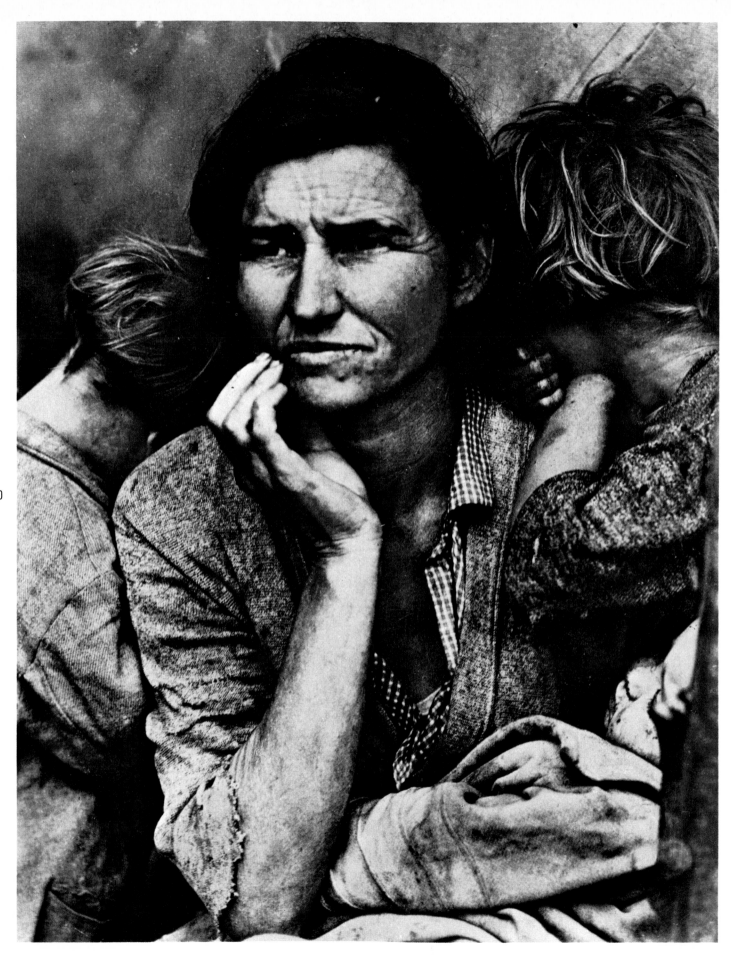

DOROTHEA LANGE
Migrant Mother, Nipomo, California, 1936
Collection of Lee D. Witkin

DOCUMENTARY AND PHOTOJOURNALISM

Among the outstanding achievements of the great
decades of magazine photography were the pictures made
by documentary and press photographers working for government
agencies and big picture magazines. Though their medium was
modern these and other commercial photographers expressed
in their work such traditional themes of
art as the beauty and heroism of exceptional men and
women, the delights and follies of ordinary
life, the horrors of war, and the inevitability of death.

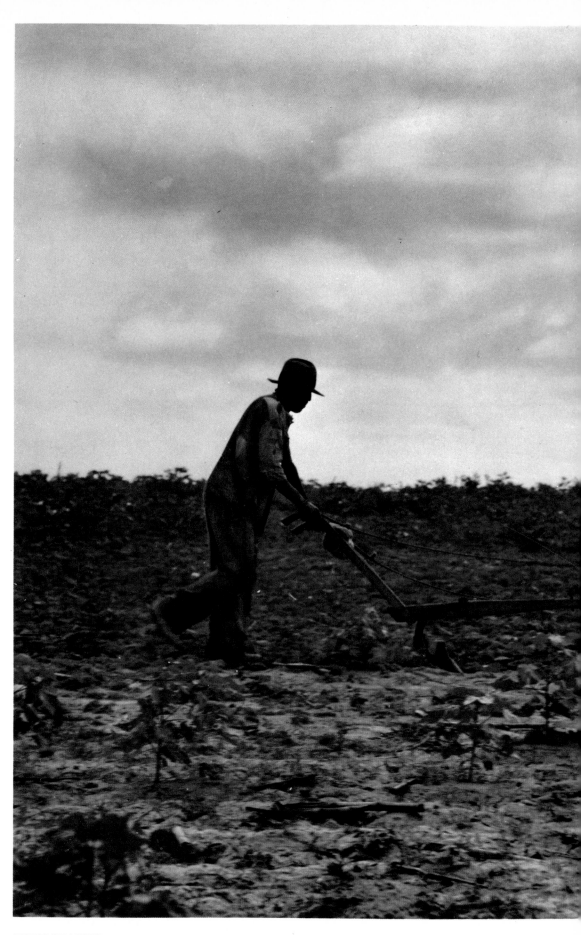

DOROTHEA LANGE
Sharecropper and Mule, Green County, Georgia, 1937
The Library of Congress, Washington, D.C.

134

BEN SHAHN
At a Fourth of July Celebration, Ashville, Ohio, 1938
The Library of Congress, Washington, D.C.

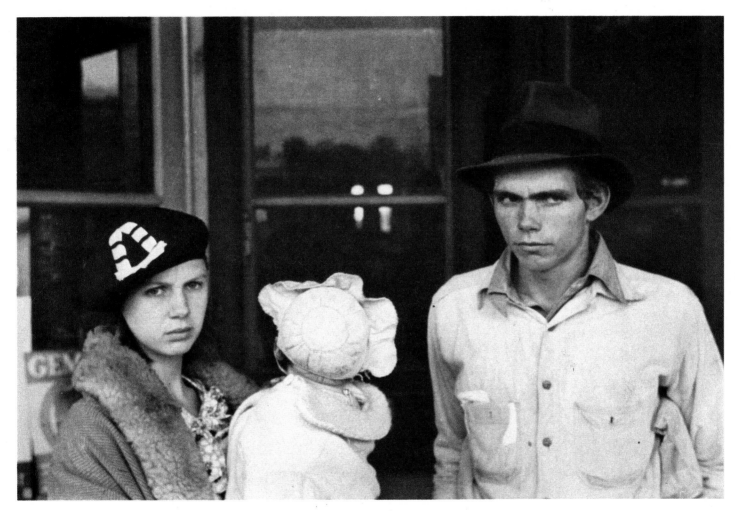

BEN SHAHN
A Young Family, Smithland, Kentucky, 1935
The Library of Congress, Washington, D.C.

136

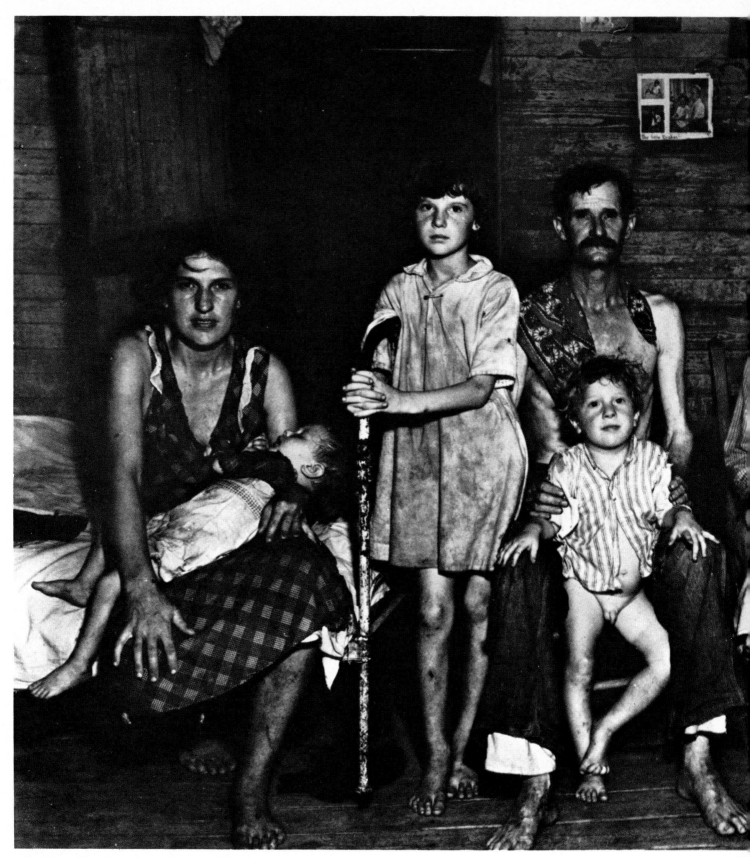

WALKER EVANS
Sharecropper and Family, Alabama, 1936
Private Collection, New York

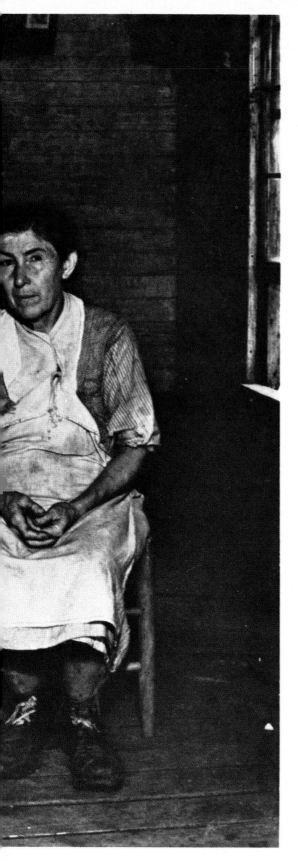

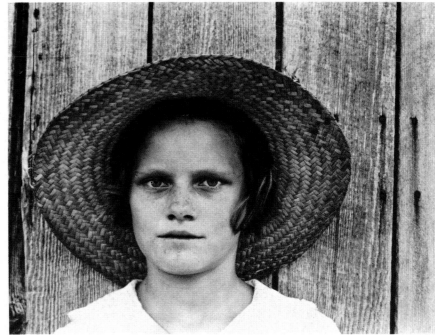

WALKER EVANS
Sharecropper's Daughter, Hale County, Alabama, 1936
The Library of Congress, Washington, D.C.

138

WALKER EVANS
Detail of Tabby Wall, St. Mary's, Georgia, 1936
The Library of Congress, Washington, D.C.

WALKER EVANS
Circus Poster Detail, Alabama, 1936
The Library of Congress, Washington, D.C.

WALKER EVANS
Sharecropper's Kitchen, Hale County, Alabama, 1936
The Library of Congress, Washington, D.C.

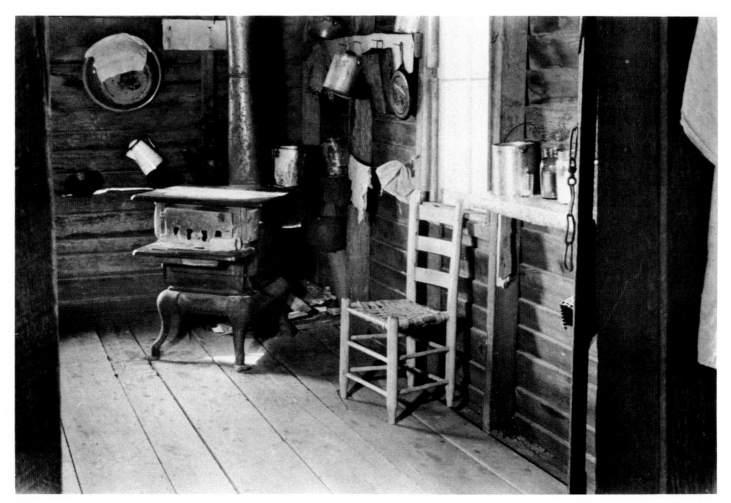

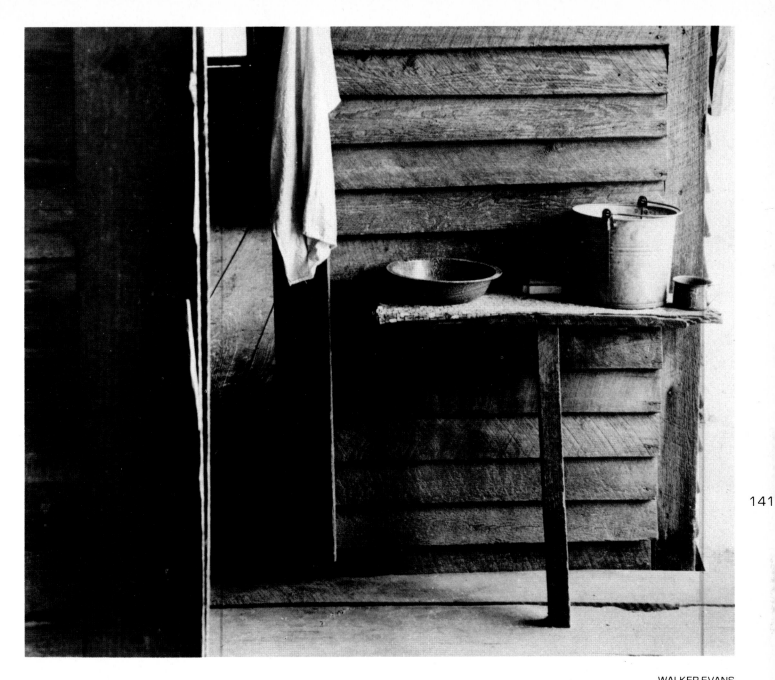

WALKER EVANS
Sharecropper's Wash Room, Hale County, Alabama, 1936
Private Collection, New York

142

JACK DELANO
Aroostook Potatoes, Caribou, Maine, 1940
The Library of Congress, Washington, D.C.

JACK DELANO
Thanksgiving Day, Ledyard, Connecticut, 1940
The Library of Congress, Washington, D.C.

144

JACK DELANO
Tenant Farmer and Wife, Greene County, Georgia, 1941
The Library of Congress, Washington, D.C.

146 JOHN VACHON
Watching the Armistice Day Parade, Omaha, Nebraska, 1938
The Library of Congress, Washington, D.C.

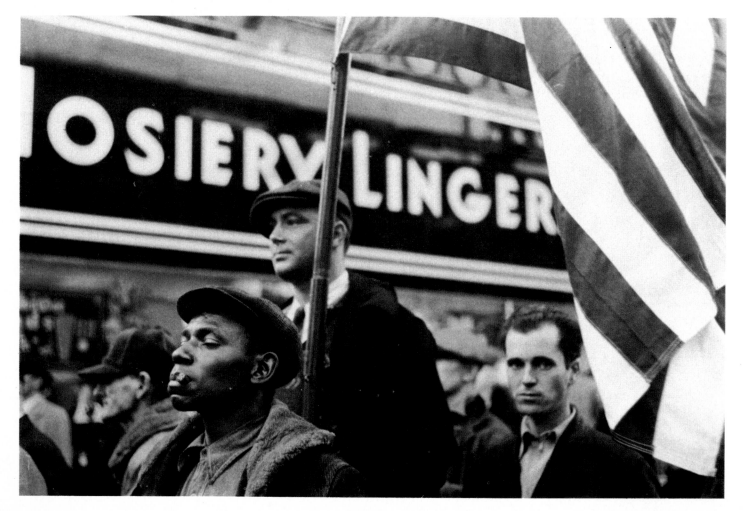

JOHN VACHON
Church, Aberdeen, South Dakota, 1940
The Library of Congress, Washington, D.C.

149

JOHN VACHON
Bedroom, Norfolk, Virginia, 1941
The Library of Congress,
Washington, D.C.

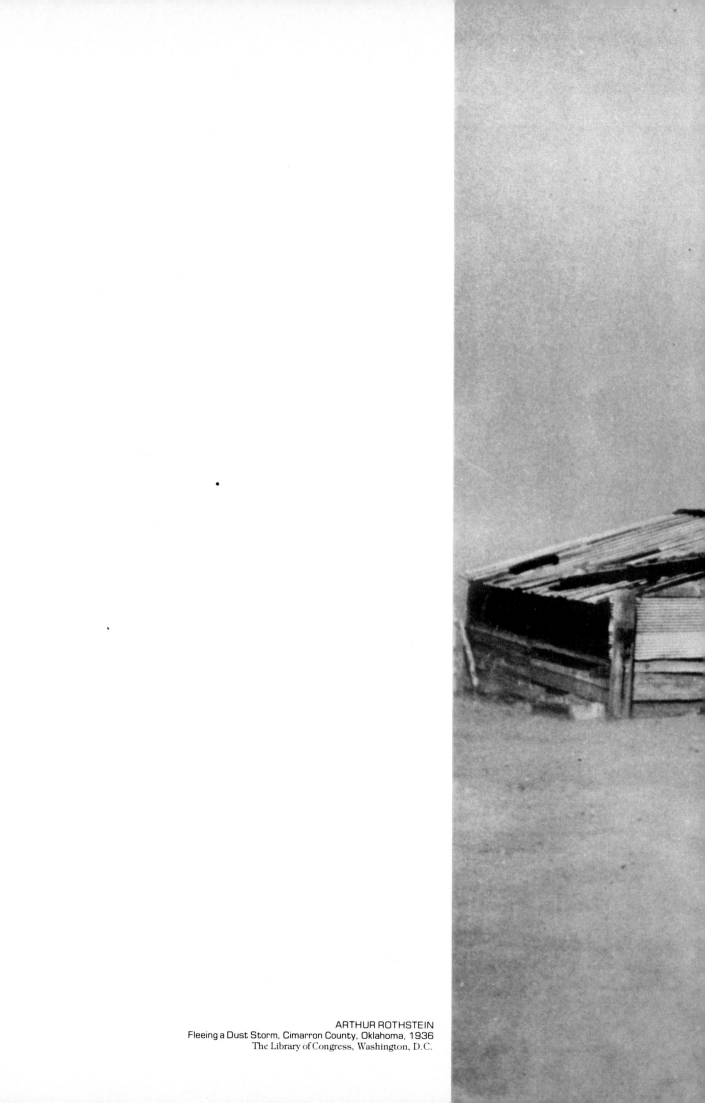

150

ARTHUR ROTHSTEIN
Fleeing a Dust Storm, Cimarron County, Oklahoma, 1936
The Library of Congress, Washington, D.C.

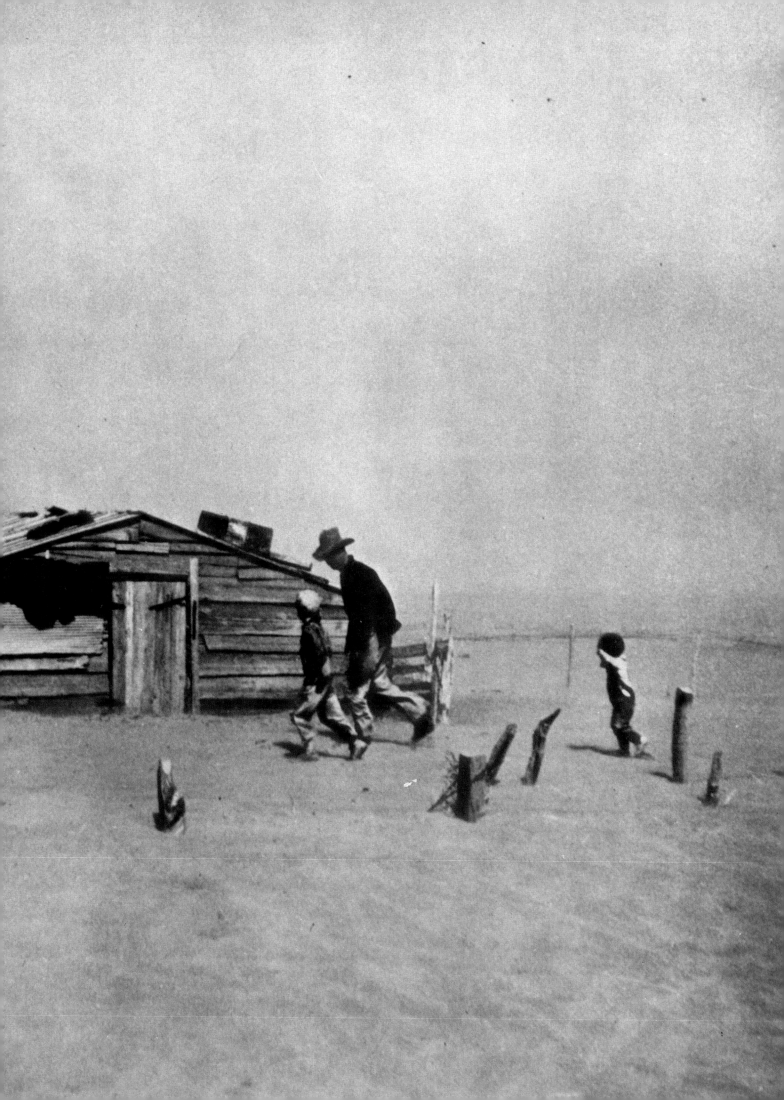

152

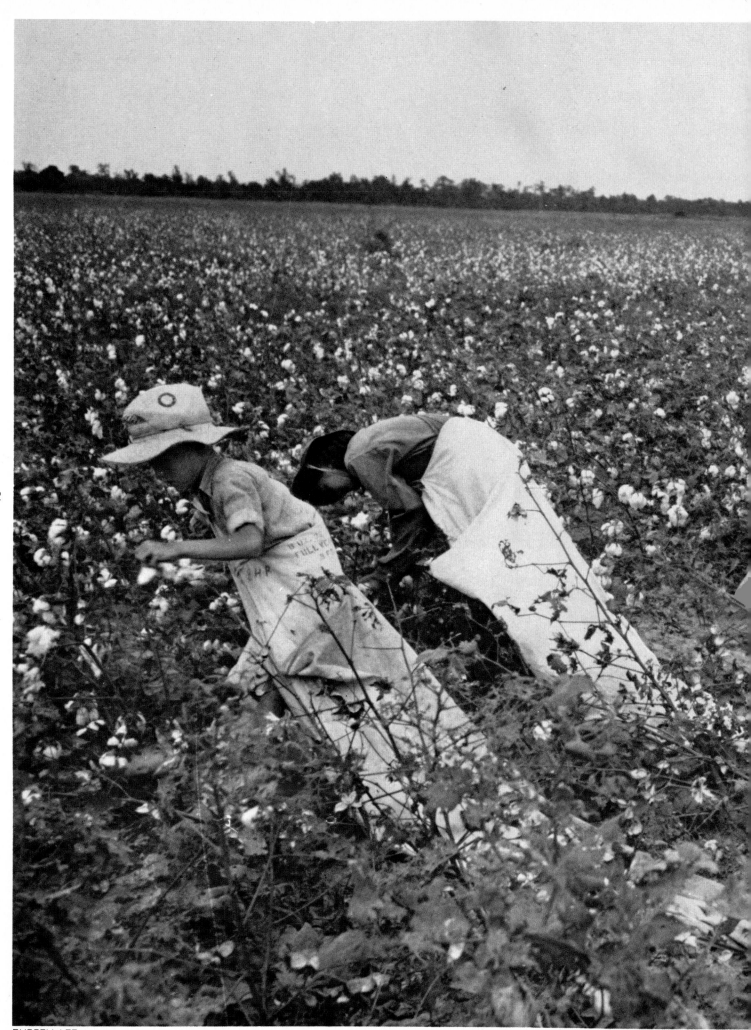

RUSSELL LEE
Picking Cotton, Lake Dick Crop Association, 1938
The Library of Congress, Washington, D.C.

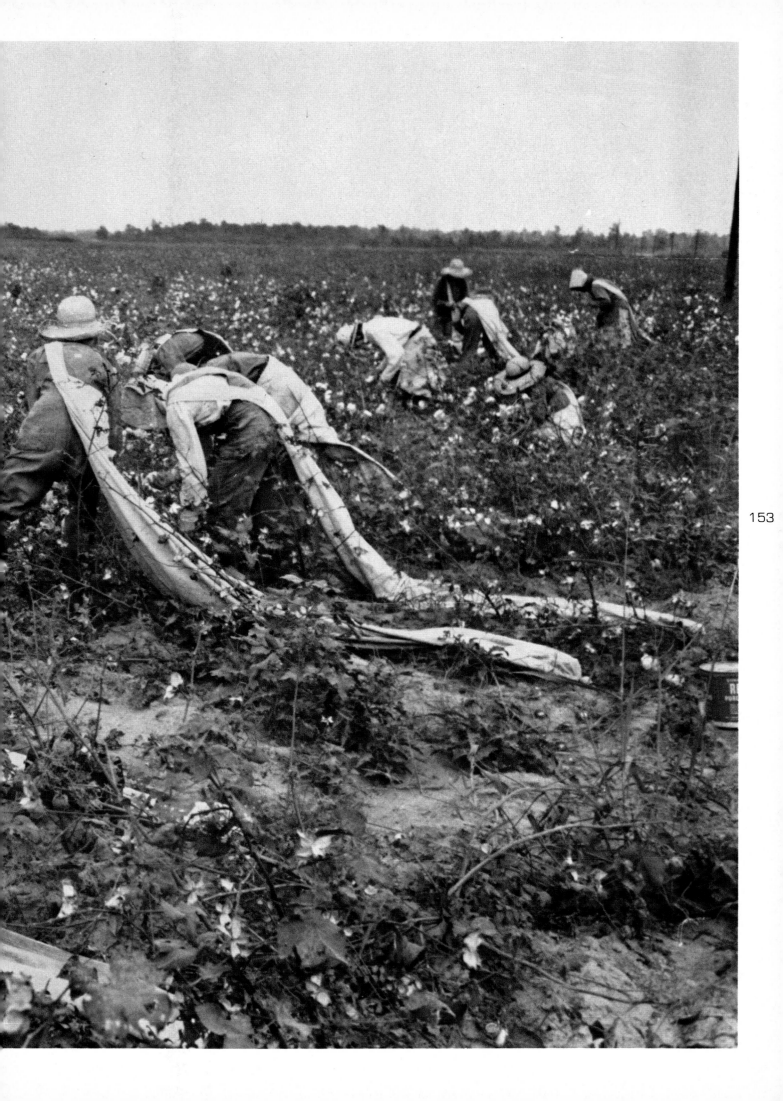

153

154

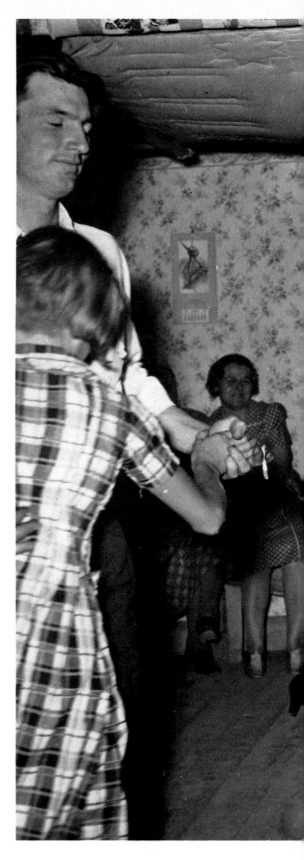

RUSSELL LEE
Dance, Pie Town, New Mexico, 1940
The Library of Congress, Washington, D.C.

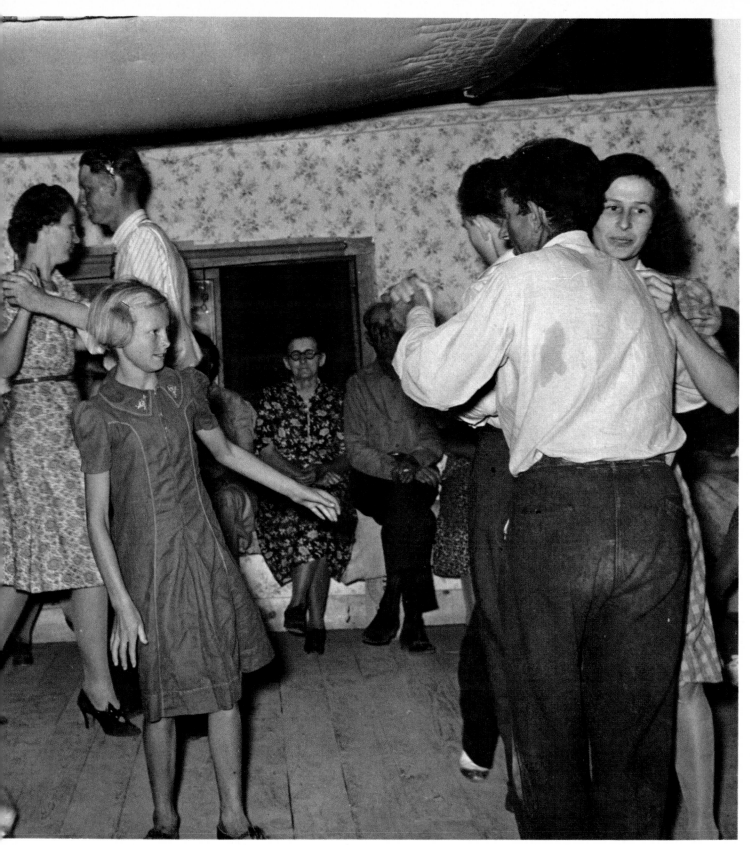

BERENICE ABBOTT
Blossom Restaurant, New York, 1930's
Courtesy Lunn Gallery/Graphics
International, Ltd., Washington, D.C.

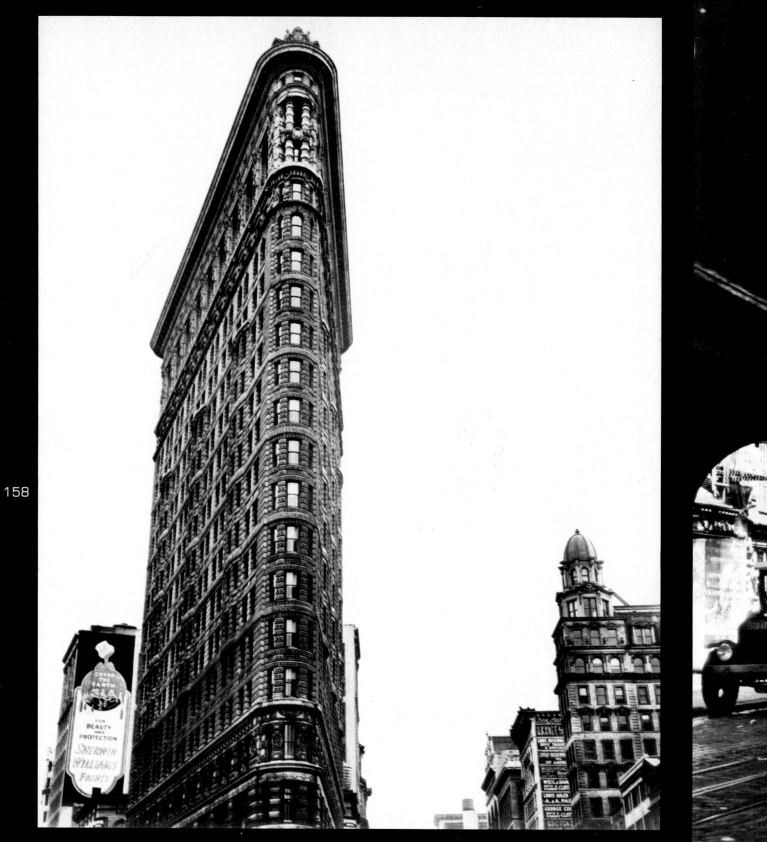

158

BERENICE ABBOTT
Flatiron Building, New York, 1930's
Courtesy Lunn Gallery/Graphics International, Ltd.,
Washington, D.C.

BERENICE ABBOTT
"El," Second and Third Avenue Lines, New York, 1930's
Courtesy Lunn Gallery/Graphics International, Ltd.
Washington, D.C.

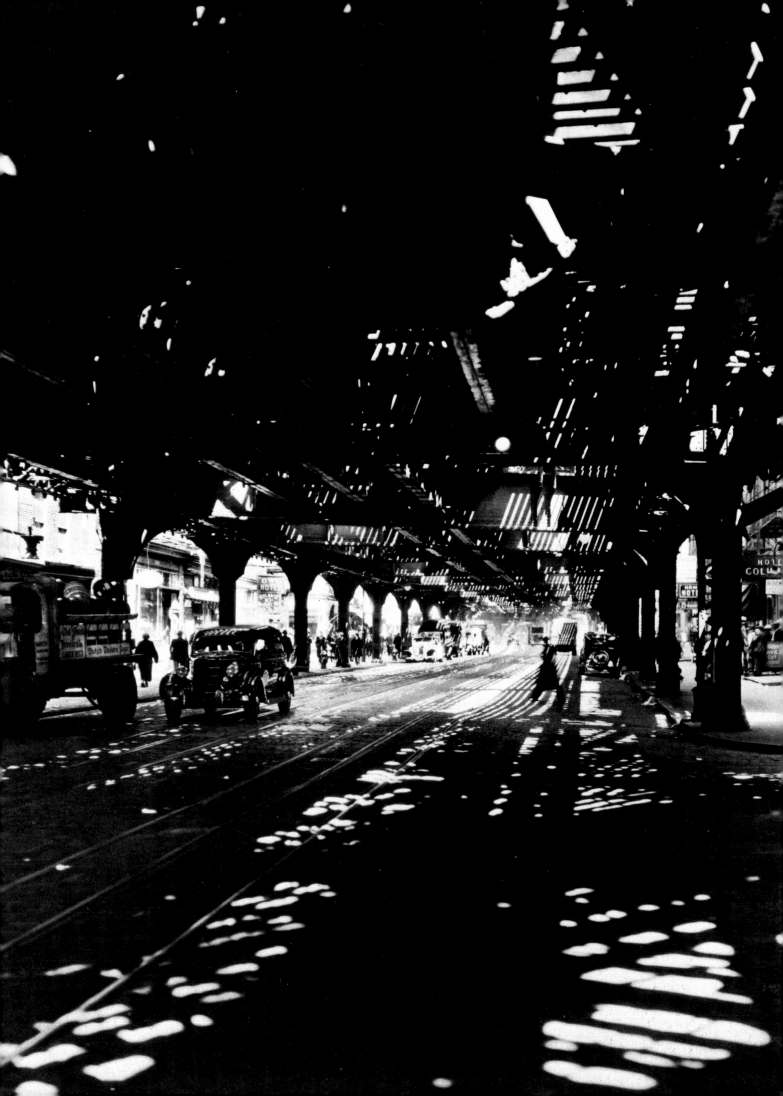

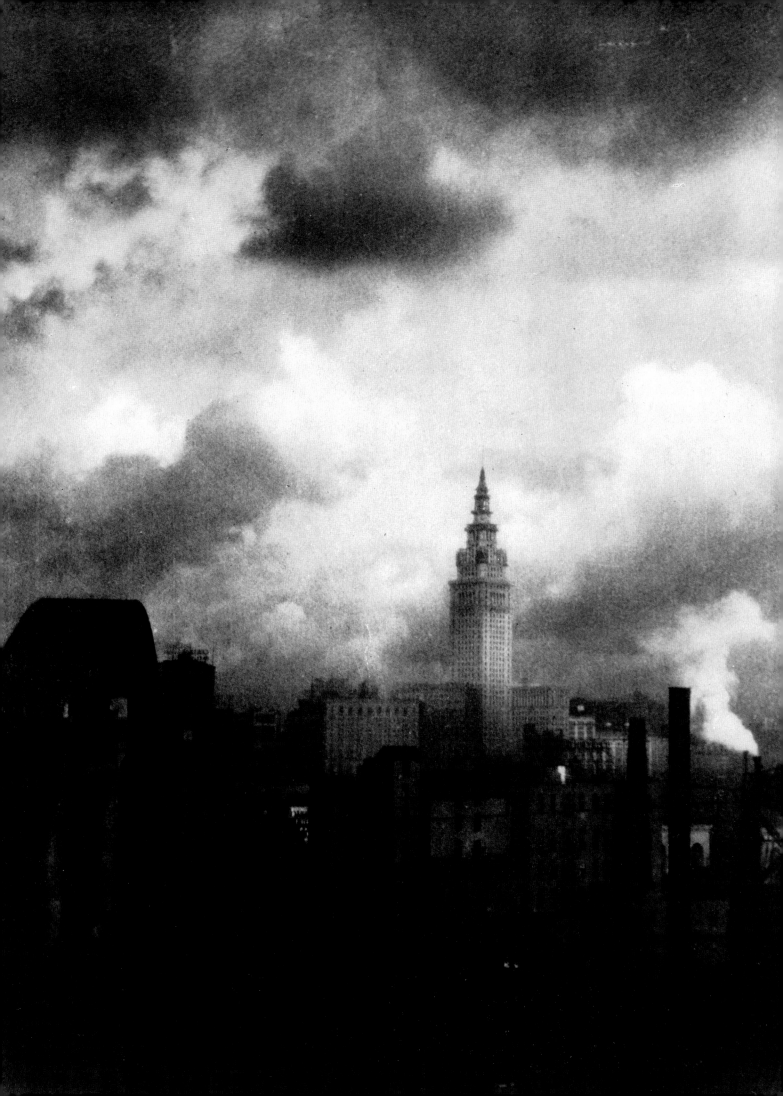

MARGARET BOURKE-WHITE
Cables, ca. 1930
Collection of Lee D. Witkin

MARGARET BOURKE-WHITE
Terminal Tower, Cleveland, 1928
Collection of Lee D. Witkin

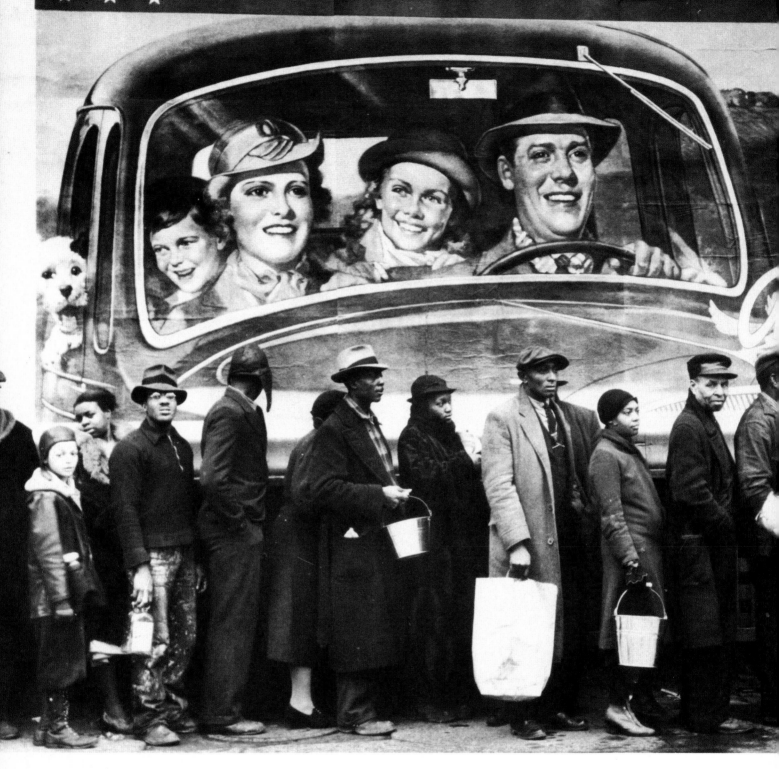

MARGARET BOURKE-WHITE
At the Time of the Louisville Flood, 1937
Collection of Lee D. Witkin

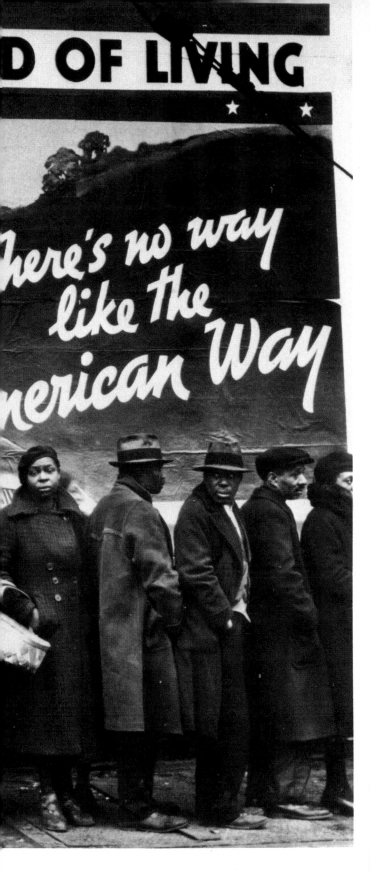

MARGARET BOURKE-WHITE
Potato Eaters, Magnetnaya, Russia, 1931
Syracuse University, Syracuse, N.Y.

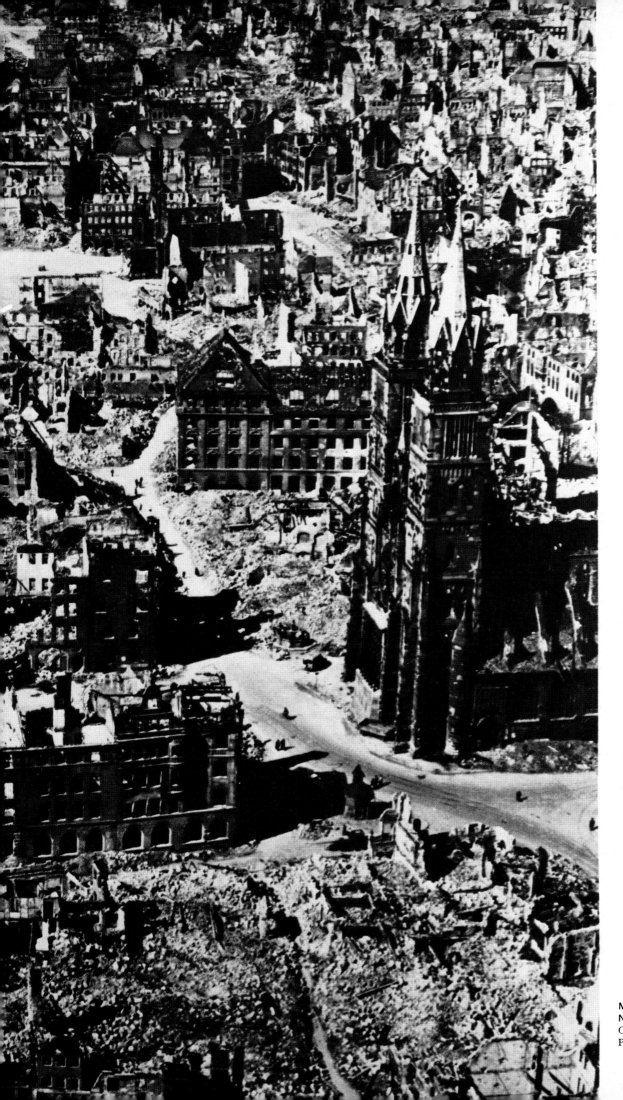

165

MARGARET BOURKE-WHITE
Nuremberg, 1945
Courtesy Time-Life
Picture Agency, © Time Inc.

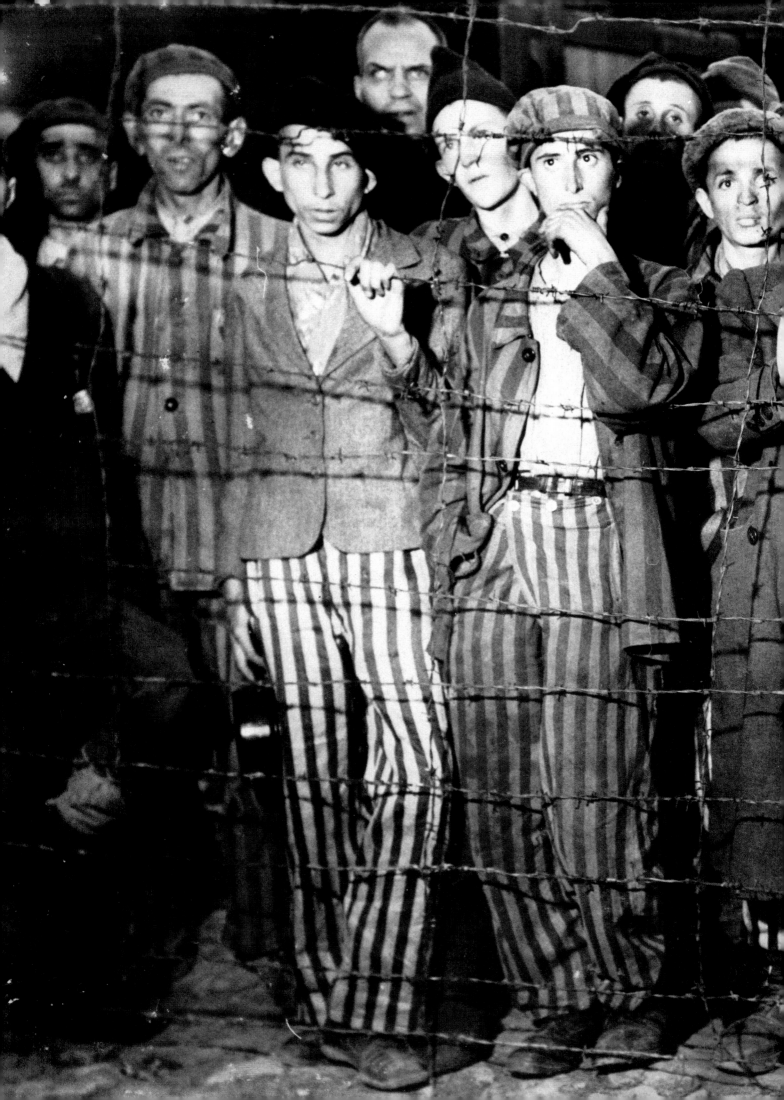

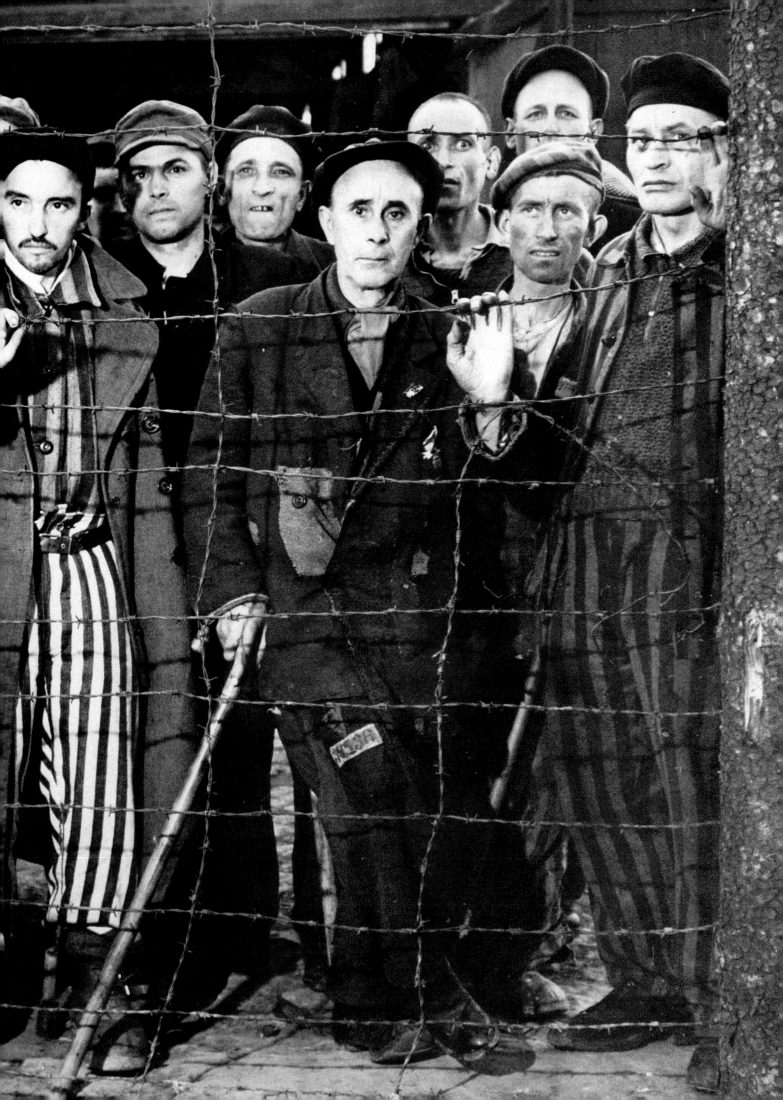

MARGARET BOURKE-WHITE
The Spinner, India, 1946
Courtesy Time-Life Picture Agency, © Time Inc.

(for pages 166-167)

MARGARET BOURKE-WHITE
The Living Dead of Buchenwald, April, 1945
Courtesy Time-Life Picture Agency, © Time Inc.

MARGARET BOURKE-WHITE
South African Miners, 1950
Courtesy Time-Life Picture Agency, © Time Inc.

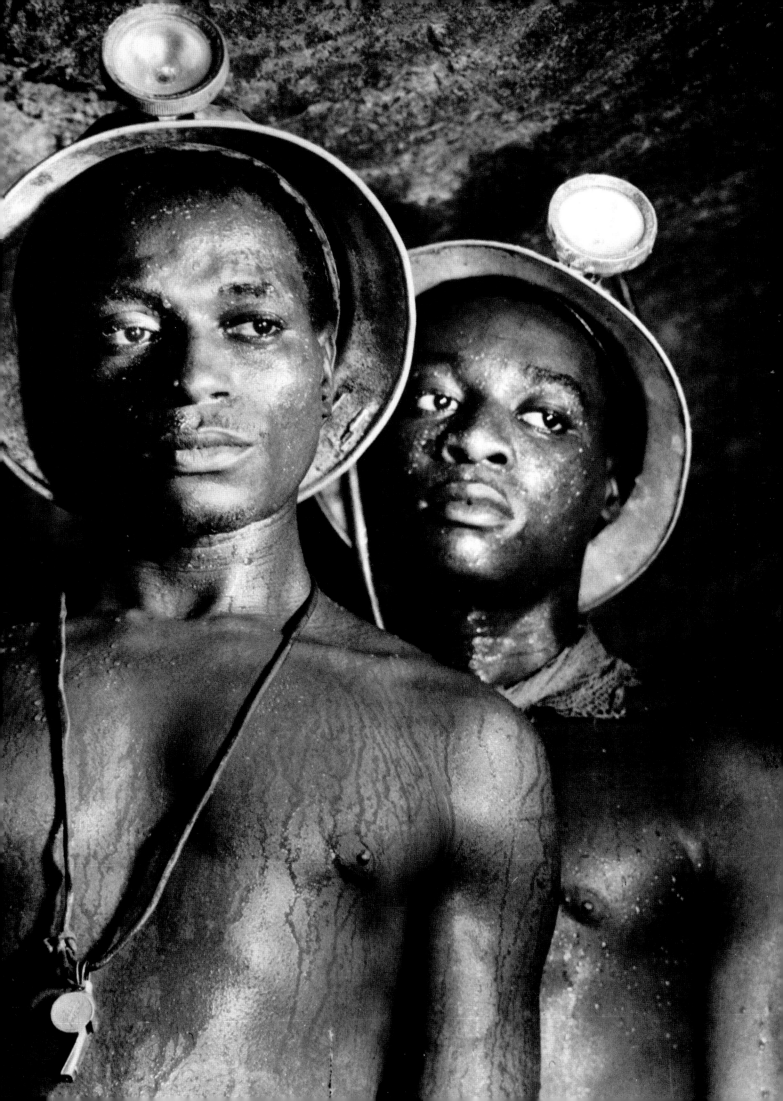

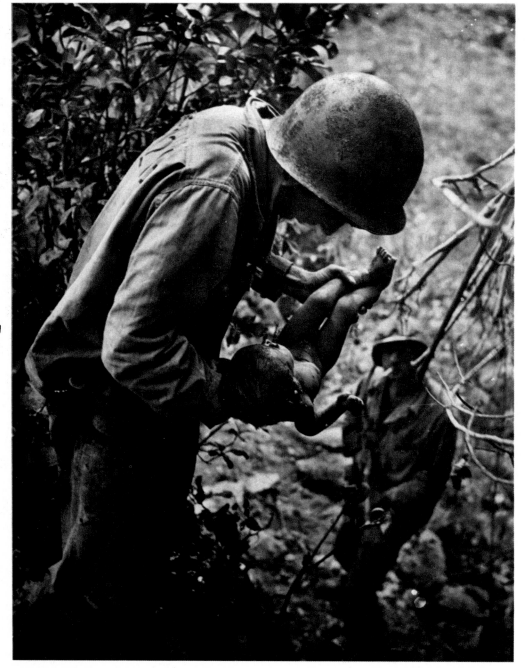

W. EUGENE SMITH
Saipan, 1944
Courtesy the Photographer

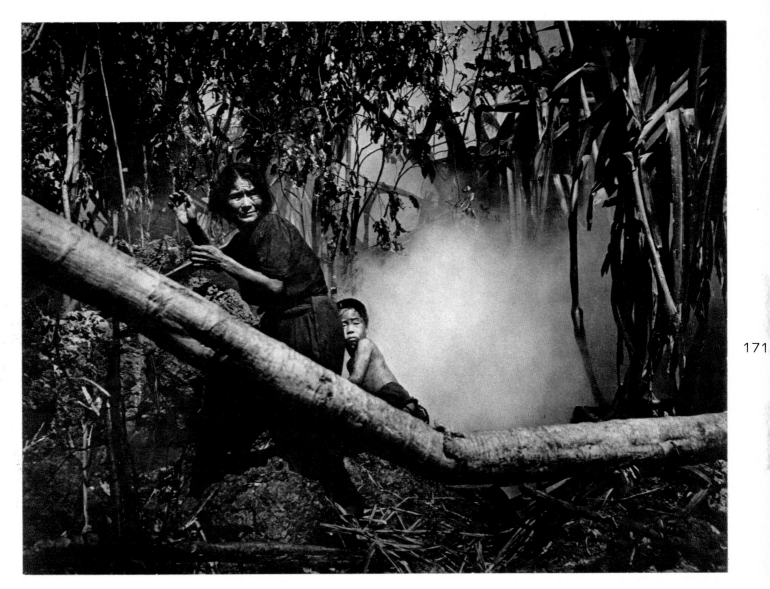

171

W. EUGENE SMITH
Saipan, 1944
Courtesy the Photographer

172

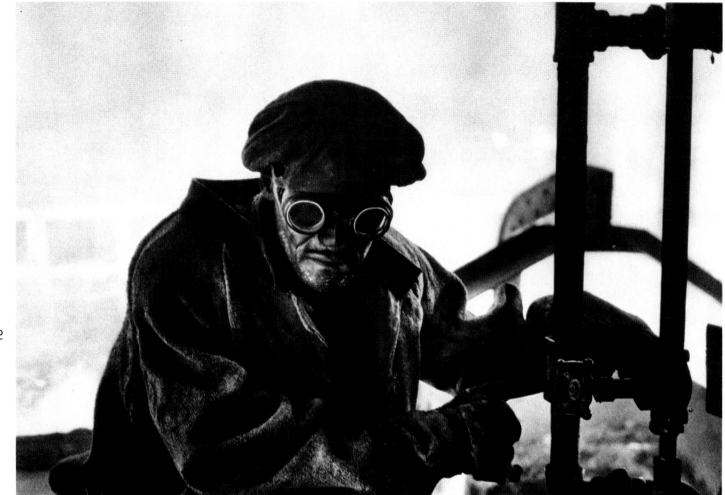

W. EUGENE SMITH
From "Pittsburgh, A Labyrinthian Walk," 1955
Collection of Lee D. Witkin

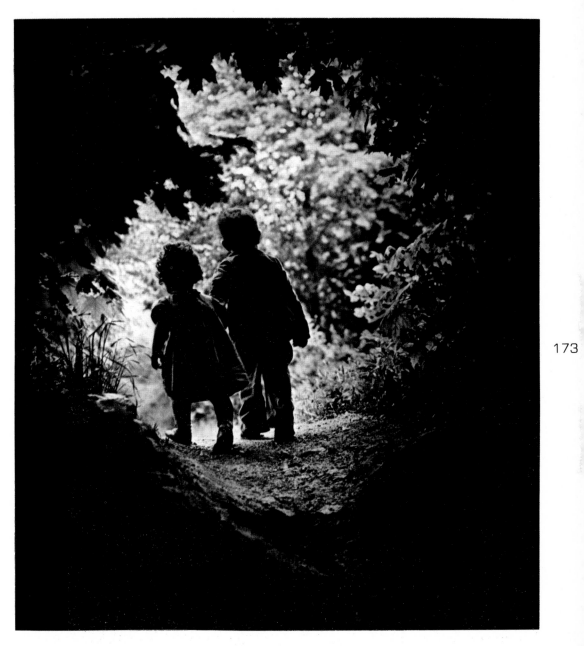

W. EUGENE SMITH
The Walk to Paradise Garden, 1946
Collection of Lee D. Witkin

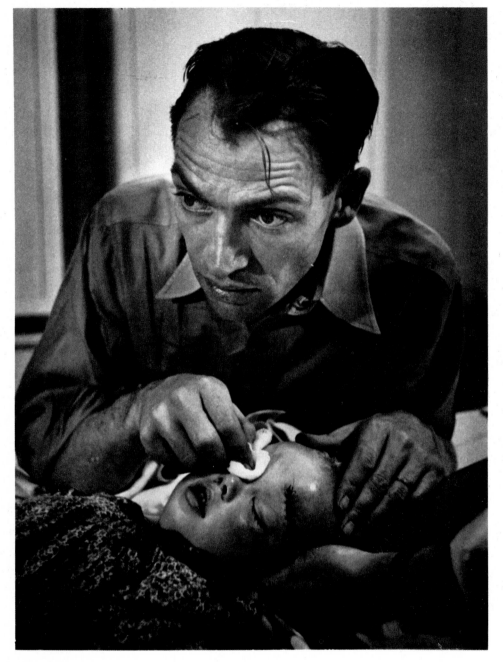

W. EUGENE SMITH
From "Country Doctor," 1948
Collection of Lee D. Witkin

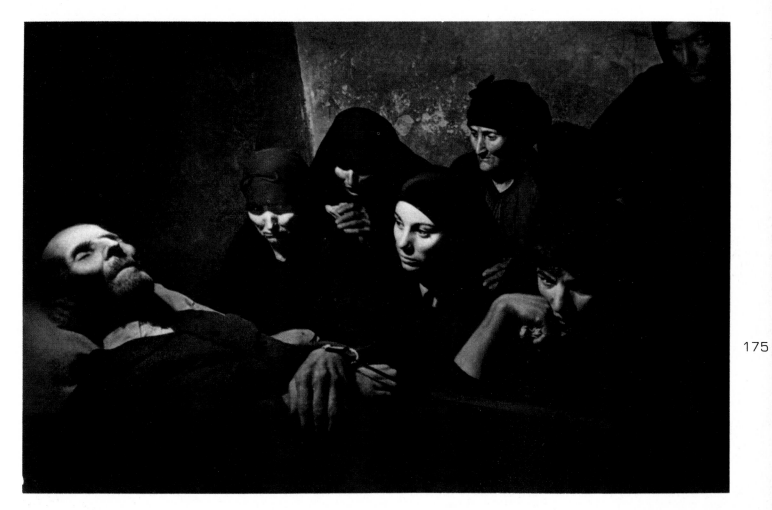

175

W. EUGENE SMITH
From "Spanish Village," 1951
The Dan Berley Collection

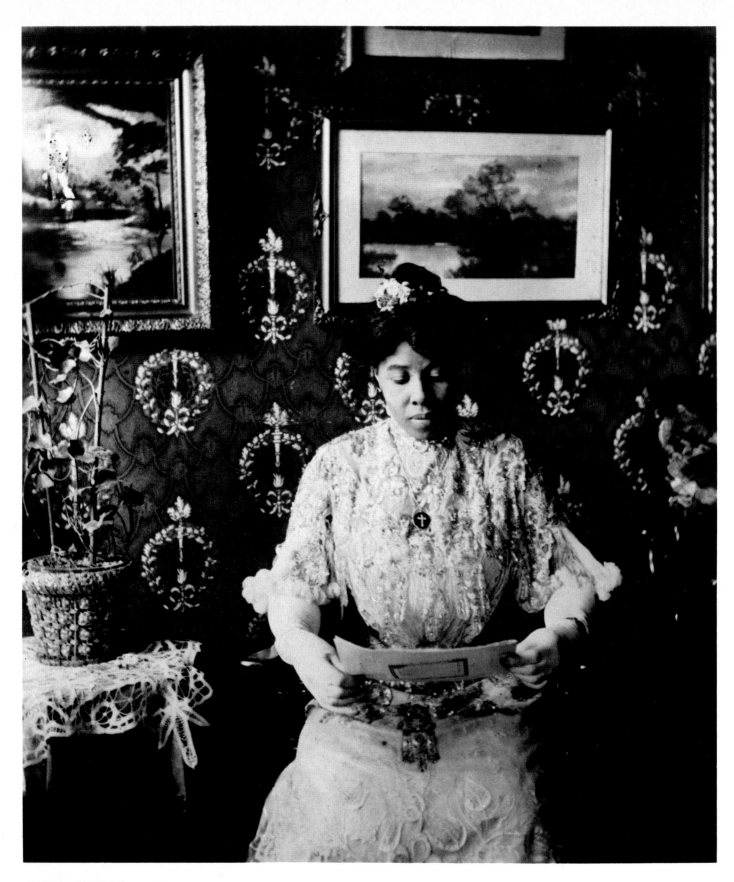

176

JAMES VAN DER ZEE
Miss Susie Porter, Harlem, 1915
Courtesy The James Van Der Zee Institute, New York

JAMES VAN DER ZEE
Blacksmith, Virginia, ca. 1905
Courtesy The James Van Der Zee Institute, New York

JAMES VAN DER ZEE
Whittier Preparatory School, Phoebus, Virginia, 1907
Courtesy The James Van Der Zee Institute, New York

JAMES VAN DER ZEE
Garveyite Family, Harlem, 1924
Courtesy The James Van Der Zee Institute, New York

180

JAMES VAN DER ZEE
Couple, Harlem, 1932
Courtesy The James Van Der Zee Institute, New York

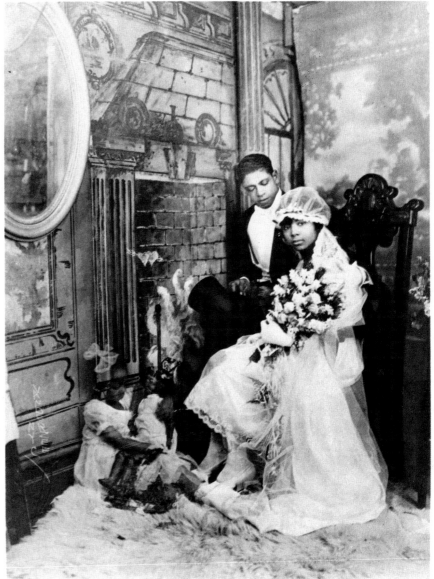

181

JAMES VAN DER ZEE
Wedding Day, Harlem, 1925
Courtesy The James Van Der Zee Institute, New York

182

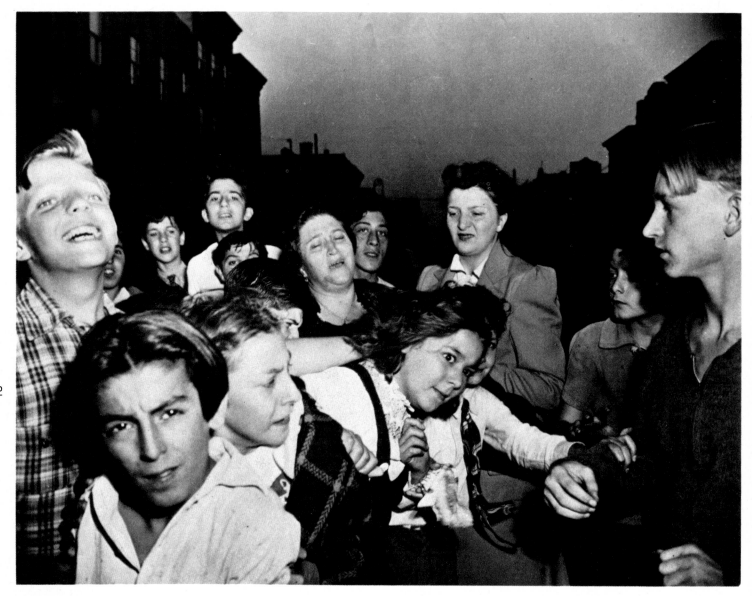

WEEGEE (ARTHUR FELLIG)
Brooklyn Schoolchildren See Gambler Murdered on Street, 1941
The Museum of Modern Art, New York

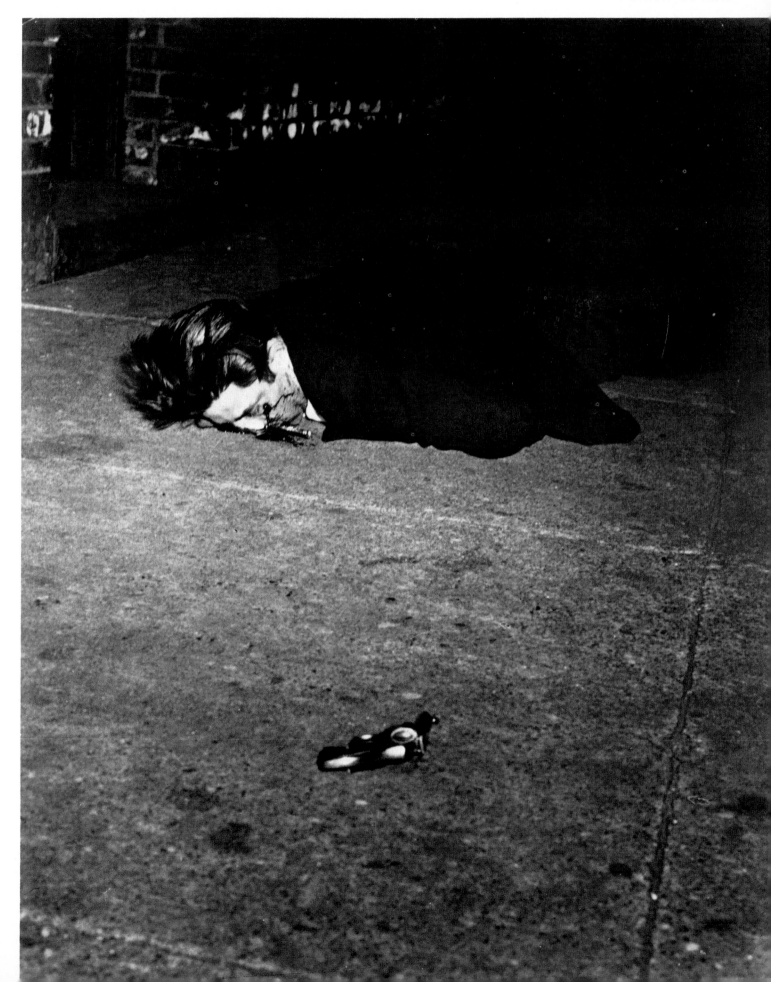

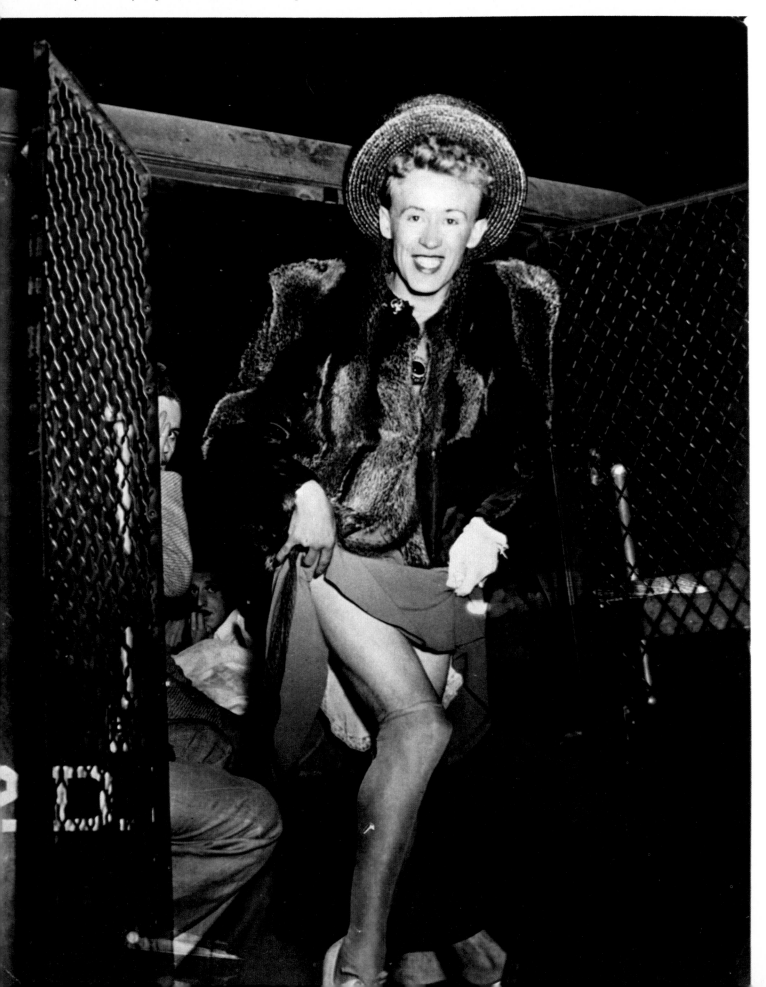

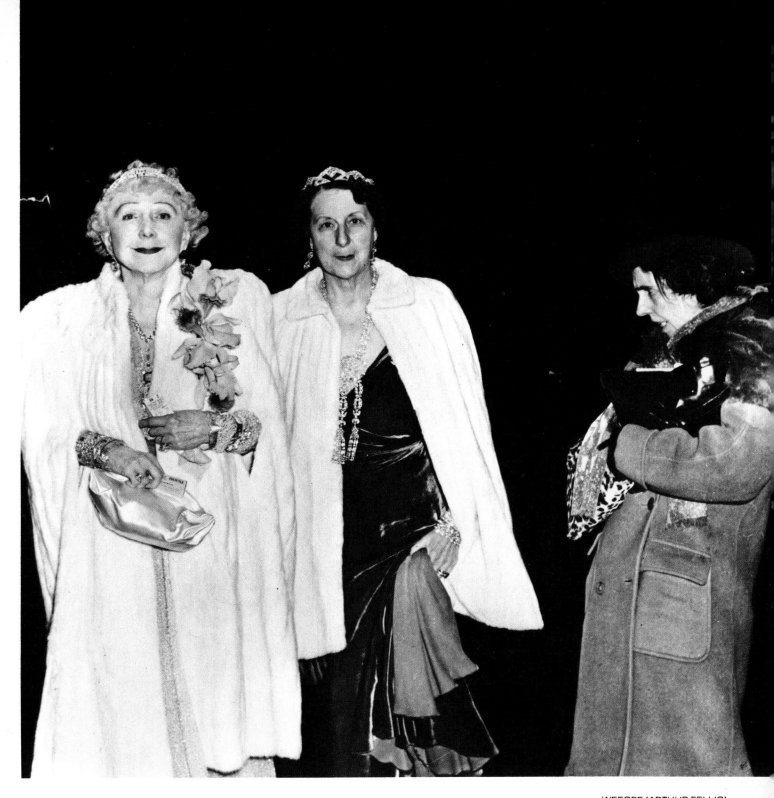

WEEGEE (ARTHUR FELLIG)
The Critic, 1943
Courtesy Lunn Gallery/Graphics International, Ltd., Washington, D.C.

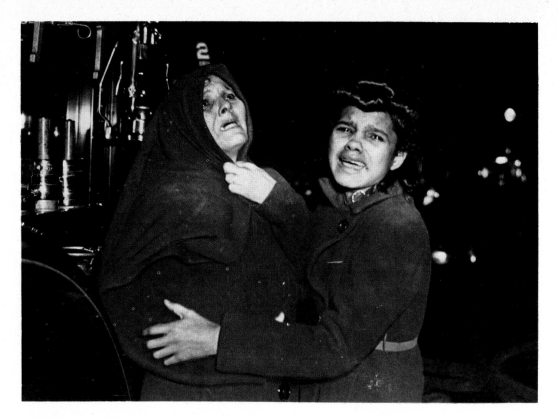

WEEGEE (ARTHUR FELLIG)
Weeping Women at Tenement Fire, Brooklyn, 1940's
Courtesy Lunn Gallery/Graphics International, Ltd., Washington, D.C.

WEEGEE (ARTHUR FELLIG)
Alfred Stieglitz, 1940's
Courtesy Lunn Gallery/Graphics International, Ltd., Washington, D.C.

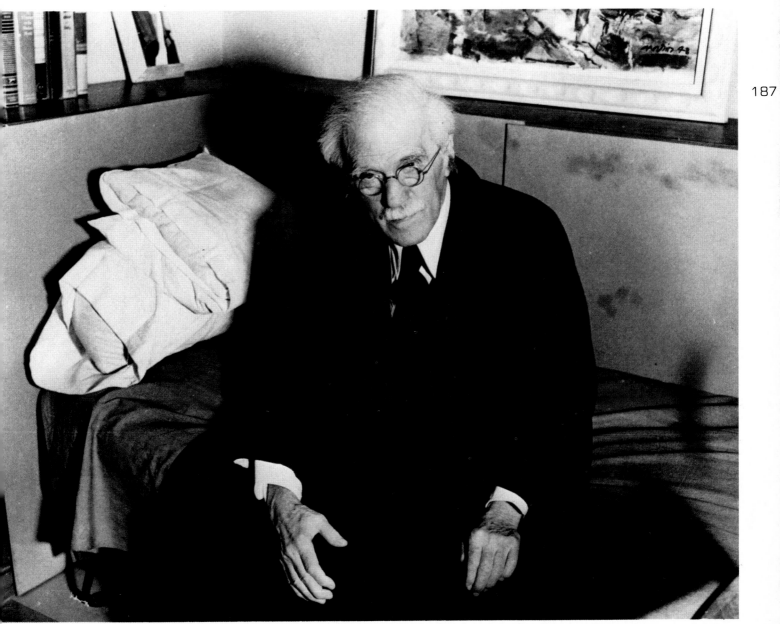

3. PERSONAL PHOTOGRAPHY NOW:

THE STIEGLITZ SUCCESSION

As a way of showing new work to the public, the
salon quietly expired during the era of magazine photography.
However, the salon tradition of photography as a means of personal
expression survived and was carried forward in silence and obsecurity
by a handful of dedicated enthusiasts, who began to achieve
prominence in recent years as the big picture magazines succumbed to
competition from television. Like Stieglitz in his late
work, they were all modernists. Also like Stieglitz, they avoided
commercial photography to keep faith with a personal
vision that grew more private, more abstract and more distinct
from the public art of the mass media.

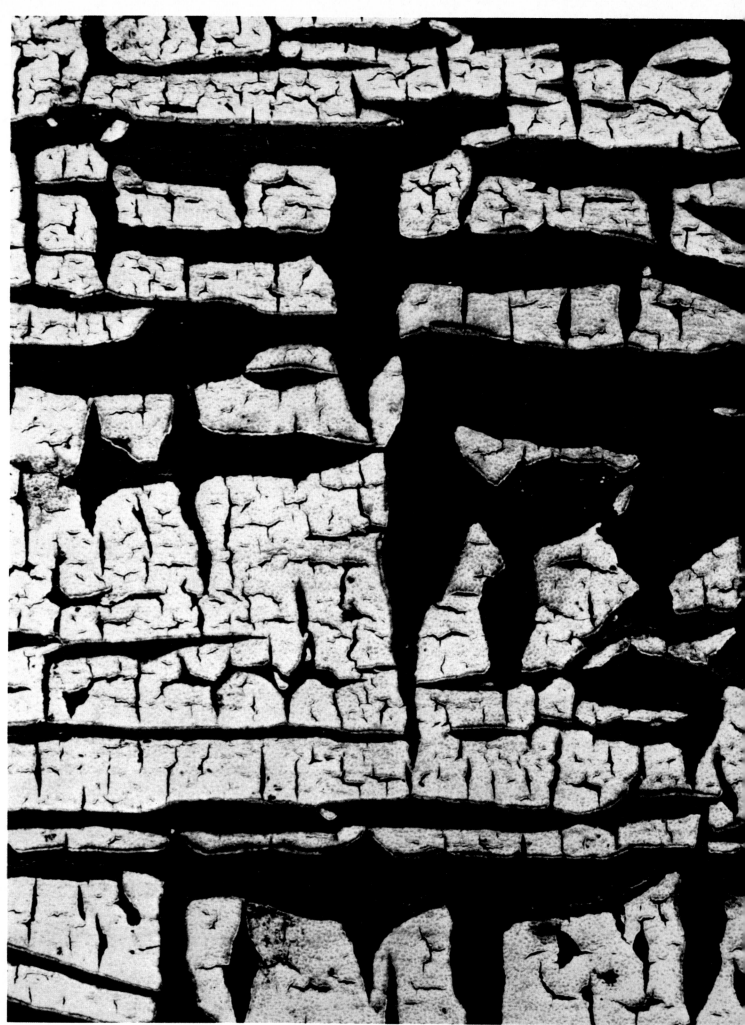

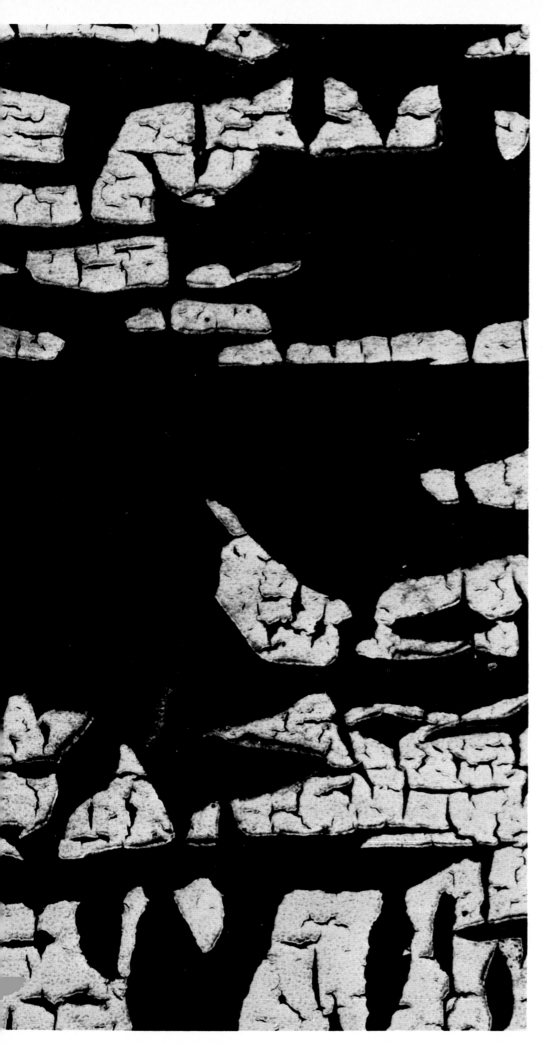

AARON SISKIND
New York, 1947
Courtesy Light Gallery, New York

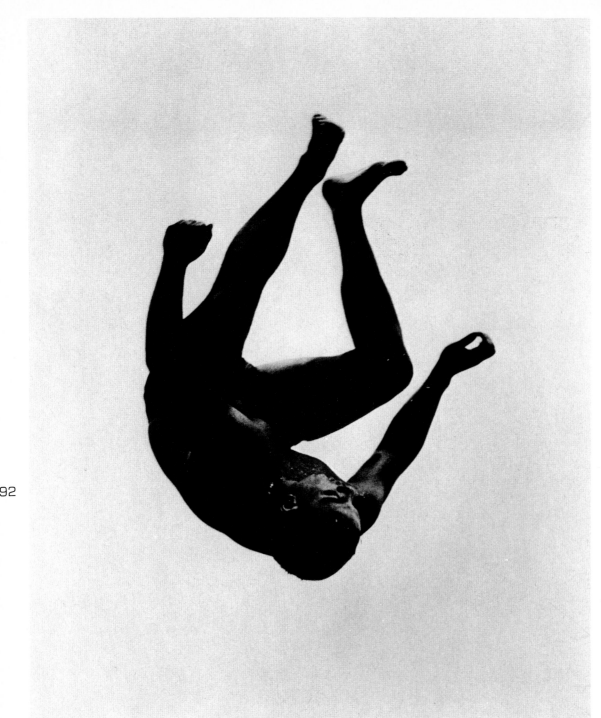

AARON SISKIND
Terrors and Pleasures of Levitation 474, 1954
Courtesy Light Gallery, New York

AARON SISKIND
Feet 139, 1958
Courtesy Light Gallery, New York

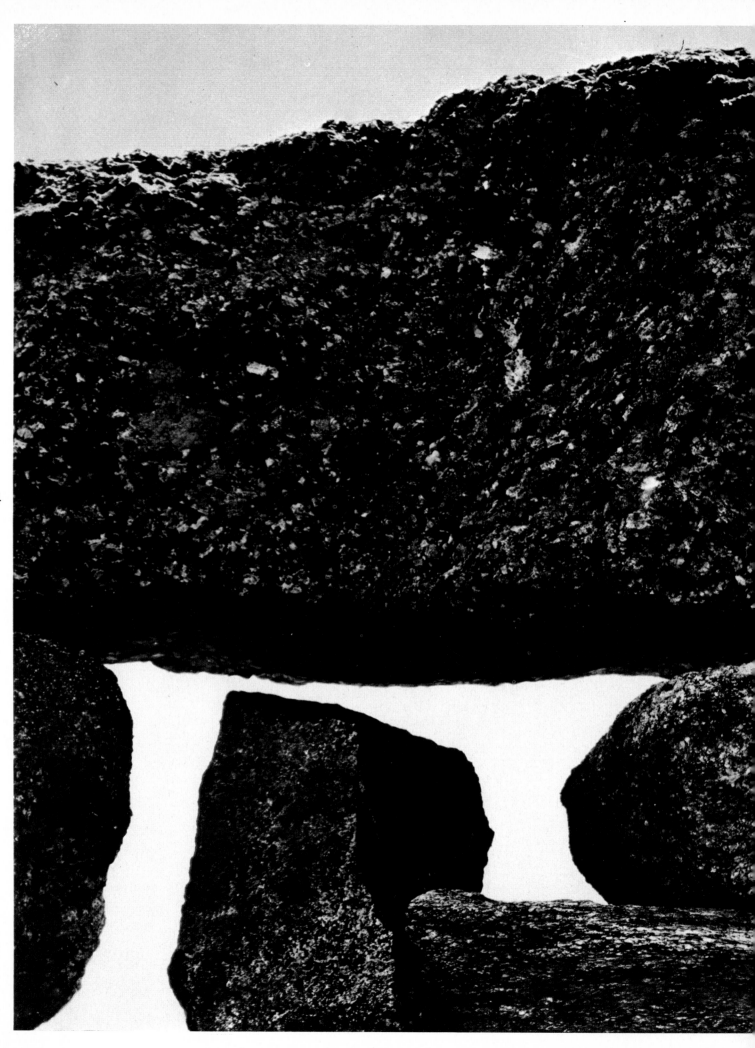

194

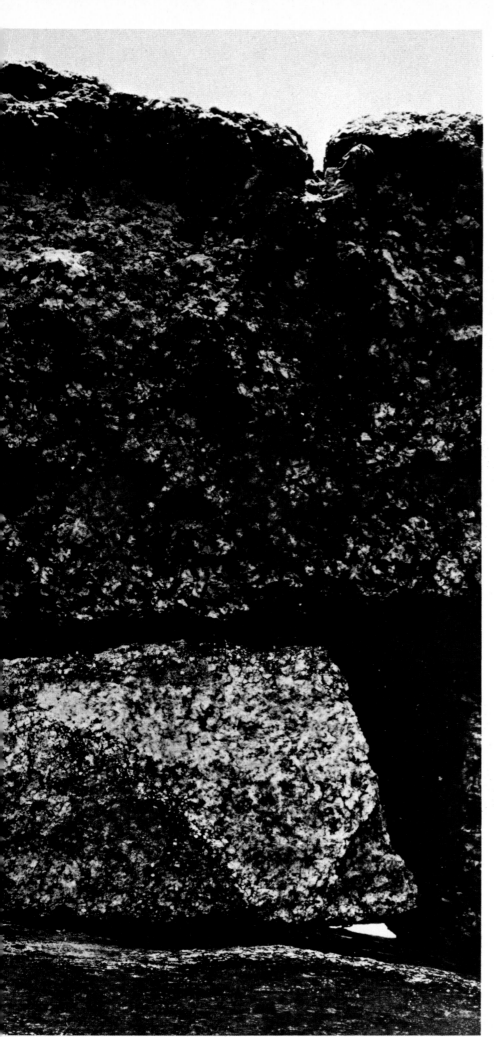

195

AARON SISKIND
Martha's Vineyard 124, 1954
Courtesy Light Gallery, New York

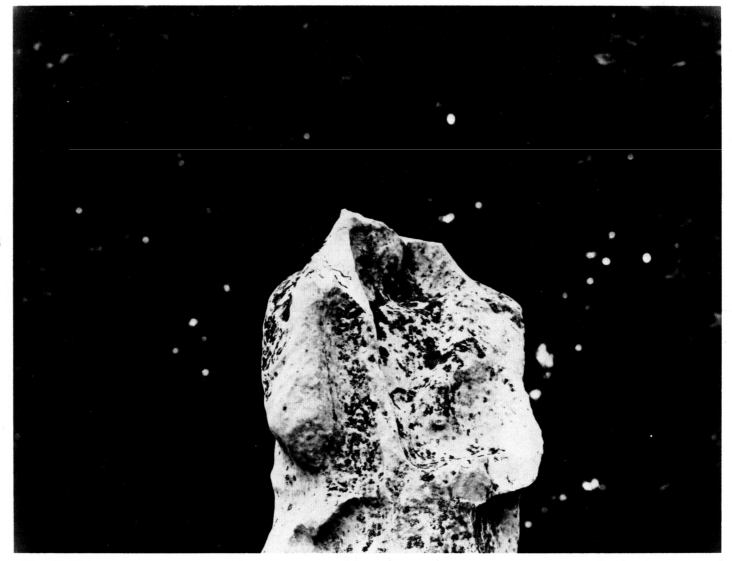

AARON SISKIND
Appia Antica 4, 1967
Courtesy Light Gallery, New York

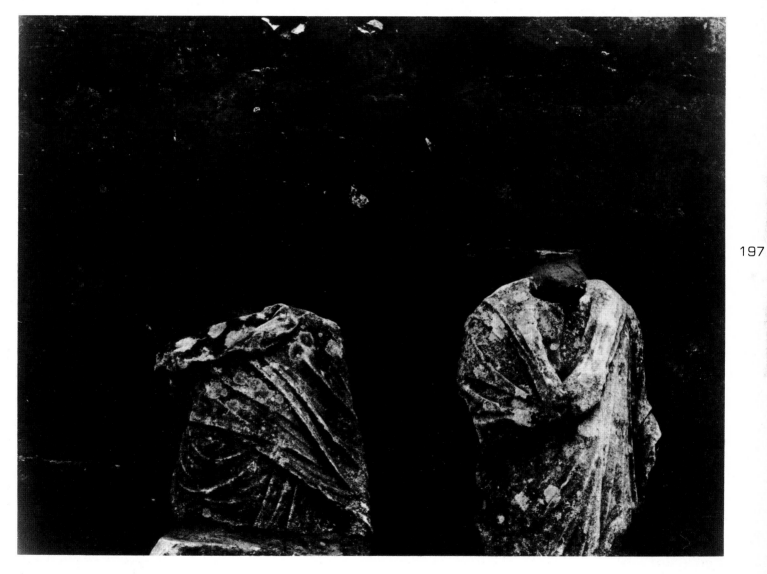

AARON SISKIND
Appia Antica 9, 1967
Courtesy Light Gallery, New York

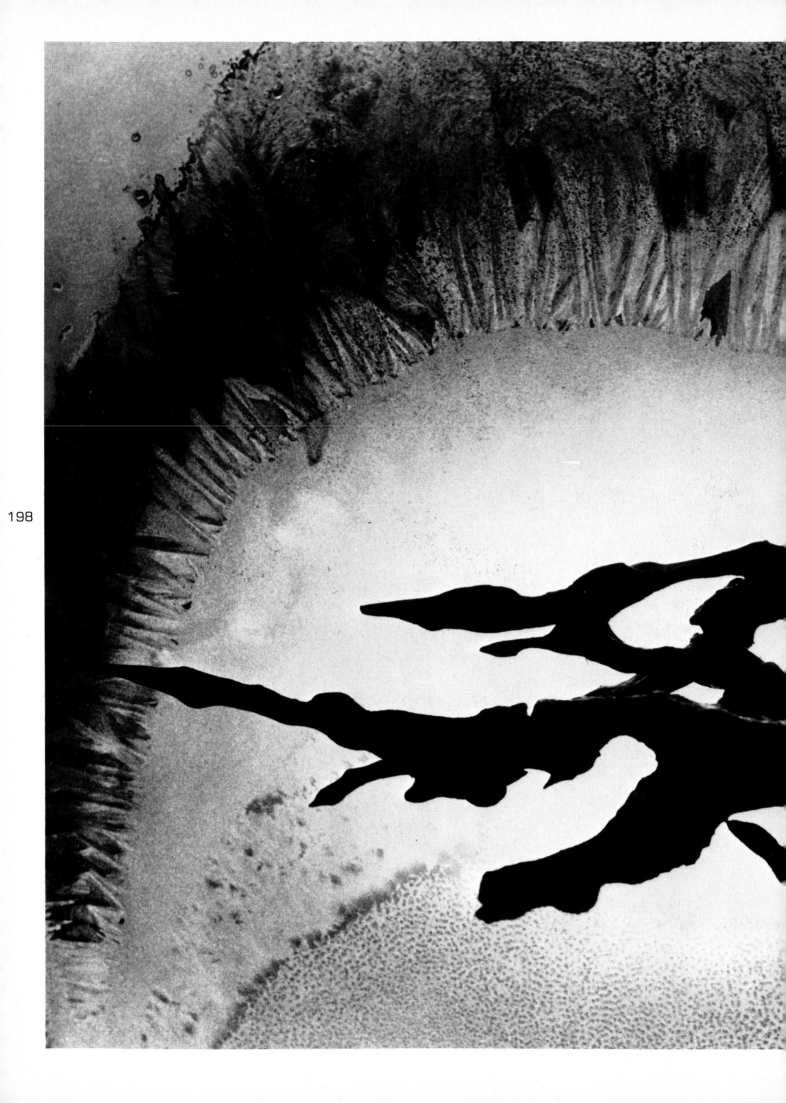

198

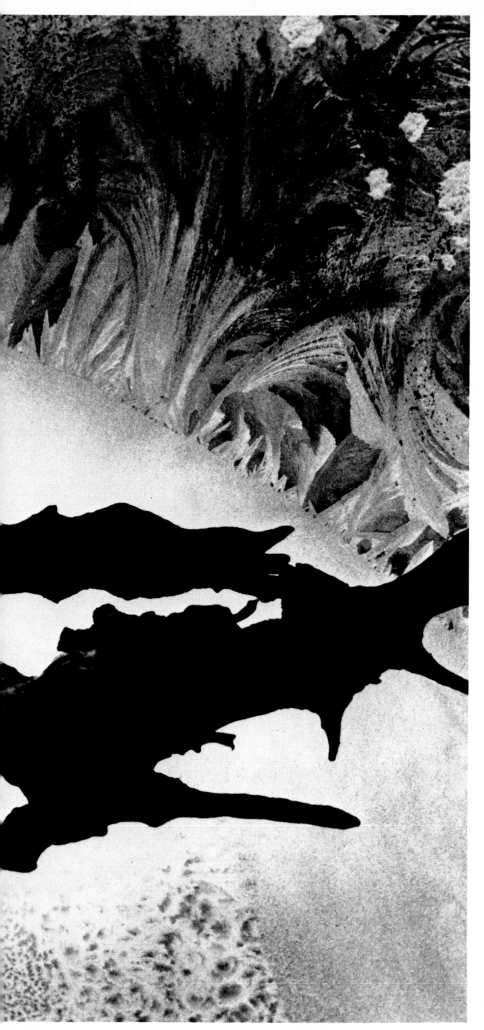

MINOR WHITE
Root & Frost, 1958
Courtesy Light Gallery, New York

MINOR WHITE
Peeled Paint on Store Window, 1951
Courtesy Light Gallery, New York

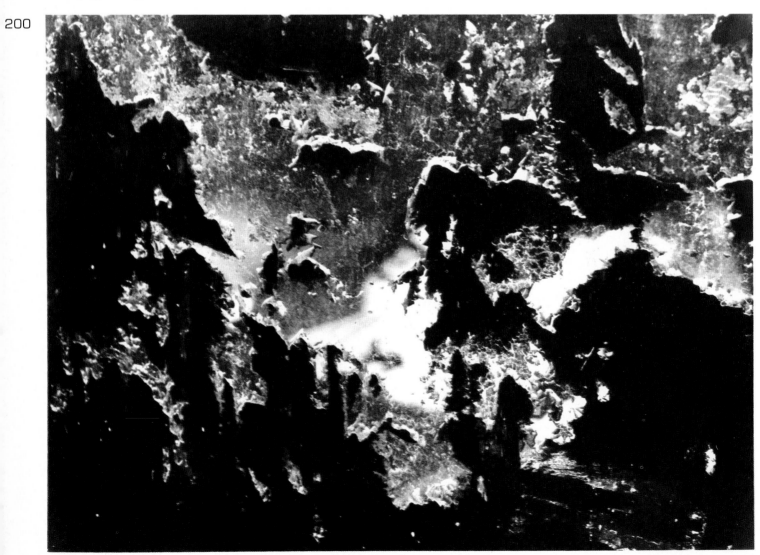

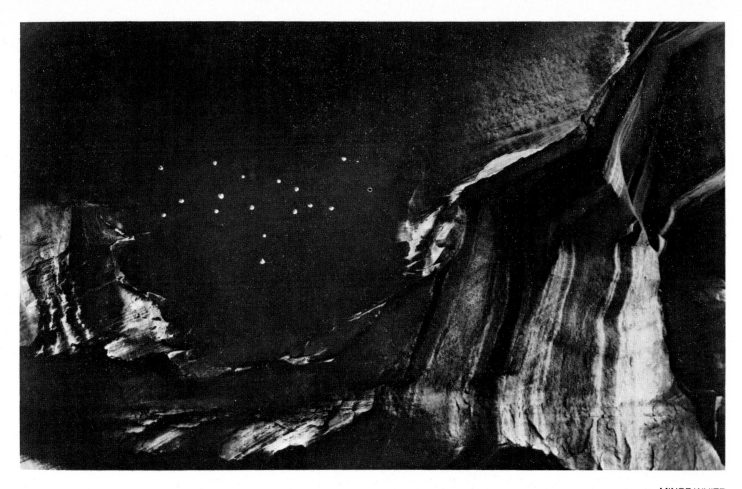

MINOR WHITE 201
Bullet Holes, 1961
Courtesy Light Gallery, New York

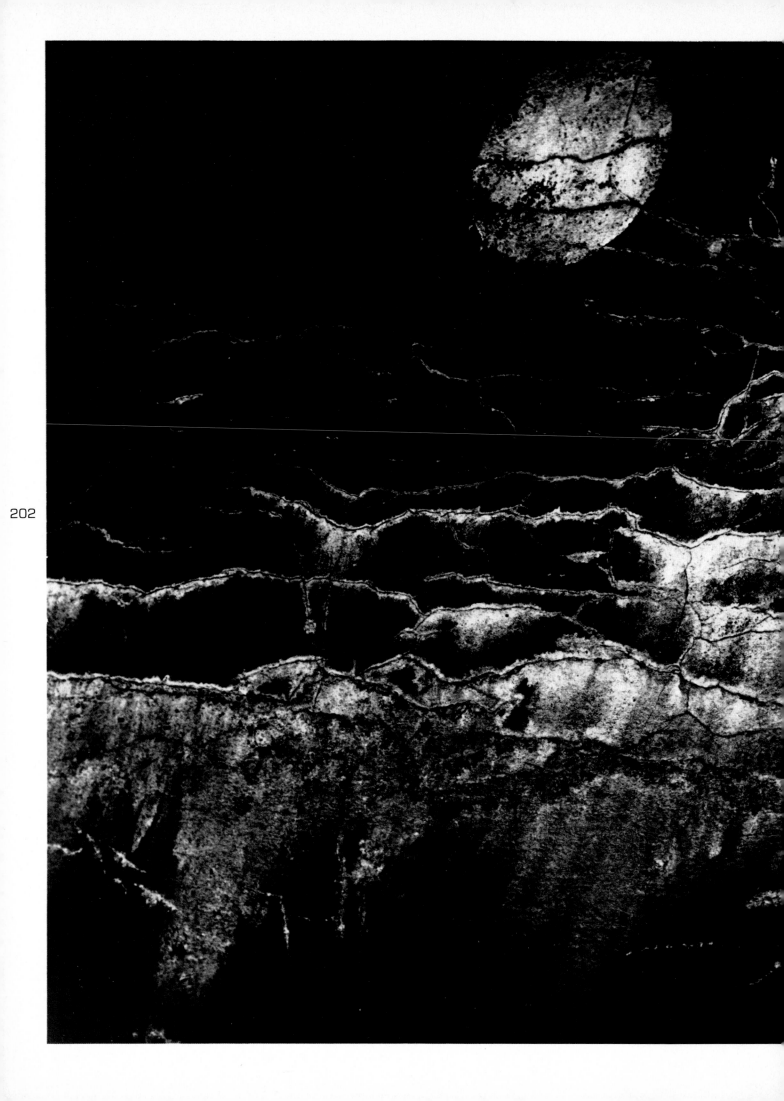

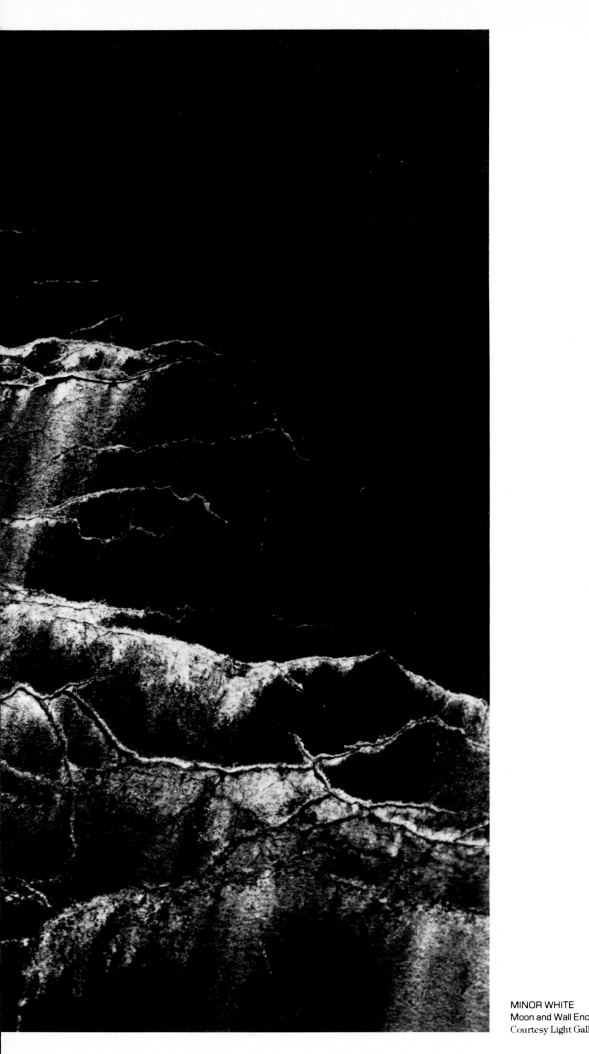

MINOR WHITE
Moon and Wall Encrustations, 1964
Courtesy Light Gallery, New York

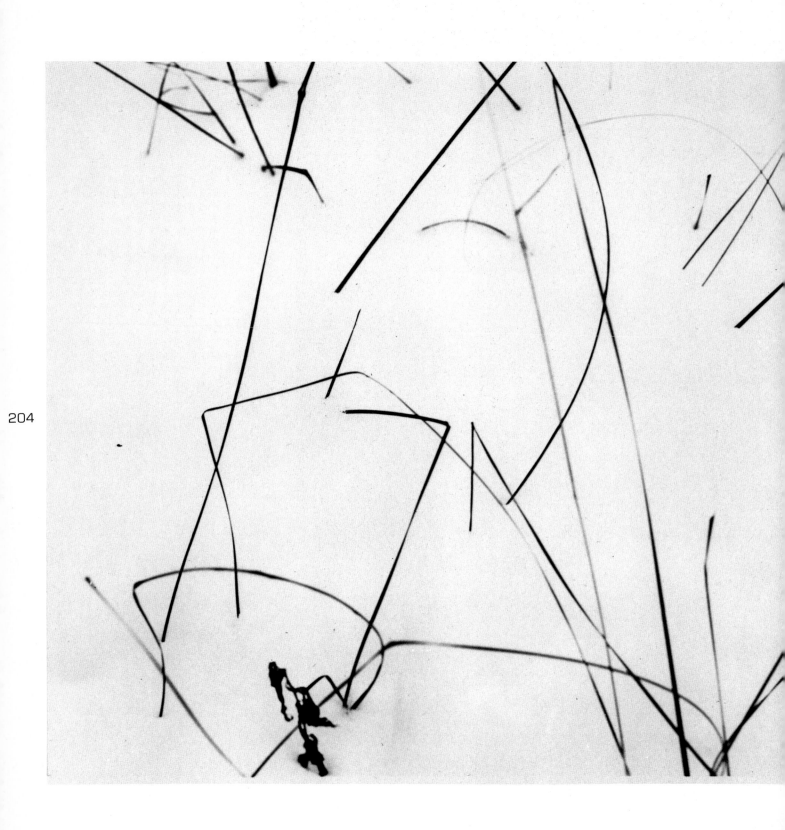

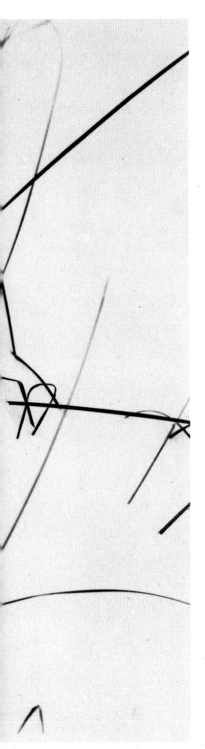

205

HARRY CALLAHAN
Grasses in Snow, Detroit, 1943
Courtesy Light Gallery, New York

206

HARRY CALLAHAN
Eleanor, 1948
Courtesy Light Gallery, New York

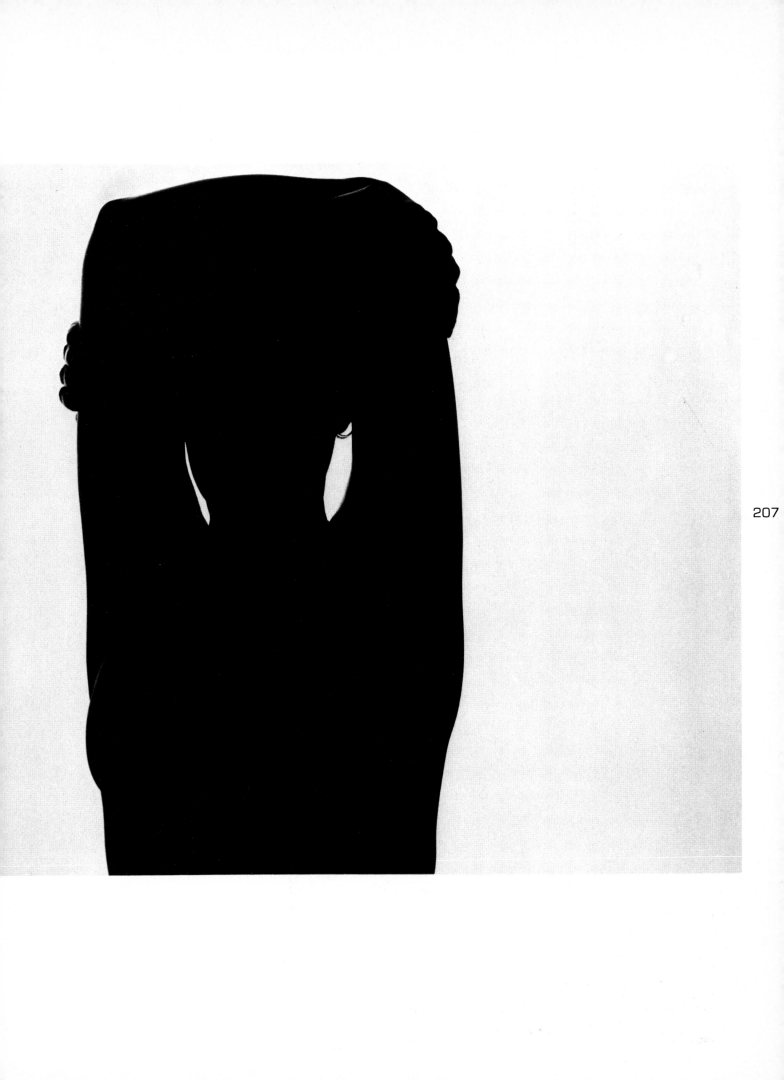

HARRY CALLAHAN
Chicago, 1961
Courtesy Light Gallery, New York

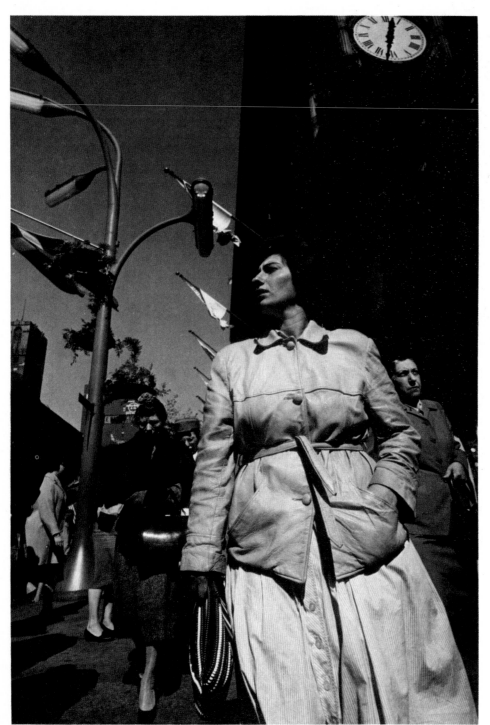

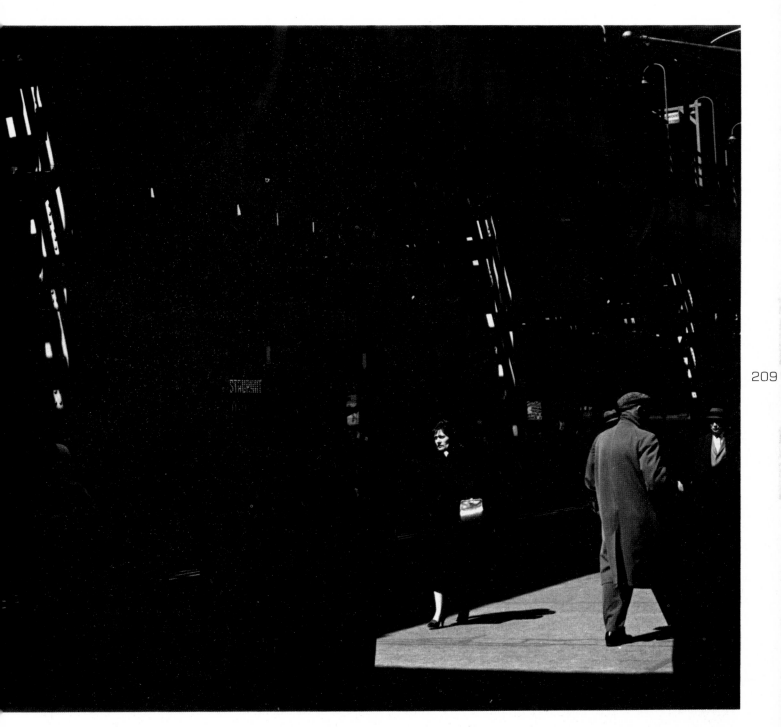

HARRY CALLAHAN
Chicago, ca. 1960
Courtesy Light Gallery, New York

210

HARRY CALLAHAN
Maine, 1962
Courtesy Light Gallery, New York

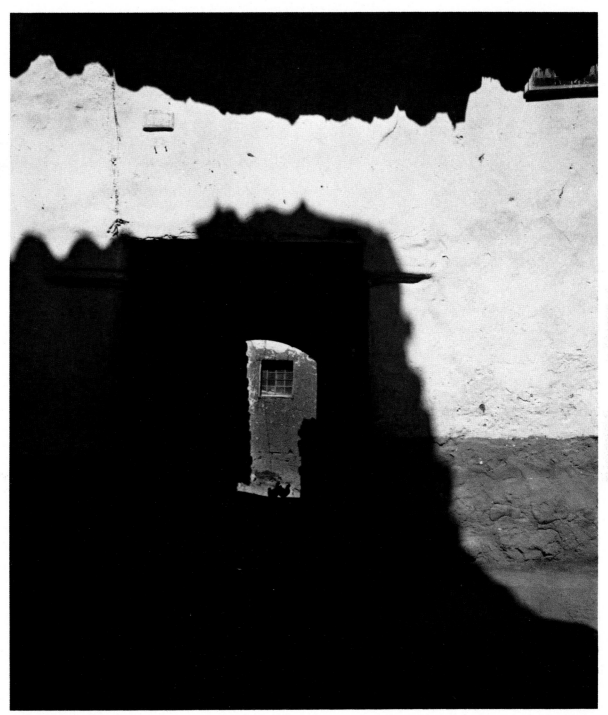

HARRY CALLAHAN
Cuzco, Peru, 1974
Courtesy Light Gallery, New York

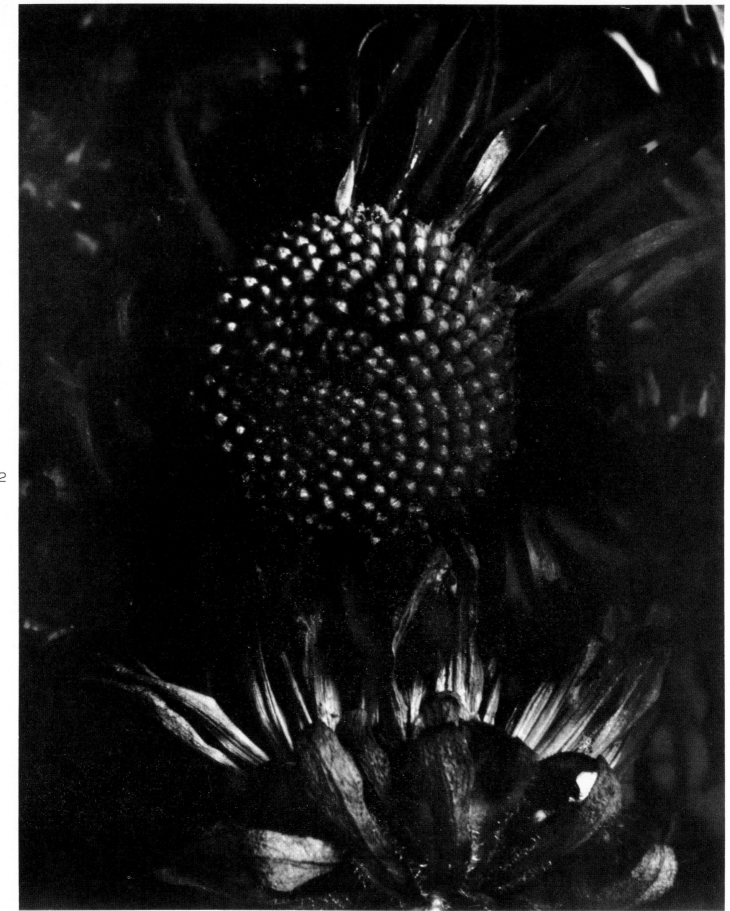

PAUL CAPONIGRO
Untitled, 1965
International Museum of Photography at George Eastman House, Rochester, N.Y.

THE YOUNGER GENERATION

Today the successors of Stieglitz include a younger
generation whose best-known work is done for themselves, not for
clients. However, most of these younger photographers
have rejected the purism and abstraction of late Stieglitz and
his immediate successors for a variety of unrelated
and sometimes opposing styles.

The comparable successors to Steichen—the gifted
young photographers whose best-known work is done for clients—
have not yet been discovered by the art
museums and galleries. They are probably fewer than
they used to be, for the decline of commercial
photography under the impact of television makes it
increasingly difficult for them to exist.

214

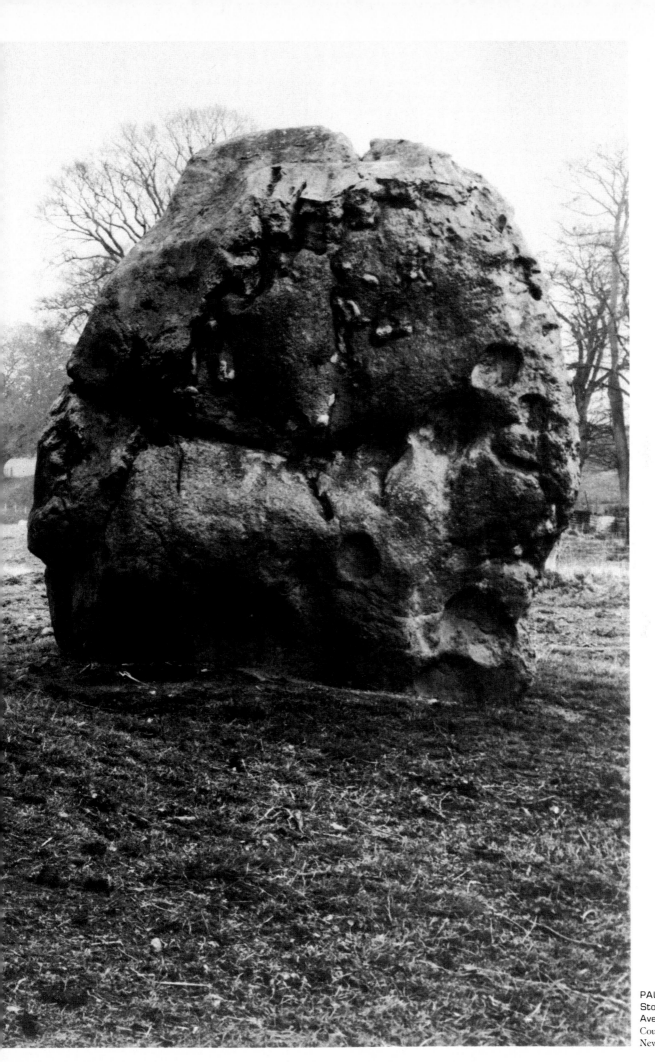

PAUL CAPONIGRO
Stone and Tree,
Avebury, England, 1967
Courtesy The Witkin Gallery, Inc.,
New York

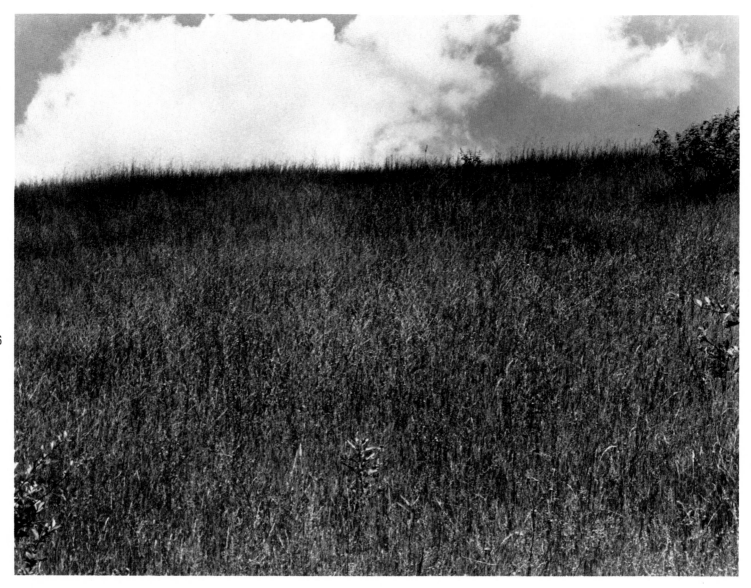

216

PAUL CAPONIGRO
Landscape, Kalamazoo, Michigan, 1970
Courtesy The Witkin Gallery, Inc., New York

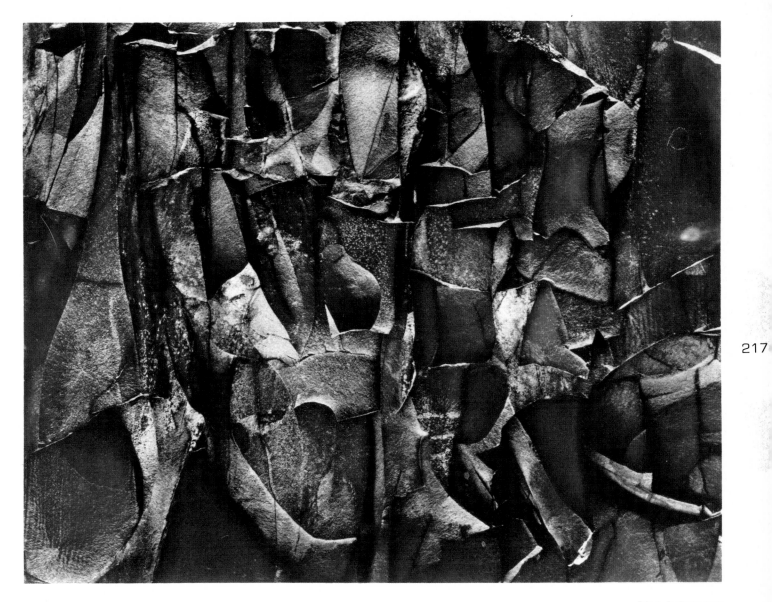

PAUL CAPONIGRO
Rock Wall Number 2, West Hartford, Connecticut, 1959
Collection of Lee D. Witkin

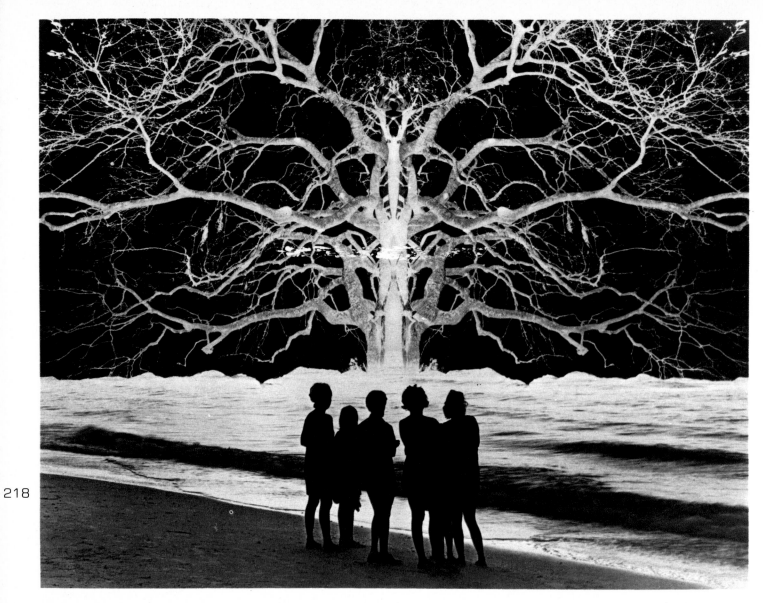

218

JERRY N. UELSMANN
Apocalypse II, 1967
Courtesy The Witkin Gallery, Inc., New York

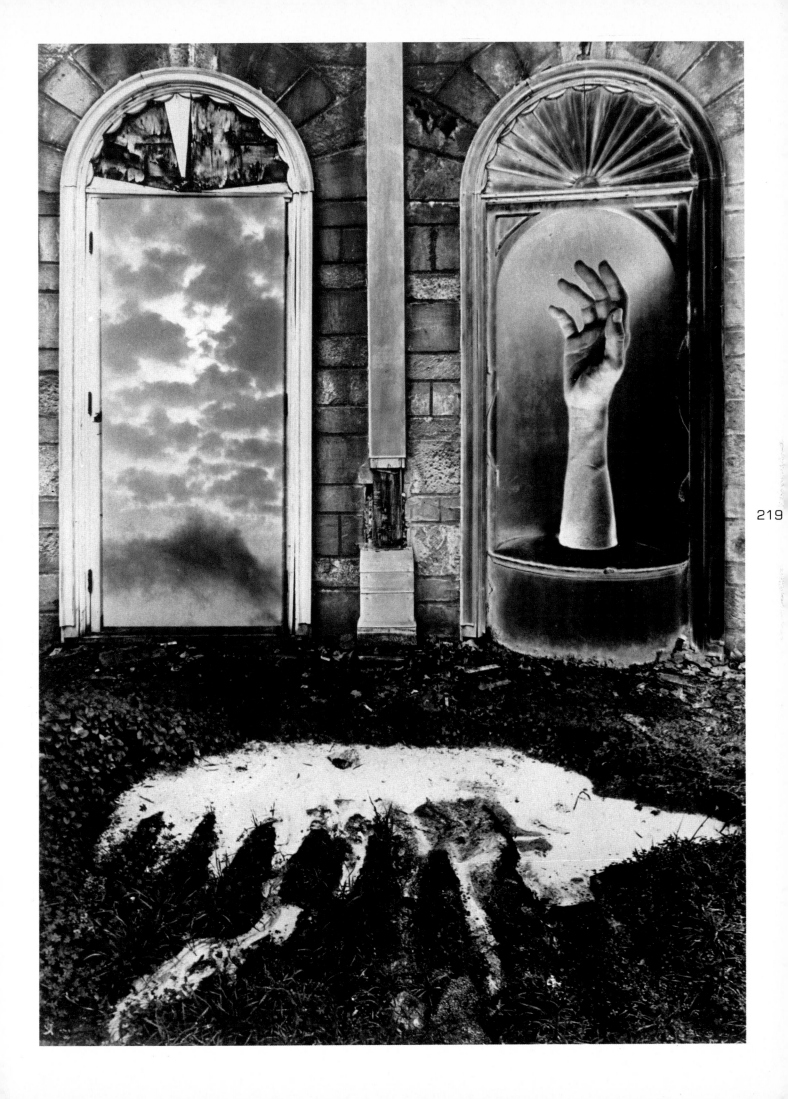

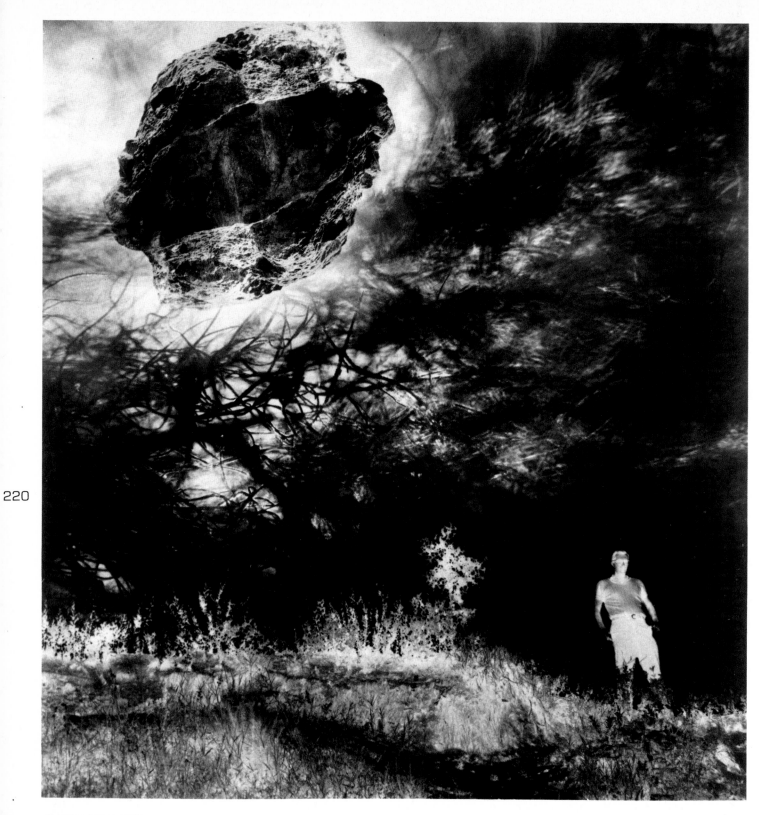

220

JERRY N. UELSMANN
Apocalypse I, 1967
Courtesy The Witkin Gallery, Inc., New York

JERRY N. UELSMANN
Equivalent, 1964
Courtesy The Witkin Gallery, Inc., New York

222

LEE FRIEDLANDER
From *Self-Portrait*, Philadelphia, Pa. 1963
Courtesy the Photographer

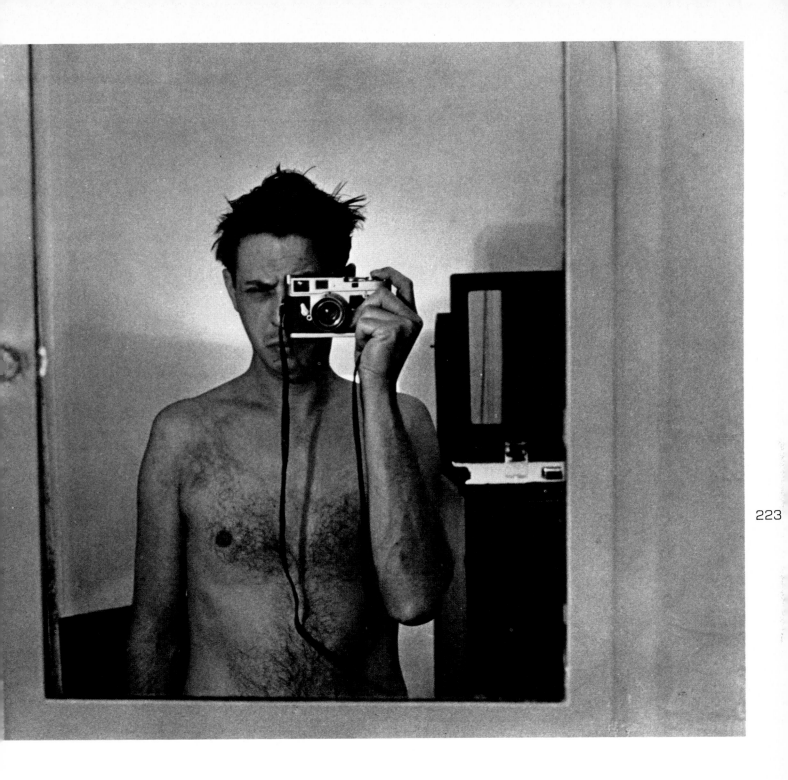

LEE FRIEDLANDER
From *Self-Portrait*, Southern U.S., 1966
Courtesy the Photographer

LEE FRIEDLANDER
From *Self-Portrait*, 1966
Courtesy the Photographer

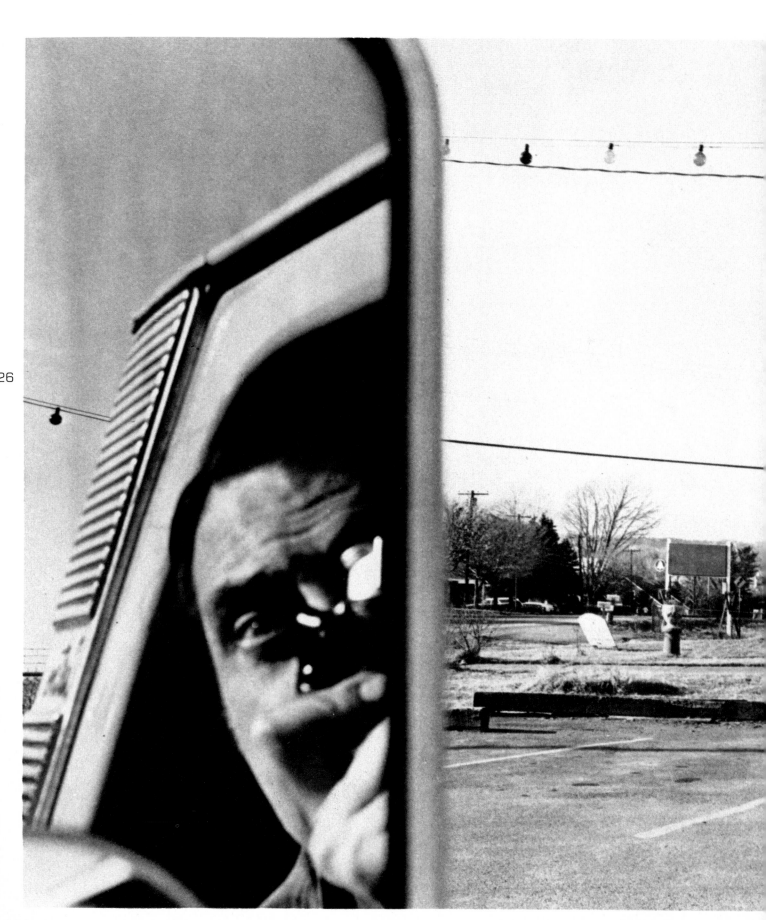

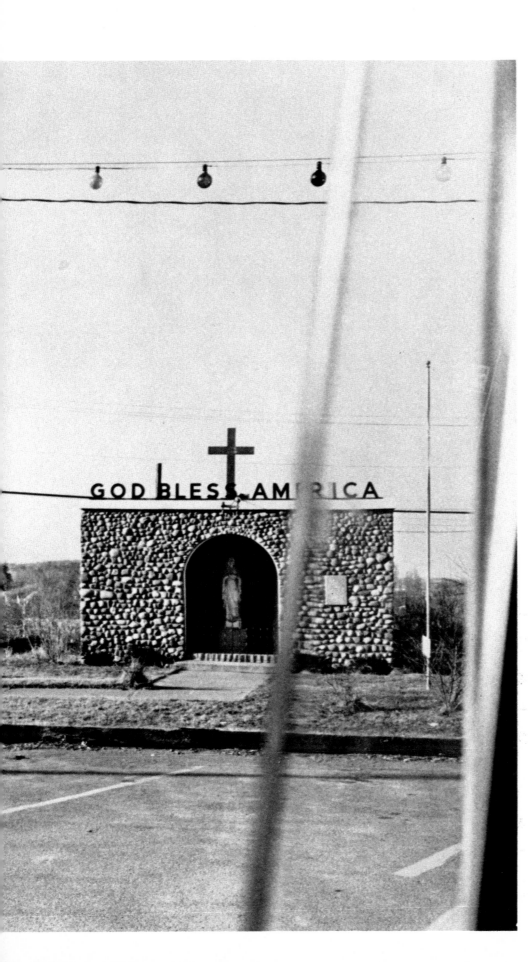

LEE FRIEDLANDER
From *Self-Portrait*, Route 9 W, New York, 1969
Courtesy the Photographer

229

WILLIAM EGGLESTON
Untitled, 1973
Lunn Gallery/Gaphics International Ltd., Washington, D.C.

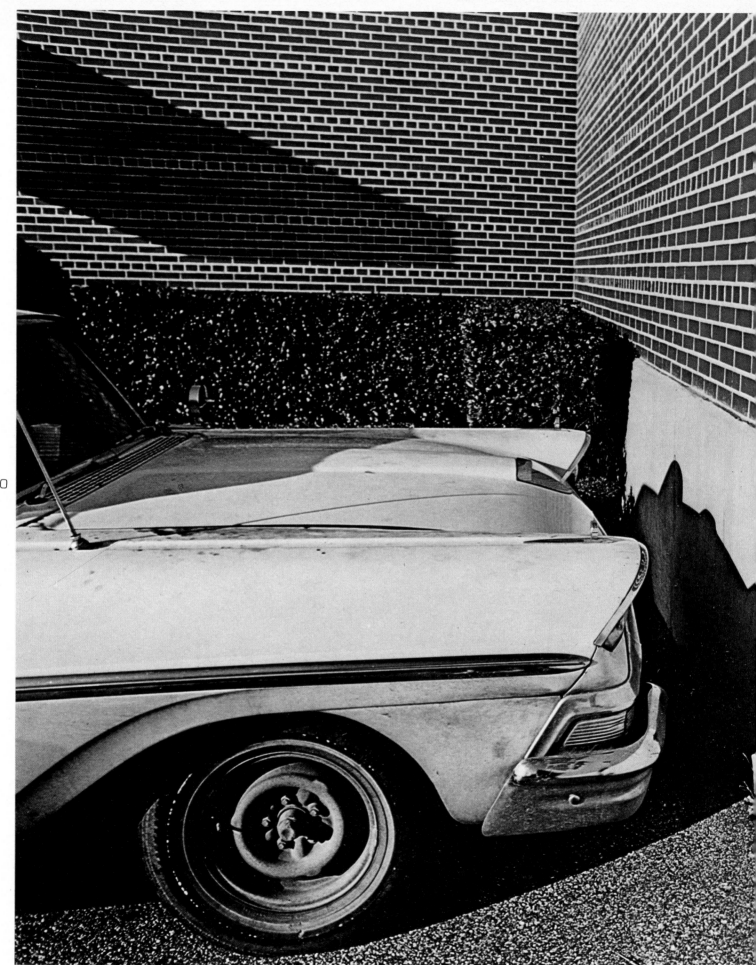

230

WILLIAM EGGLESTON
Untitled (Memphis), 1971
Courtesy Lunn Gallery/Graphics International, Ltd., Washington, D.C.

231

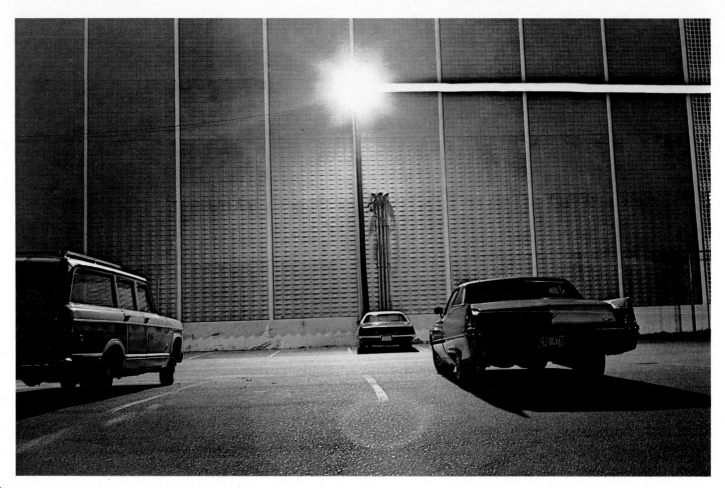

232 WILLIAM EGGLESTON
Parking Lot at Night, ca. 1972
Courtesy Lunn Gallery/Graphics International, Ltd., Washington, D.C.

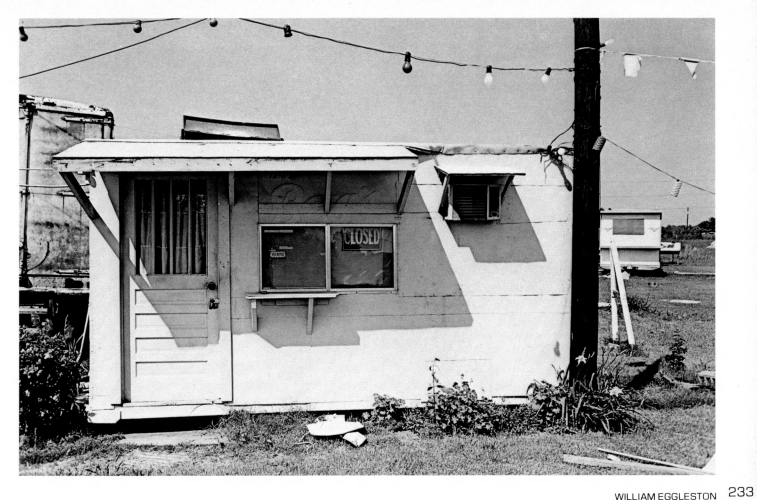

WILLIAM EGGLESTON 233
Untitled (Environs of New Orleans), 1972
Courtesy Lunn Gallery/Graphics International, Ltd., Washington, D.C.

BENNO FRIEDMAN
Untitled, 1973
Courtesy Light Gallery, New York

BENNO FRIEDMAN
Untitled, 1974
Courtesy Light Gallery, New York

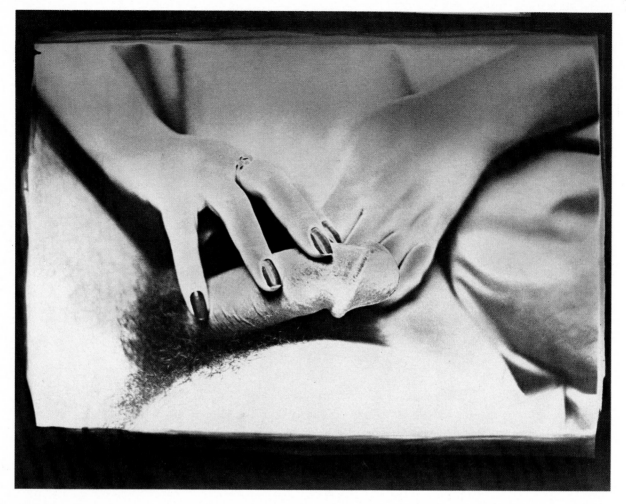

BENNO FRIEDMAN
Untitled, 1974
Collection of Susan Harder, New York

BENNO FRIEDMAN
Untitled, 1975
Courtesy Light Gallery, New York

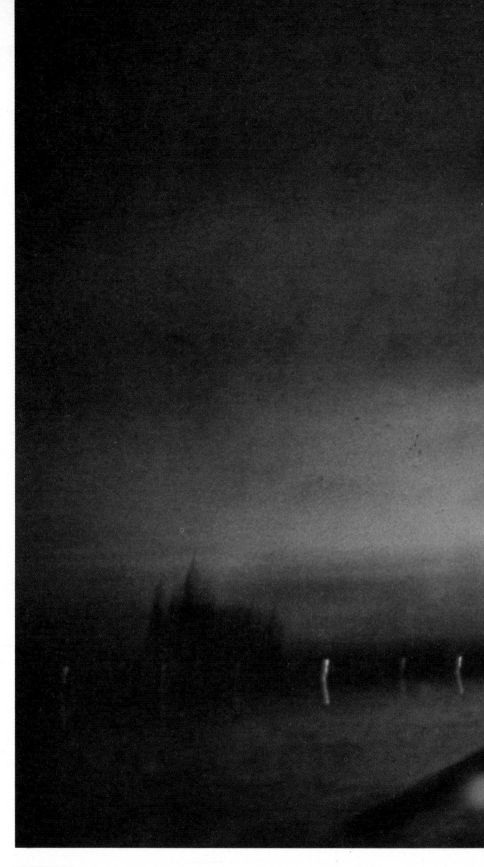

ERNST HAAS
Venice, Gondolier, 1955
Courtesy the Photographer

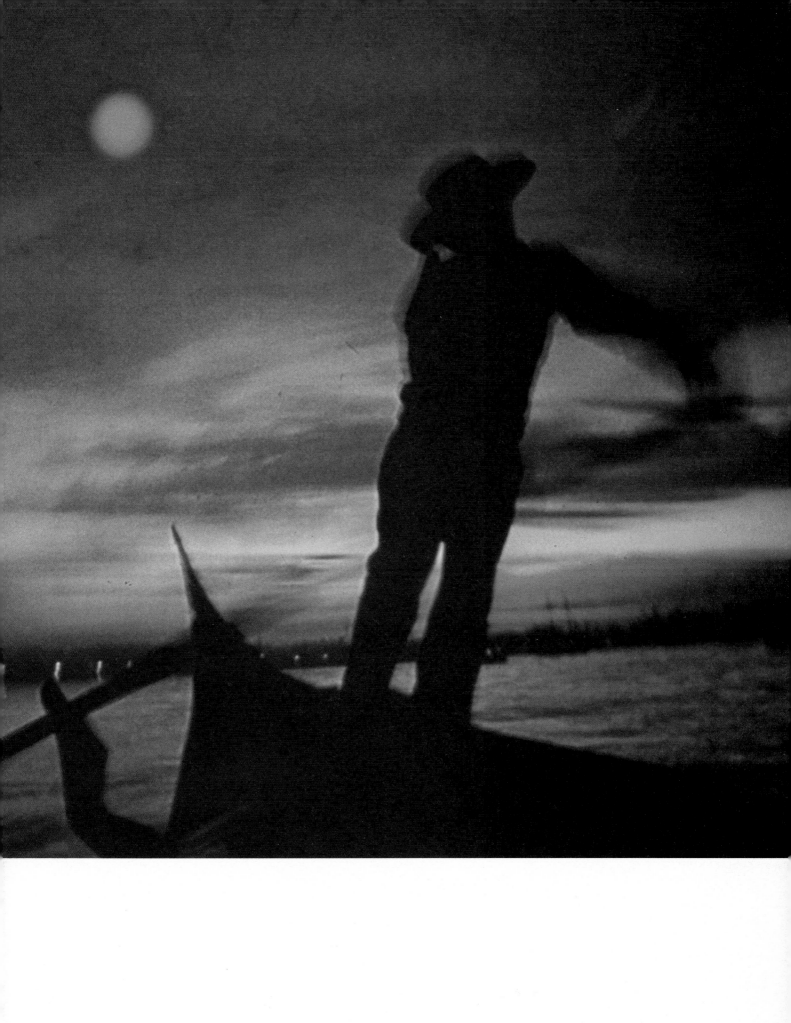

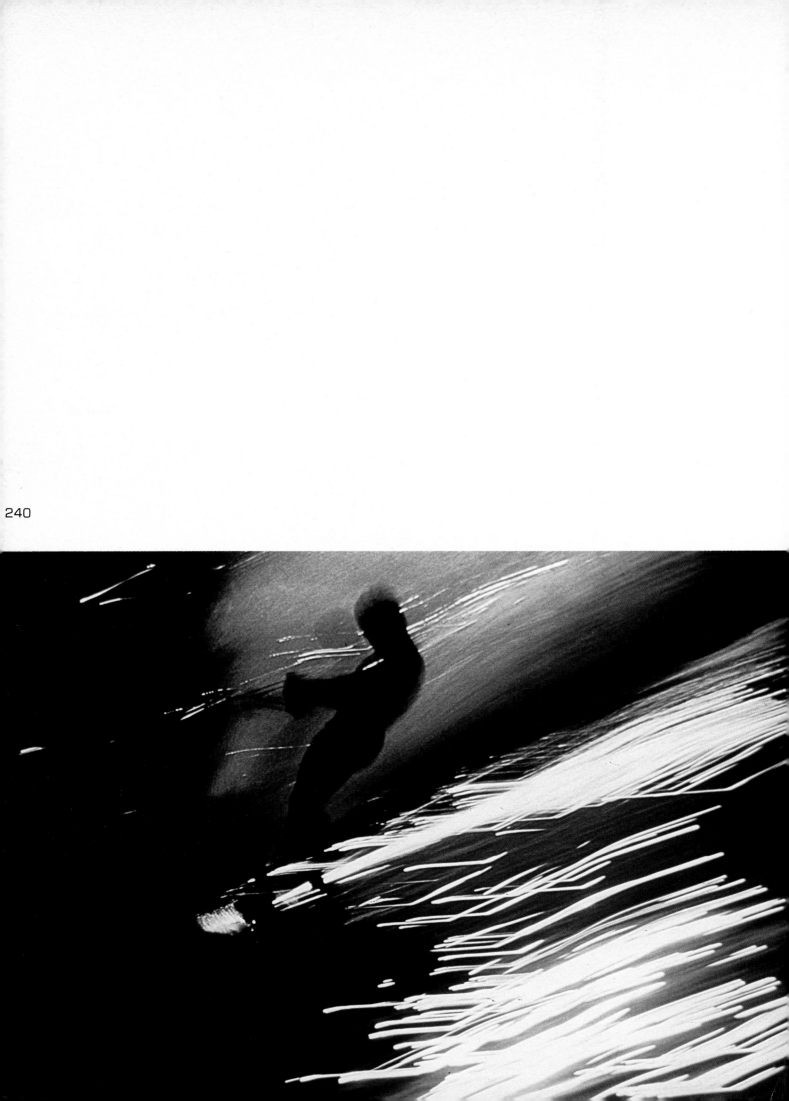

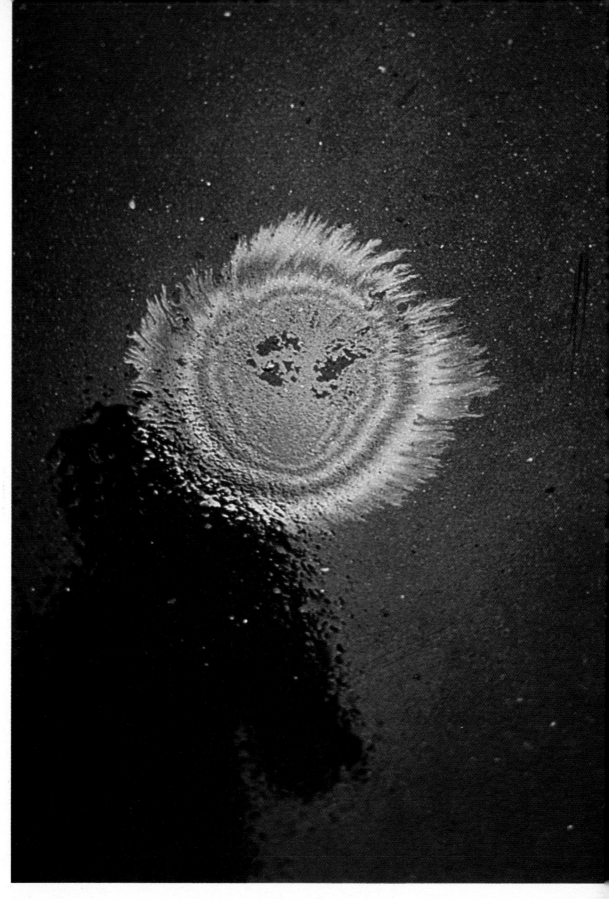

ERNST HAAS
Oil Spot, 1952
Courtesy the Photographer

ERNST HAAS
Water Skier, 1958
Courtesy the Photographer

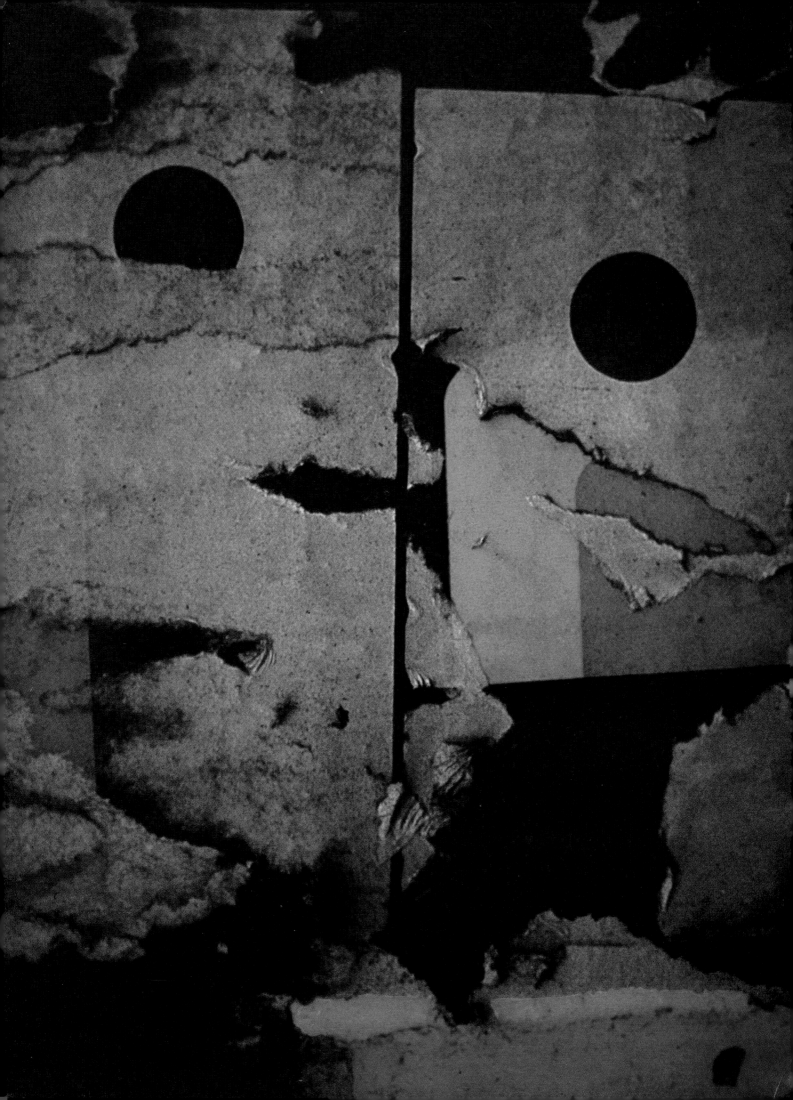

243

ERNST HAAS
Abstract Poster, 1956
Courtesy the Photographer

244

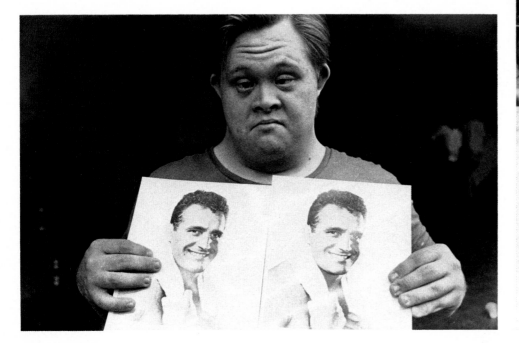

GEOFF WINNINGHAM
From *Friday Night at the Coliseum,* 1970. Fan with Photos
Courtesy the Photographer

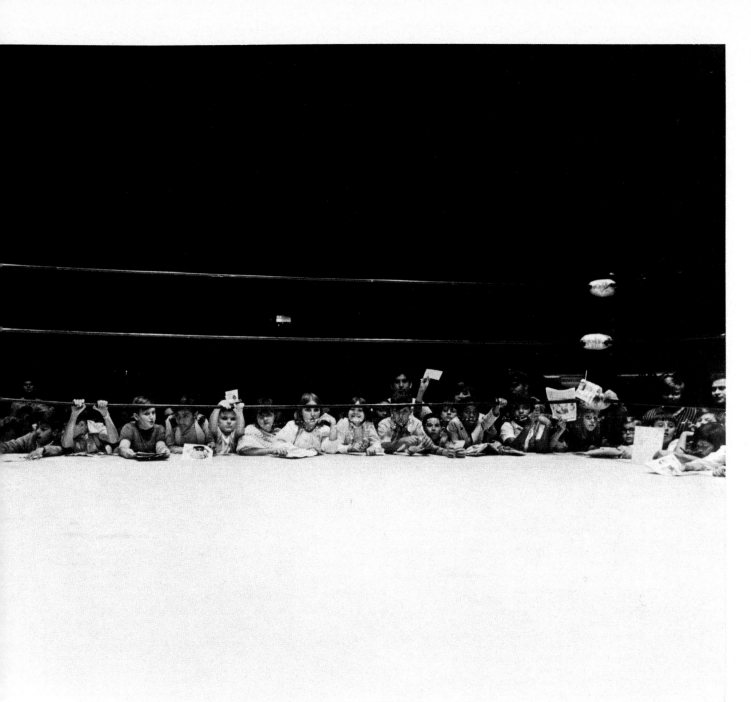

245

GEOFF WINNINGHAM
From *Friday Night at the Coliseum*, 1970: Crowd at Ringside
Courtesy the Photographer

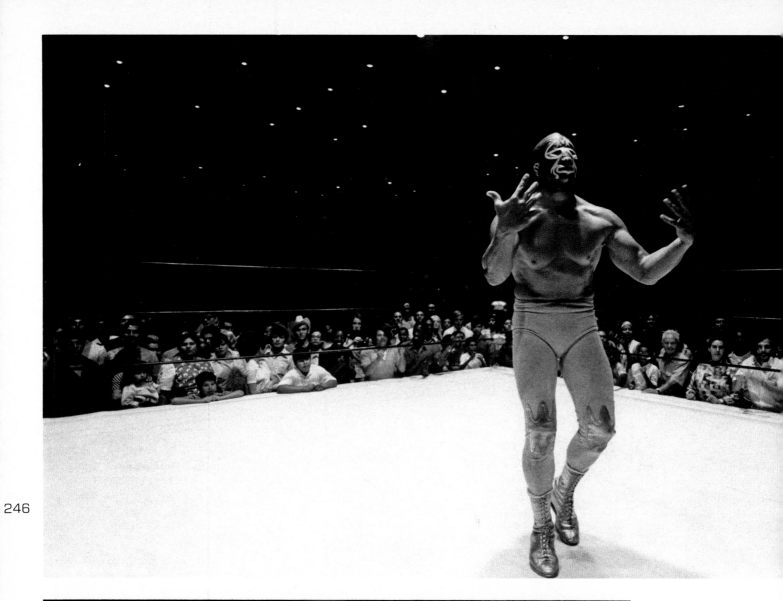

246

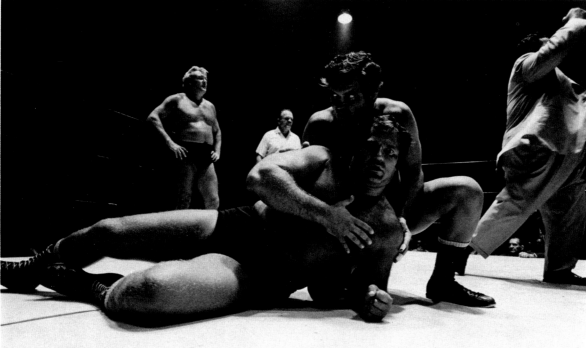

GEOFF WINNINGHAM
From *Friday Night at the Coliseum*, 1970: Tag Team Partners
Courtesy the Photographer

GEOFF WINNINGHAM
From *Friday Night at the Coliseum*, 1970: Wrestler Greeting Crowd
Courtesy the Photographer

247

GEOFF WINNINGHAM
From *Friday Night at the Coliseum*, 1970: Russian Chain Match
Courtesy the Photographer

248

GEOFF WINNINGHAM
From *Friday Night at the Coliseum,* 1970: After the Match
Courtesy the Photographer

INDEX TO THE PHOTOGRAPHERS

Numbers in italic refer to photographs